# Ancient and High
# Crosses of Cornwall

# Ancient and High Crosses of Cornwall

## Cornwall's Earliest, Tallest and Finest Medieval Stone Crosses

Ann Preston-Jones, Andrew Langdon
and Elisabeth Okasha

UNIVERSITY
*of*
EXETER
PRESS

First published in 2021 by
**University of Exeter Press**
Reed Hall, Streatham Drive
Exeter, Devon EX4 4QR
*www.exeterpress.co.uk*

**British Library Cataloguing in Publication Data**
A catalogue record for this book is available
from the British Library.

ISBN: 978-1-90581-661-3 – paperback
ISBN: 978-1-90581-662-0 – ePub
ISBN: 978-1-90581-663-7 – PDF

Cover images:
*Front panel, left to right:* Cardinham 1; Laneast 2;
Laneast Downs, Lesnewth; Lelant; Mullion, Predannack
*Spine:* Michaelstow
All images © the authors

Typeset in Minion by
BBR Design, Sheffield

# Contents

## *Catalogue of Crosses*

CONTENTS

## *Parish Pages*

# Acknowledgements

The authors are happy to acknowledge the many people who have helped them in the course of writing this book.

We are very grateful to all friends and colleagues who have offered us advice and encouragement, and have provided us with references and other material. These include, but are not confined to: Bert Biscoe, Garry Earley, Nancy Edwards, Nick Johnson, Graeme Kirkham, John Lumsden, Peter Rose, Daniel Rose-Jones, Thomas Rose-Jones, David Thomas, and the churchwardens and incumbents of the many churches we have visited to take photographs. Dot Blackman, Val Jacob, Brian Oldham and Martin Thomas kindly allowed us to use their photographs. In addition, Angela Broome of the Courtney Library of the Royal Institution of Cornwall, Truro, and the Morrab Library, Penzance, have given us permission to reproduce images from their collections.

We acknowledge with gratitude financial assistance towards publication costs from the National University of Ireland and from the Aurelius Trust. We would also like to thank the Cornwall Archaeological Society for its support with this publication.

The foundation and springboard for this book was our *Early Cornish Sculpture*, volume XI in the British Academy series *Corpus of Anglo-Saxon Stone Sculpture*. It is a pleasure to thank Professor Rosemary Cramp and Dr Derek Craig for their support of both projects.

Last but not least, we must acknowledge the patience of our long-suffering families in the years that we have been working on these stones.

# Introduction

The purpose of this book is to present one hundred of the finest and most accessible of the early Cornish crosses, each carefully illustrated, in a format and at a price to make the book available to as many people as possible.

The current authors were involved, as part of a team, in producing *Early Cornish Sculpture*, volume XI of the *Corpus of Anglo-Saxon Stone Sculpture*, published by the British Academy in 2013. However, *Early Cornish Sculpture* is a large and expensive volume, and it was felt that a shorter, more colourful book was also required. It is hoped that the present work will be of interest to the many Cornish people who are justly proud of their heritage, and also to some of the visitors to Cornwall who wonder at the ubiquity of these striking monuments and would like to know more about them.

This book is not merely a shortened version of *Early Cornish Sculpture*, although the authors are happy to acknowledge the debt they owe to that volume and what they learnt from producing it. Although many of the crosses in the current book do appear in *Early Cornish Sculpture*, there are also many that do not. Unlike *Early Cornish Sculpture*, this book does not contain any early sculpture other than crosses.

The one hundred crosses included in the present book are all of medieval date, and all fall within the date range of around AD 900 to 1300. These crosses were chosen because they are excellent examples of ancient or high crosses and because many of them have an interesting history. In addition, almost all of them are accessible to the public, though sometimes with care. Some of the crosses featured in this book may not now appear impressive, but this is because they survive only as fragments of the original whole, having been damaged or broken up for reuse.

From surviving crosses and fragments, base-stones and documents, we know that there were once over 650 medieval crosses in Cornwall and probably originally more.[1] The selection presented in this book, then, is exactly that—a

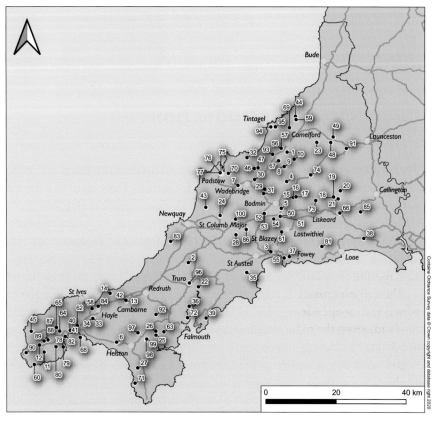

Fig. 1. Locations of all the crosses in the Catalogue. Map by Thomas Rose-Jones.

selection, intended to represent the finest and most interesting of those which have survived, from across the county (Fig. 1).

The bulk of the book consists of the Catalogue, with one entry for each of the one hundred crosses and one or more accompanying photographs. Each entry gives a brief account of the history of the cross, a short description of its decoration, and a discussion of the type of cross and its place among the other crosses of the area. Another feature of the book is the inclusion of some parish pages, which illustrate a selection of the crosses from individual parishes, often remarkably homogeneous in style. The Bibliography lists all works referred to in the text and provides for further reading.

# Historical overview

The early crosses of Cornwall are Christian monuments and the earliest of them are probably to be dated to the late ninth or early tenth century.[1] However, Christianity certainly has an earlier origin in Cornwall. There is no actual evidence for it in the Roman period, although it would not be unreasonable to expect this. Instead, the earliest physical evidence consists of the enclosed Christian sites known as *lanns*,[2] and the early inscribed stones that probably date from the late fifth century.[3]

The earliest crosses date from a turbulent period in Cornwall's history, in which the independent Brittonic kingdom was gradually becoming part of England. From the ninth century, Cornwall was coming under the control of the Anglo-Saxon kingdom of Wessex, following military campaigns by King Ecgbert. When he died in 839, he granted six estates in Cornwall to the minster at Sherborne in Dorset, clear evidence both of English land acquisition and appropriation, and also that the church in Cornwall was coming under English governance. From this time onwards, there was increasing cultural influence from Anglo-Saxon England. The earliest crosses are in a variety of styles: some relate closely to sculpture in Ireland and Wales, and some exhibit some English cultural influence, although they all display a unique Cornish identity and retain their own cultural inheritance.

During the tenth century, Cornwall came increasingly under English control. King Athelstan of England (r. 924–39) established a bishopric for Cornwall at St Germans. He probably oversaw the establishment both of the River Tamar as the boundary of Cornwall and also of the introduction of the English legal system into Cornwall. As Padel has demonstrated, the manuscript known as the Bodmin Manumissions gives us interesting information about life in Cornwall from the late tenth century.[4] The spread of English names even among the poorest in Cornwall, along with the use of Anglo-Saxon and Viking motifs in the sculpture, clearly indicate the spread of English cultural influence.

By the eleventh century, the absorption of Cornwall into the English state was virtually complete. Cornwall appears in Domesday Book (1086) as a county of England and the landowners had largely English names, although this does not necessarily imply that they were ethnically English.[5] Padel gives an interesting account of an individual who well illustrates the mix of cultural influences of the Irish Sea basin, which forms 'the context for the mix of cultural influences seen in the stone monuments'.[6] This was a man named Maccos, who was probably of mixed Norse–Irish origins, but who had apparently risen in Cornish society to become a landowner and an administrative official within the English legal system.

The Norman Conquest brought changes to power and governance in Cornwall, as it did in other parts of England, although it is probable that the basic fabric of Cornish society remained unchanged, at least at first.[7] By 1086, Count Robert of Mortain, the new overlord of Cornwall, had built his castle in Launceston, established a market there and started to develop and endow St Stephen's as his religious centre.[8] Other churches and religious houses fared less well, but the parochial system, already developing by the tenth century, gradually became more formalized; by 1291 the parochial system was in a structure that survived until the establishment of new mining parishes in the nineteenth century.[9] Surviving building remains, stone fragments and fonts indicate that in the twelfth and thirteenth centuries new churches were being built across Cornwall. Although there is no record of the creation of the simpler wayside crosses, this is the period to which most of them belong.

# Inscriptions on the crosses

Seventeen of the crosses contain one or more inscribed texts.[1] They are: 3 St Blazey, Biscovey; 15 Cardinham 1; 16 Cardinham 2; 18 St Cleer 1, Doniert Stone; 22 St Clement; 32 St Endellion, Long Cross; 35 St Ewe, Lanhadron; 37 Fowey, Tristan Stone; 40 Gulval 1; 41 Gulval 2; 43 Gwinear 2, Lanherne Cross; 56 Lanteglos by Camelford 1; 69 Minster, Waterpit Down; 82 Penzance, Market Cross; 87 Sancreed 1; 88 Sancreed 2; 94 Tintagel 1.

The monuments containing the inscriptions vary a great deal in their date and the type of monument they appear on. For example, the Tristan Stone (37 Fowey) and 22 St Clement originated as post-Roman memorials probably of fifth- to eighth-century date, whereas both the stones at Lanteglos (1 and 2) and Tintagel are inscribed crosses of the eleventh or possibly early twelfth century. The majority are carved crosses which incorporate a commemorative inscription as part of their decorative scheme. The Doniert Stone (18 St Cleer 1) and the Lanherne Cross (43 Gwinear 2), of the late ninth to tenth centuries, are the best and clearest examples of these. St Ewe 1, Lanhadron is an inscribed cross-base; the cross that it once supported is now lost, although there is historical evidence that it was inscribed as well.

The script used is either capitals, or an insular script, or a mixture of these. The texts are short and most often consist of one or more words in Latin along with one or more personal names. Some of the inscriptions remain very clear, despite

Fig. 2. Inscription on the St Clement stone (no. 22).

5

Fig. 3. One of two inscriptions on the Lanherne Cross, Gwinear 2 (no. 43).

their age, whereas others are eroded and scarcely legible, with even the type of script uncertain. In some cases, earlier readings suggest that the inscriptions were then more legible than they are today and help to provide a possible reading. Lichen and moss growth can greatly hamper legibility; however, there is the possibility that in the future new technologies may allow the inscriptions to be more easily deciphered. The laser scan of the Lanhadron cross-base (no. 35) and a photogrammetric survey of the Gulval 2 base-stone by Tom Goskar indicate the potential.[2]

Each text is transliterated, translated and discussed in its appropriate entry in the Catalogue. The texts are transliterated into small capitals, regardless of what script is used. Word division is inserted and the following signs are used:

'A̱' indicates a damaged letter A; '[A] indicates a badly damaged letter, probably A; '[…]' indicates three lost letters; '-' indicates complete loss of text; 'A/B' indicates two conjoined letters; 'Ā' indicates an abbreviation. In the translations, added letters appear inside square brackets. In addition, specific early English letters are used in 56 Lanteglos by Camelford 1: Æ (for A E); Þ and Ð (both for modern 'th'); 7 (for &).

# Cornish groups or schools of stone sculpture

The crosses illustrated and described in this book cover a period of three to four centuries. They range from pre-Norman crosses with complex decoration to simpler wayside crosses of the twelfth and thirteenth centuries. From among the earliest carved crosses in Cornwall a number of different groups of sculpture can be recognized, based on their decoration and geographical location. It is also possible to discern the influence of individual religious houses in their creation. Not all examples of sculpture can be pigeonholed in this way, but the following are the main types.[1]

## *Panelled interlace group*

This is the earliest group of crosses in Cornwall, so named from the style of decoration employed. It includes the cross-shaft at St Neot (no. 73; Fig. 4) and St Cleer 1, the Doniert Stone (no. 18; Fig. 5). These stones are carved with regular and beautifully worked interlace in panels. There are only a few examples in this group, which, with one exception, are all found in south-east Cornwall; the exception is at St Just in the very far west of Cornwall (no. 45). One of these crosses, the Doniert Stone, has an inscription that may commemorate Dungarth, the last Cornish king, who probably died in AD 875 or 876.[2] This group of crosses probably dates from the late ninth century to the tenth century.

These may have been composite monuments, with different sections socketed together (Fig. 5). The shaft at St Neot is well designed with a noted entasis and very competently worked, complex interlace patterns. The decoration consists only of interlace and simple knots (unlike similar monuments in Wales and Devon, which also feature key patterns on their shafts). None of the crosses still has a head, so this aspect of their appearance remains unknown.

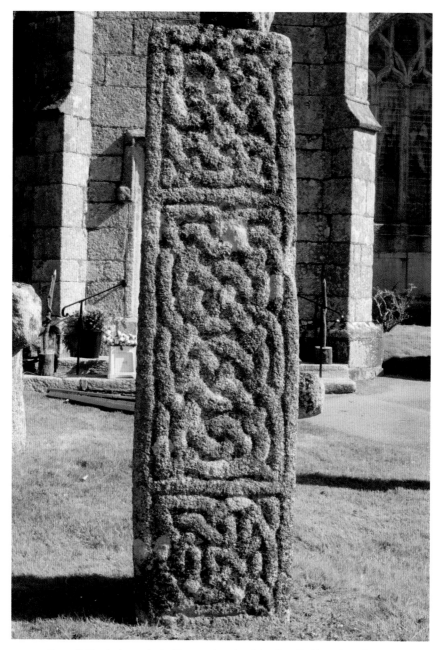

Fig. 4. St Neot 1 (no. 73), the finest example of the Panelled Interlace Group.

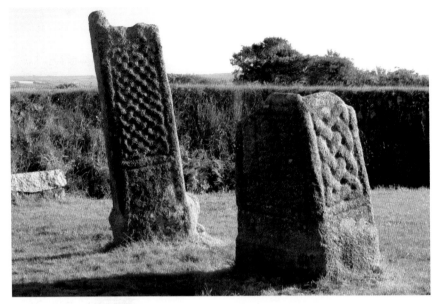

Fig. 5. St Cleer 1 and 2 (nos 18 and 19), showing interlace and plaitwork in regular panels. Both crosses were socketed together in parts and the remains of a mortice can be seen in the tops of both stones.

With the finest of the monuments in this group being at St Neot, which is known to have been the site of a pre-Conquest religious house, it is possible that the creation of these monuments was the work of sculptors based at this monastery.

## Penwith group

In the far west of Cornwall is a highly distinctive group of sculpture. It is known as the Penwith group because all examples are found within the ancient hundred of Penwith, which embraced the Land's End peninsula and the north coast as far east as the parishes of Redruth and Illogan.

The defining characteristic of this very individual group, exemplified most impressively by the St Buryan Cross (no. 11; Fig. 6), is the cross-head, which features a crucifixion on one side and five bosses on the other. The style may have developed within the context of a monastic workshop at St Buryan. Other decorative elements used to embellish monuments in this group include simple

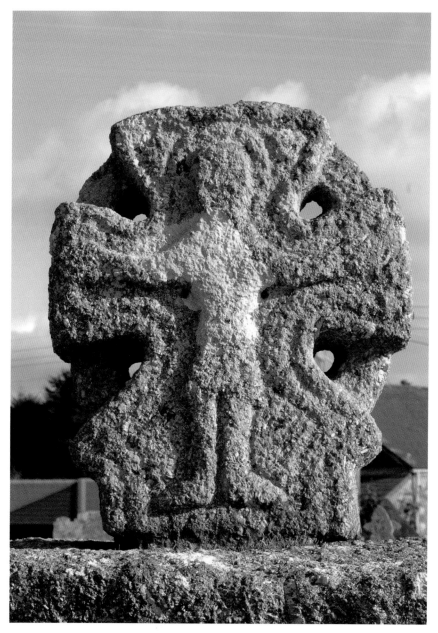

Fig. 6. The crucifixion on St Buryan 1 (no. 11). The crucifixion
is a defining feature of the Penwith group.

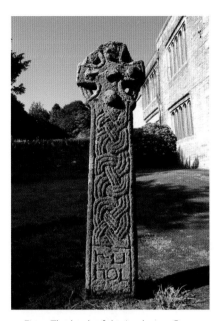 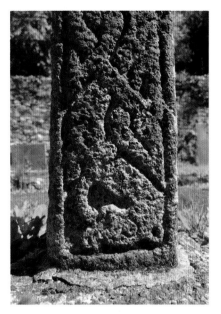

Fig. 7. The back of the Lanherne Cross (Gwinear 2, no. 43) demonstrates features of the Penwith group, including five bosses on the head, inscription and multi-strand interlace.

Fig. 8. Detail of the serpent's head on the side of the Lanherne Cross (Gwinear 2, no. 43). This motif also appears on the Sancreed 1 cross (no. 87).

key patterns and knots such as the Carrick bend and Stafford knots worked in multiple strands (Fig. 7). The Lanherne cross (no. 43) and the Sancreed cross (no. 87) also feature a ribbon-like animal, weaving its serpentine coils up and down the side of the shaft (Fig. 8).

The Penwith crosses display an impressive level of cultural influence, which is perhaps not surprising given the location of the monuments at the tip of the peninsula, surrounded by sea. The five bosses and the crucifixion on the heads of the crosses in this group may reflect Irish influence, while the serpent can be paralleled in carvings from as far afield as County Durham and Sussex. The simple knotwork patterns are ubiquitous in early medieval art, while the use of multiple strands is common in Welsh sculpture.

The crosses in this group date may date from the mid-tenth century to the eleventh century.

## Mid- and East Cornwall group

This third group of sculpture presents a notable contrast with the first two. The decoration on the shafts is characterized by plant scrolls and plant trails, derived from two distinct sources, their contrasting style being exemplified most perfectly on two outstanding crosses on Bodmin Moor: the Cardinham cross (no. 15; Fig. 11) and the Four Hole Cross (no. 74). The tightly spiralling scroll of the Cardinham cross is a western and northern form, seen also in crosses in Cumbria, while the loose, flowing plant trail with floppy leaves seen on the Four Hole Cross (Fig. 10) is based on the tenth-century southern English decoration known as the Winchester Style. Other features of both these crosses reflect the same contrasting origins, and most other monuments in mid- and east Cornwall combine the two types of plant in a simplified, devolved fashion.

With most crosses in this group being found in mid-Cornwall, it is likely that their innovation and development is linked to St Petroc's religious house, which from the tenth century was the wealthiest and most powerful

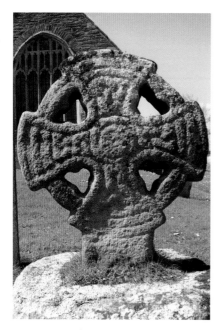

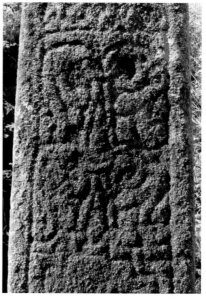

Fig. 9. Trefoil-shaped holes in the head of St Columb's cross (no. 24).

Fig. 10. Detail of the worn floppy-leaved acanthus plant-decoration on St Neot 3, the Four Hole Cross (no. 74).

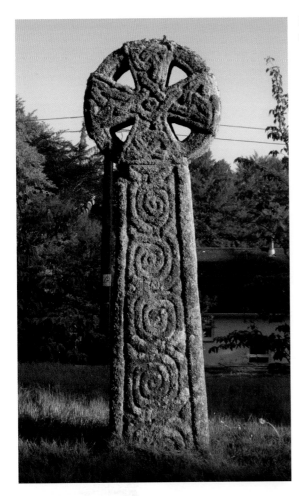

Fig. 11. Tight spiralling plant scroll on Cardinham 1 (no. 15).

in Cornwall. They date from the mid-tenth century through to the eleventh century. Most crosses in this group are (or were) very tall, some exceptionally so. This increasing height is a particularly distinctive feature of later members of the group, along with the parallel development of trefoil-shaped holes in their ringed cross-heads (Fig. 9). An outstanding, reconstructed, example is the churchyard cross at Quethiock (no. 85), which at over 4m (13ft) high dwarfs the surrounding Victorian headstones. Other decoration on these monuments includes plaits, knotwork and interlace, often difficult to identify because the carving is generally in very low relief.

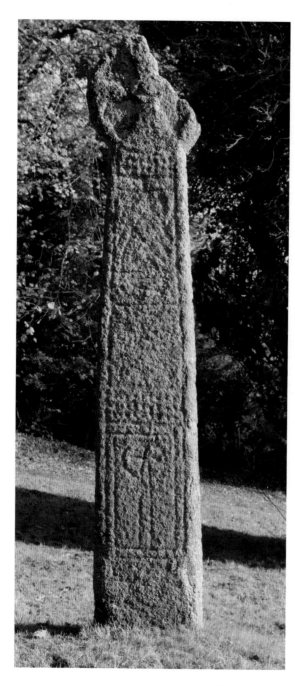

Fig. 12. Lanivet 2 (no. 53) with disc- or wheel-head, incised decoration and rows of dots.

## Crosses with incised decoration

During the eleventh century, and perhaps continuing into the early twelfth century, a very much simpler style of decoration developed in Cornwall. In contrast with the three previous groups, where the decoration is all carved in relief, there was a move towards the use of incised decoration that features, in particular, many rows of tiny dots. This can be seen especially on St Piran's Cross (no. 83) where the close-spaced dots may have been designed to replicate the effect of interlace work but would have been far easier to carve. The incised work also includes simple lines, diagonal crosses and occasional figures, such as appear on the crosses Lanivet 2 (no. 53; Fig. 12) and the Penzance Market Cross (no. 82; Fig. 13). The Lanivet cross, which contains elements of earlier pattern styles, such as key patterns, as well as incised work, is especially significant in representing a transition between early and later medieval forms of decoration.

Crosses in this group have simpler heads. Lanivet 2 (no. 53) and Lanteglos by Camelford 2 (no. 57) have solid round wheel- or disc-heads and this in turn became the most common type of cross-head for the later Cornish

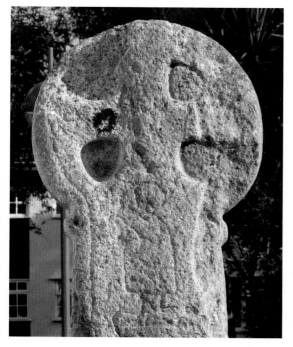

Fig. 13. The solid disc- or wheel-head of the Penzance Market Cross (no. 82), with below it the faint traces of a small incised figure.

wayside crosses. A more unusual variant also developed, in which the holes of the ring-head replace the arms, creating a diagonal St Andrew's Cross. The heads of the Kenwyn cross (see under no. 82 Penzance) and Perranzabuloe (no. 83) exemplify this. They may hint that the carving was no longer the work of monastic workshops working perhaps from pattern books, but was instead evolving in the hands of local masons acting with a good deal of independence.

## Cornish crosses after the Norman Conquest

After the Norman Conquest, the tradition of carving and erecting crosses continued, but tended to move from the churchyard into the countryside, with hundreds of rustic granite crosses being set up as wayside and boundary crosses. With the exception of a group of crosses with chevron decoration in the parishes of Wendron and Stithians (no. 92), these crosses were much simpler in form. On

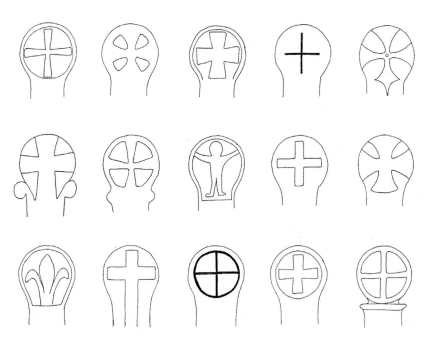

Fig. 14. Examples of the different types of carved crosses found on Cornish wheel-headed wayside crosses.

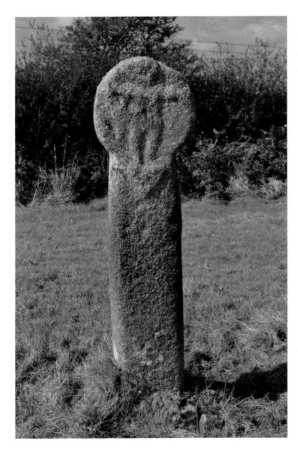

Fig. 15. Trevales Cross, Stithians, an example of a wheel-headed wayside cross (no public access).

most, the only decoration may be the cross symbol on the cross-head (Fig. 14), and sometimes also a very simple rendering of the crucifixion (Fig. 15).

These crosses were more parochial in style and were usually carved by local stonemasons, leading to similarities in style within some parishes. For example, in St Clether parish, all the crosses have large wheel-heads with projections at the neck and all were originally at least 2.5m (8ft 2in) high (Fig. 16). At Lanivet, most of the wayside crosses display equal-armed crosses in relief on their heads. St Buryan's wayside crosses often feature a very simple crucifixion (see the St Buryan parish page). Some parishes opted to carve Latin-style crosses rather than wheel-headed crosses, including the parishes of St Cleer, St Neot and Paul (nos 21 and 80; see Fig. 17 and the St Neot parish page).

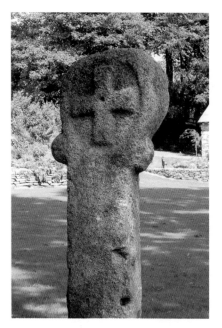

Fig. 16. Ta Mill Cross, St Clether, a local style with projections beneath the head (no public access).

Fig. 17. Latin cross in St Minver churchyard, originally from Treglines.

Occasionally, some of the taller wheel-headed crosses have a lower cross-arm that extends down the front of the shaft, and these are more reminiscent of designs depicted on medieval grave-slabs or coffin-lids of the same period. On these crosses, the lower arm may terminate in a ball, a triangle or a stepped base representing a stylized Hill of Calvary (nos 27, 55 and 61). Further motifs are depicted on wayside crosses which also have parallels with the decoration on grave-slabs. For example, at Egloshayle there is a cross (no. 31) that has a fleur-de-lys on each face, rather than a traditional cross symbol, while a cross at Feock (no. 36) has a bracelet cross. Further motifs include an hourglass or a chalice-shaped motif (no. 28), while a shield is depicted on a churchyard cross at Sancreed (no. 88). Although their simplicity makes them difficult to date, these motifs indicate that most of the wayside crosses may date from the twelfth and thirteenth centuries.

# Dating the monuments

The dating of Cornish crosses is a topic that in the past has been fraught with speculation. Exceptionally early dates have often been proposed, usually for no reason other than the rustic, weathered appearance of the crosses and their simplicity of style; moreover, the popular term 'Celtic' cross leads to the assumption of a pre-Saxon date. Although it can be demonstrated that the decorated crosses, often in churchyards, were the first to be set up in Cornwall, the earliest dates have often been assigned to the simple wayside crosses. For example, a wayside cross preserved in the churchyard at Altarnun is said to have been set up by St Nonna in around 527,[1] while the date suggested for the wheel-headed cross at Gerrans (no. 39) is between the sixth and tenth centuries.[2] In fact, crosses were not set up in Cornwall until the late ninth century, with the majority of the simpler wayside crosses being of twelfth-century or later date. The evidence for this is summarized below, and although it should be noted that this is not an exact science, it explains the dating of the stones suggested in the Catalogue.[3]

The only Christian monuments in Cornwall that might be as much as 1,500 years old are the inscribed memorial stones. The palaeography and wording of the inscriptions, which can be related to Roman-period honorific pillars and funerary monuments, demonstrate their early origin. Most are simple pillars with an inscription carved on one face and no other ornament; some also have a simple incised cross or chi-rho (no. 32). Although opinion varies, these stones date broadly from the late fifth to seventh centuries.[4]

On present evidence, it appears that no carved monuments were set up in Cornwall through the eighth and most of the ninth centuries. The first cross whose date is reasonably certain is St Cleer 1, the Doniert Stone (no. 18), whose inscription suggests that a late ninth-century origin is likely, this date depending on the equation of the name Doniert with Dungarth, a Cornish king who died in 875 or 876.[5] Although the identification is unprovable, it is philologically

19

acceptable if we assume that this cross was his memorial; it would presumably have been carved soon after Doniert's death. The high quality of the sculpture may support this late ninth-century date; the patterns on the stone are simple, but the layout and execution of the carving are outstanding compared with most other early sculpture in Cornwall. Other members of the panelled interlace group of cross carving, which share the same sculptural qualities, may be the earliest crosses in Cornwall, probably dating from the tenth century.

In the far west of Cornwall, crosses in the Penwith group are likely to have been carved in the tenth and eleventh centuries. Most of the decorative motifs employed (for example, the crucifixion, the five bosses and the ribbon animal) support this very broad date, but cannot be used to refine it. However, it has been suggested that the (re-)foundation of a religious house in about AD 940 at St Buryan, where the finest example of the group exists (no. 11), may have been the context for the development of cross carving in the area.[6] The Penwith group is therefore dated from the mid-tenth century, but some of the crosses in the group, for example Phillack (no. 84) with its lightly incised angular plaits, may be of the eleventh century.

Decorative details help to show that the contrasting mid-Cornwall crosses, with their foliage scrolls and trails, may also have been carved and set up from the mid-tenth century. On the Cardinham Cross (no. 15) is a motif known as a Manx or Borre ring chain. This pattern, of Scandinavian origin, was in use for a relatively limited period during the tenth century. How it found its way to Cornwall is uncertain, but it helps in dating the cross; while the variety and quality of the other decoration helps place the monument in the mid-tenth century. In the same group, the Fourhole Cross on Bodmin Moor (no. 74) may be a little later, perhaps of the second half of the tenth century. Lightly incised on it are plant trails with drooping acanthus leaves, which are an excellent example of Winchester-style ornament. As the name suggests, this was an English style of decoration that developed in Winchester in the early tenth century.[7] Later crosses belonging to this group of sculpture, such as Lanivet 1 and a cross at Prideaux Place, Padstow (nos 52 and 77), combine both Scandinavian and English influences in a purely Cornish sculptural style; this may have been fostered in stonemasons' yards at St Petroc's monastery in Padstow and Bodmin. The crosses with trefoil-shaped holes in their heads may be later members of the group, which is dated from the mid-tenth into the eleventh century.

To the eleventh and early twelfth centuries belong a small number of monuments that appear to be transitional between early and later medieval

styles of ornament. They combine features of both the pre-Norman decorated crosses and the later, simpler wayside crosses, hence the suggested date range. Monuments in this group include some of the most intriguing and quirky of Cornish crosses. One of the best examples is Lanivet 2 (no. 53), a monument whose rich all-over decoration is based to some extent on pre-Norman patterns, although the decoration is mainly incised and contains some more unusual elements. Its decoration is all panelled, like St Cleer 1 (no. 18) and St Neot 1 (no. 73), but the decoration includes later features, such as rows of dots and incised crosses (some diagonal), alongside key patterns; the poor execution of these shows a lack of understanding of such complex designs.

Lanteglos 1 and 2, arguably two parts of the same monument, have also been included in this group. They would, if fitted together, form a tall cross with a neatly cut, tapering, rectangular shaft, which is plain apart from the inscription, as well as a disc-head with wide flared cross arms, central boss and four bosses in each of the spaces between the cross-arms. The cross, with its socketed parts, is reminiscent of early medieval monuments such as St Cleer 1 and 2 (nos 18 and 19), and the bosses on the head can be compared with the Penwith group. However the lack of decoration, the arrangement of the bosses on the head and the disc-head represent a development away from these. The vertical arrangement of the inscriptions is surprisingly like that of the post-Roman inscriptions, but they are in early Middle English and commemorate people with English names. A late eleventh- or early twelfth-century date is likely for the inscription;[8] and the further features of this cross must also be of that date and help in dating other similar monuments.

The solid and much simpler disc- or wheel-heads of both the Lanivet and Lanteglos crosses are replicated in hundreds of wayside crosses across Cornwall. Other features supporting the indication of the later, Norman-period date already suggested by the type of cross-head are the forms of the crosses carved on them and further small decorative details and motifs, where these exist.

On most of these monuments there is almost no decoration other than the cross symbol, but the single cross can itself help to give an indication of date. The simple outline Early Geometric cross, which most wayside crosses display, can be paralleled on cross-slab grave-covers in other parts of the country, where they are considered to be early Romanesque.[9] Although the majority of the Cornish wayside crosses have no sculpture or decoration on them, a few do have features that support this later medieval date. These indicators include the fleur-de-lys and chevron patterns.

In the parishes of Wendron and Stithians is a small group of wheel-headed crosses decorated with chevrons, diamonds, zig-zags and triangles. One example, the Tretheague Cross, is included in the Catalogue (no. 92). Architecturally, the chevron is a well-known element of Romanesque or Norman work, often seen on Norman doorways.[10] Hence these monuments are most likely to be of late eleventh- or twelfth-century date.

The fleur-de-lys is an emblem that features on the cross-heads of three wayside crosses in north Cornwall (see no. 31). Although its design can be traced to many parts of the world, the first appearance of the fleur-de-lys in the Western world was during the late twelfth century, so crosses with fleur-de-lys are likely to be of thirteenth-century or later date.[11]

Some wayside crosses have features suggesting that they may belong to the thirteenth rather than to the twelfth century. Such features include chamfering of the sides of the shaft (e.g. no. 17, Cardinham 3, Treslea). A high proportion of the Latin-style wayside crosses, particularly in south-east Cornwall, for example the Bosent Cross on the boundary between Liskeard and St Pinnock parishes, have chamfered shafts, indicating that generally the Latin crosses may be of later date than the wheel-headed crosses.

In summary, there is remarkable continuity in cross carving in Cornwall from the late ninth century through to the thirteenth century and beyond. The types of crosses created during these four centuries evolved from substantial, elaborately carved monuments to much simpler wayside and boundary markers. The context and commissioning of the monuments may help to explain this development. Whereas the earlier, more elaborate monuments are likely to have been created in monastic workshops and commissioned by people of standing in society, the later, simpler crosses were the products of local stonemasons, often working out on the moor from which the stone was quarried.[12]

# Function of the crosses

The majority of the crosses described in this book are found in parish church-yards. Sometimes they are the oldest features visible on the site and demonstrate the age of the churchyards; in some instances a place-name in *lann, a dedication to a Celtic saint or a curvilinear enclosure may indicate that the site is even earlier and the cross is a later addition.

Crosses at church sites may have had many functions. Where a stone has an inscription, this may show it to be memorial, commemorating a person or people of local significance. Where the stone is small, like the Lanherne Cross (no. 43), the memorial may have been a private one. However many of the crosses described in this book are very large. In these cases the memorial must also have been a public monument, a reminder of the importance of the commemorated individual as well as a focus for remembrance or prayer. That at Cardinham (no. 15) may have been one such, especially since Cardinham's church site is associated with a manor emerging by the time of Domesday Book as a major centre of secular power. On the other hand, the crosses in the churchyards at Michaelstow, St Teath and Quethiock (nos 67, 93 and 85 respectively) stand well over 3m (9ft 10in) high and dominate their settings, even today. These have no commemorative inscriptions and must primarily have been a focal point of these early church sites.

The sculpted figures of the Four Evangelists on the cross-base at Gulval (no. 41) suggest that this stone once supported a cross that was used for preaching. The crucifixions on the crosses in the West Penwith area may have been used in the same way, the five bosses on their reverse sides perhaps representing the five wounds of Christ. One of the finest of the Penwith crosses, the churchyard cross at St Buryan (no. 11), stands on the site of a pre-Norman collegiate church and its creation may have been associated with a grant to the college by King Athelstan. The stone at St Clement (no. 22) demonstrates clearly the longevity and changing style of these monuments and the sites

where they stand. In origin, the stone may have been a prehistoric menhir. In around the sixth century, an inscription commemorating Vitalus, son of Torricus, was cut on the stone. Later, a single name, Ignioc, was added in a different hand, and later still, probably in Norman times, a cross-head was fashioned on the top of the pillar.

These monuments did not only grace parish churchyards. One cross at St Cleer (no. 21) is associated with a holy well. At Merther Uny (no. 99) and at Mabe, Helland (no. 63), there are crosses at chapel sites, close to the boundaries of small oval enclosures; the enclosure at Helland, called 'the Graveyard' in around 1840, is now the garden of a private house. The name of Helland is from *hen-lann, the 'former or disused Christian enclosure'.[1]

Of the stones in this book, nearly half are out in the countryside, as the majority of medieval Cornish crosses would have been when first set up. Here, the crosses fulfilled many functions, as memorials, as boundary markers, as wayside markers or guide-stones and, less obviously now, as wayside shrines and places of rest, ritual and prayer.

The Doniert Stone (no. 18) is a classic example of a memorial, and may commemorate the last recorded Cornish king. Set beside a road that ran across the south side of Bodmin Moor and above a ford over the River Fowey, it may have been positioned here in order to be seen by travellers from far and wide, not just by the local population. In the inscription, passers-by are told 'doniert rogavit pro anima', that is 'Doniert requested for [his] soul'. What Doniert requested might have been prayers or might have referred to the actual monument. The original cross was a very substantial monument and appears to be a public act of piety, but also perhaps a challenge to the English who were increasingly taking over power in Cornwall at the time the stone was erected.

Many of the simpler stones in this book would have originated as wayside crosses marking routes of local or regional importance; hence the Holyway Cross (no. 91) as well as the more elaborate Four Hole Cross (no. 74) both stand beside a historical east–west route (now the A30 trunk road) over Bodmin Moor. By contrast, the Tresinney cross in Advent (no. 1) stands beside a footpath leading to the parish church, and at an even more remote place the Middle Moor Cross (no. 10) stands on an open moorland track within sight of Cornwall's highest hills, Roughtor and Brown Willy. Remarkably, the crosses demonstrate the longevity of these routes, most of which are still in use today. These wayside crosses frequently also mark a significant point on the path, for example the transition from enclosed fields to open moorland (no. 23), a bridging point or ford (no. 92)

or a crossing or meeting of ways (the Treslea Cross, no. 17). The Treslea Cross also stands on the boundary of Cardinham's former glebe land.

Many other stones may also mark boundaries. The massive Carminow Cross (no. 5), now at the centre of a large roundabout on the outskirts of Bodmin, once marked the boundary of the parishes of Cardinham, Lanhydrock and Bodmin, as well as the boundary between the paramount manor of Cardinham and lands belonging to Bodmin Priory.

In the later part of the medieval period, the significance of many of these monuments declined or was entirely lost. Many churchyard crosses were taken down, broken up and built into the fabric of churches, which at the time were being extended with new aisles; examples include Cardinham and Paul. Alternatively some crosses, such as Padstow 2 (no. 76), were broken and became gradually buried as the levels of their surrounding graveyards rose with generations of burials. After the Reformation, others may have suffered at the hands of puritan iconoclasts, although specific examples are difficult to pin down.

Crosses in the countryside may have fared better, as a reference in 1656 notes that some parishioners were still performing rituals at them, bowing, hugging or kissing a cross in Sennen.[2] Some may have survived because they continued to have value as boundary markers: the Four Hole Cross (no. 74) is a good example. It stands beside the A30 in the heart of Bodmin Moor, on parish and hundred boundaries. The letters GLW on its shaft, incised deeply through the fine tenth-century plant trails, show the cross to have been adopted as a boundary stone for the post-medieval tenement of Great Lord's Waste. However, in the eighteenth and nineteenth centuries, as enclosure advanced on to previously rough ground many, such as the Crewel cross (no. 61), were built into hedges and stiles or were adopted as gateposts. In the countryside, further reuse included being utilized as building stone (no. 47 St Kew 2 and no. 90 Sennen) or as parts of bridges; one or two cross-heads were even hollowed out for use as animal troughs, such as that at Lesnewth (no. 59).

At the same time, changing attitudes brought a gradual (though not universal) change in fortune for the crosses. Through the eighteenth and especially the nineteenth centuries, the crosses once more became respected, though their value now was not religious, but as objects of study and antiquarianism. Some, such as Lanhydrock 2 and possibly St Michael's Mount (nos 51 and 68), found new uses as landscape features and ornaments in the gardens of the wealthy. In the twentieth and twenty-first centuries, the crosses have acquired further value as icons of Cornish distinctiveness.

# Antiquarian study and restoration

## Summary of earlier research

Modern interest in Cornish crosses can be traced back to the sixteenth century in the work of historians and topographers interested in early Cornwall. Such were John Leland (*c*.1503–52), John Norden (*c*.1547–1625) and William Camden (1551–1623). William Camden's *Britannia* was first published in 1586 and was subsequently edited and updated throughout the seventeenth and eighteenth centuries, most notably by Richard Gough (1735–1809). The only two crosses recorded before 1700 are St Cleer 1 (the Doniert Stone, no. 18) and St Cleer 2 (no. 19, Fig. 18), but by 1800 several more had been noted in print: St Blazey (no. 3), St Buryan 1 (no. 11), Camborne 1 (no. 13) and St Neot 3 (no. 74).

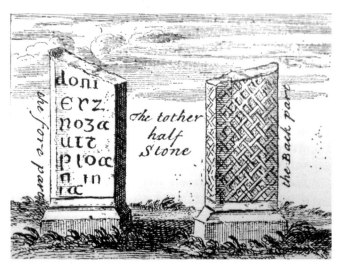

Fig. 18. Illustration of St Cleer 1 and 2, nos 18 and 19, by John Norden; the first known depiction of two Cornish crosses (Norden, 1728, 59).

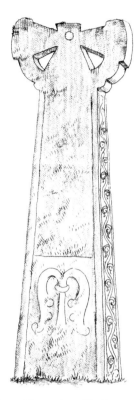 

Fig. 19. Illustration of St Neot 3, the Four Hole Cross (no. 74), in Lysons and Lysons 1814, ccxlv, fig. 28.

Fig. 20. Illustration of Sancreed 2 (no. 88) by Blight (1856, 18).

In the eighteenth century, we find local interest in the antiquities, including crosses, starting to emerge. Walter Moyle (1672–1721) of Bake, St Germans, corresponded with a great number of people, comparing notes on national affairs as well as on local matters of interest such as crosses. Rev. William Borlase was rector of Ludgvan from 1722 to 1752 and was one of the first to record early stones in a systematic manner. Interestingly, however, he apparently failed to notice the carved cross fragment built as a threshold step into the inside of the second storey of the tower of Ludgvan church.[1]

The nineteenth century saw the restoration and rebuilding of many Cornish churches, a process that coincided with a noticeable rise in interest in local history in general and in Cornish crosses in particular. The Royal Institution

of Cornwall was founded in 1818 and several local history societies were well supported, an example being the Penzance Natural History and Antiquarian Society (founded 1839). Individuals, from Daniel and Samuel Lysons early in the century (Fig. 19), to William Iago and John Thomas Blight later on (Fig. 20), all described and discussed many crosses that had not previously been known. The outstanding figure of the century was of course Arthur G. Langdon (1852–1911). A small number of his illustrations have been included within the Catalogue, including Cardinham 1 (no. 15), where his illustration shows the fragments of the cross before they were removed from the church wall. On the other hand, his drawing of the Middle Moor Cross (no. 10; Fig. 21) shows it in much the same setting as now, demonstrating the remarkable continuity of some monuments in the landscape. Langdon's work culminated in his monumental *Old Cornish Crosses* (1896), a work that still retains great value today.

Fig. 21. Illustration of the Middle Moor Cross, St Breward (no. 10) by Arthur G. Langdon (1896, 240).

In the last hundred years, much important work on crosses has been undertaken by such people as Charles Henderson, by those compiling the Parochial Check-lists of Antiquities, published in *Cornish Archaeology*, and by Professor Charles Thomas (1928–2016); indeed, much of Charles Thomas's life was spent working on Cornish archaeology and artefacts.[2] Some of the people mentioned above are described in more detail below.

## Status, discovery and restoration of stones from the nineteenth century to the present day

Had it not been for a rise in antiquarian interest during the Victorian period, many of Cornwall's stone crosses, especially those in churchyards, would not now be known, while wayside crosses out in the countryside might have suffered greater depredation than they have done.

### Early nineteenth century

In the early nineteenth century, many of the most celebrated of Cornwall's churchyard crosses were simply not visible. However, a small number survived almost intact, of which St Piran's Cross (no. 83) is one of the best examples: although badly eroded, it shows no sign of deliberate damage and still stands in its original base-stone, now below ground level. In some cases, the cross-head only survived, as for example at St Buryan (no. 11), at St Erth (no. 34) and at Paul (no. 78).

The wayside and boundary crosses of the twelfth century and later survived better, although many by now were in use as gateposts, head down in the ground. Some, such as the cross at Laneast Downs (no. 49) and the Tresinney cross (no. 1), still stood in their original positions largely undamaged.

### Victorian discovery

The majority of the churchyard crosses of the tenth and eleventh centuries were discovered built into the fabric of their parish churches during Victorian church restoration. Further crosses, such as Padstow 2 (no. 76), were discovered at this time; it was found deeply buried in the churchyard by the parish sexton while opening the ground for burials. The cross at Phillack (no. 84), of which it seems likely the head only was visible in the early nineteenth century, was set up in its present position in 1856, while the church was being restored.

Many wayside crosses were 'rescued' by local gentry from their original settings and moved to their estates and gardens to act as landscape or garden features. One of the earliest known examples is a cross probably originally from Kenwyn parish, which was moved by Davies Gilbert in 1817 to his manor house in Eastbourne 'to show the poor, ignorant folk that there was something bigger in the world than a *flint*'.[3] Others preserved as landscape features can be seen at places such as Boconnoc and Trelissick,[4] and St Michael's Mount (no. 68). The clergy similarly removed crosses to their vicarages and rectories in the name of preservation: for example, both the crosses Lanteglos by Camelford 1 and 2 (nos 56 and 57) were formerly in the gardens of the rectory.

## Victorian restoration

The Victorians were responsible for restoring many of the crosses they discovered during the nineteenth century, including four of the tallest crosses in the county. The scale of their work can be seen from the fact that in the mid-nineteenth century the tallest high cross in Cornwall was that on the west side of Lanivet churchyard, Lanivet 1 (no. 52), measuring 3.2m (10ft 8in),[5] while between 1869 and 1883 four other high crosses were discovered and restored, all of which were considerably taller than the one at Lanivet.

Sometimes Victorian stonemasons restored the newly discovered medieval cross-heads by placing them on modern shafts, as is the case with the Carminow Cross (no. 5) and Lanhydrock 2 (no. 51). In the case of the cross at Pencarrow (no. 29), the large cross-head was simply mounted on a large rock as a base-stone. Several crosses of which more substantial remains were found had parts joined back together, although at Cardinham (no. 15) and Sancreed (no. 87) the top parts of the shafts are missing, meaning that the decoration has been truncated. Such work would have involved a local blacksmith forging an iron dowel for the stonemason to use in joining the parts together. Some crosses, those at St Teath (no. 93) and Quethiock (no. 85) being the prime examples, had been so damaged that their restoration must have involved a jigsaw-like puzzle.

## Examples of Victorian restoration

The cross-head and base-stone of the Quethiock cross (no. 85), the tallest cross above ground level in Cornwall, were discovered by workmen building a new churchyard wall on the south side of Quethiock parish church. According to Nicholas Hare of Liskeard, the stones were discovered deeply buried just inside

an old fence.[6] Rev. William Willmott decided to search for the remaining pieces, and was rewarded when he exposed the gateposts of an unused entrance to the churchyard and found them to be the two halves of the cross-shaft. The bottom of the cross-head had an exposed tenon, which was found to fit into a mortice in the top of one half of the shaft. The bottom of the second piece of shaft ended in another tenon, which exactly fitted the mortice in the base-stone. On 25 July 1881, the restored monument, now 4.06m (13ft 4in) tall, was set up where the head and base-stone had been previously found.[7]

The St Teath cross (no. 93) had first been discovered in around 1835 in use as a footbridge across the outlet to a pond, and in 1841 was taken into the churchyard for preservation. Unbelievably, it appears that soon after this date the cross was broken up for reuse.[8] However in April 1883, less than two years after no. 85 Quethiock had been restored, the broken parts of the St Teath cross were rediscovered. Part had been used as a pivot for the churchyard gate, while further pieces of shaft were built into the churchyard wall or split lengthways and used as coping for the wall. The *Western Antiquary* reported that Rev. Thomas Worthington, the temporary priest in charge at St Teath, organized the reconstruction of the monument, which now measures 4.01m (13ft 2in).[9] The lower half of the shaft, which had been split in two, was bolted back together, and three cubes of shaft were pinned to the top (Fig. 22); fragments of the cross-head reconstructed with pieces of red brick, slate and mortar were found at the time of some more recent restoration work during 1995.[10]

In 1883, another tall cross was discovered at Michaelstow (no. 67), used as the bottom step in a flight leading up to the west entrance of the churchyard.[11] This, together with its elegant cross-head that was found built into the boundary hedge of the churchyard, is the third tallest above ground level, standing at 3.4m (11ft 2in).

## Twentieth- and twenty-first-century restorations

Throughout much of the twentieth century, local Old Cornwall Societies took on the role of organizing, commissioning or funding the restoration of stone crosses. For example, the Bodmin society was responsible for returning the Long Cross at St Endellion (no. 32) back to its former site at Trelights, and in 1939 for setting up the Middle Moor Cross at St Breward (no. 10) after it was knocked over.

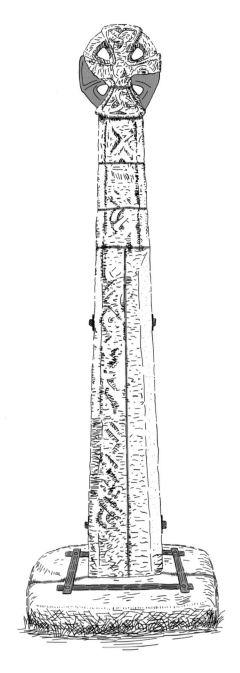

Fig. 22. This illustration highlights in red the many pieces that St Teath's cross (no. 93) had been cut into and, in purple, the repairs made by 1883. Drawing by Daniel Rose-Jones, after Langdon, Arthur G. (1896), 393.

Fig. 23. David Attwell, formerly of North Cornwall District Council, guiding the restoration of the Whitecross, St Breock (no. 7), in 1994.

More recently, during the 1990s, the archaeological unit of Cornwall County Council (now Cornwall Council) organized repairs to a number of crosses protected as Scheduled Ancient Monuments. These include the Whitecross (no. 7; Fig. 23), St Erth 1 (no. 33) and Paul 1 (no. 78). Further restoration projects have taken place in the twenty-first century, funded and organized by both professional organizations and local groups; that at St Buryan is a notable example (no. 11), which included an additional outreach project, with walks, talks and exhibitions aiming to encourage and promote an interest in these ancient stones.

## Significant antiquarians

**John Thomas Blight** (1835–1911), artist, archaeologist and writer (Fig. 24)
John Blight was born in Redruth, the eldest son of Robert, a schoolteacher, and his wife Thomasine. When John was four years old the family moved to Penzance, where his father had a school. Here many of John's artistic skills were learnt.[12]

Blight's interest in Cornwall's antiquities started at an early age: in 1856 he published his first book, *Ancient Crosses, and other Antiquities in the West of Cornwall*, followed shortly afterwards, in 1858, by his volume on east Cornwall. Blight not only produced detailed sketches and drawings of Cornwall's antiquities, but also carved the wooden engravings used to produce the illustrations. Further publications, such as *A Week at The Land's End* (1861) and his 1865 work on the churches of west Cornwall, included illustrations of Cornish crosses. Sadly, at the age of 36, illness prevented Blight's talent from flourishing further, although second editions of his works were produced.[13]

**Arthur Gregory Langdon** (1852–1911), architect and antiquarian (Fig. 25)
Arthur G. Langdon was born in Glasgow of Cornish parents. At 18 he was articled to an architect in Hastings, and then spent time in London before retiring to Launceston. Even before moving to Cornwall he started recording and illustrating Cornish crosses, as letters written from his Craven Street, London, address show.[14]

Langdon wrote numerous papers on Cornish crosses, culminating in his masterpiece in 1896 *Old Cornish Crosses*. Even after this he continued to publish articles, including a paper for the *Victoria County History* in 1906 adding many crosses discovered after 1896. The Catholic church on St Stephen's Hill in Launceston was designed by Langdon; he also designed memorial crosses, including the Boer War Memorial at Haverfordwest, based on a copy of the 'Cross of Irbic' at Llandough, all carved by a local stonemason, F.H. Nicholls of Lewannick.[15]

**Charles Gordon Henderson** (1900–1933), historian and antiquarian (Fig. 26)
Charles Henderson was born in Jamaica and died in Rome.[16] He spent most of his childhood in Cornwall, and from a very early age was fascinated by Cornwall's history, place-names, topography and monuments. Ill health during his school years meant that Henderson was regularly tutored at home,

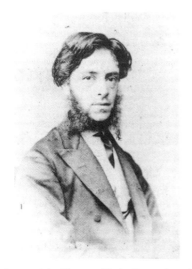

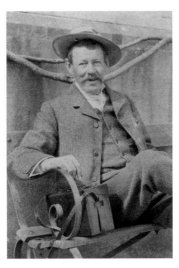

Fig. 24. John Thomas Blight. Reproduced by permission of the Courtney Library of the Royal Institution of Cornwall.

Fig. 25. Arthur Gregory Langdon. Reproduced by permission of Mrs D. Blackman.

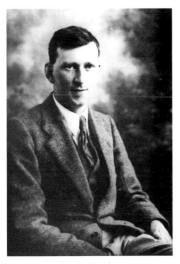

Fig. 26. Charles Gordon Henderson. Reproduced by permission of the Courtney Library of the Royal Institution of Cornwall.

Fig. 27. Mary Henderson.

giving him the opportunity to travel around Cornwall recording antiquities.[17] He attended Wellington School and later graduated from New College, Oxford in modern history before becoming a lecturer at University College, Exeter, and later at Corpus Christi College, Oxford.[18]

Henderson amassed a collection of some sixteen thousand documents, freely given from gentry families and solicitors' offices.[19] He recorded or noted many stone crosses, leading him to prepare notes for a supplement to Langdon's *Old Cornish Crosses*, and he published papers such as that entitled 'Missing Cornish Crosses'.[20]

**Mary Henderson** (*c.*1913–1993), local historian (Fig. 27)
Mary Henderson (no relation to Charles Henderson) was born in London and spent much of her working life there. She started recording crosses on regular holidays in Cornwall and finally moved there after taking early retirement. From 1952 to 1983, she worked tirelessly visiting and recording all Cornish crosses. She was thorough with her research, systematically examining every tithe map for field names that might refer to a cross site.

Her lasting legacy was a four-volume manuscript, accompanied by a volume of pen and ink illustrations by Laura Rowe and Roger Penhallurick, which was deposited in the Royal Institution of Cornwall's Courtney Library;[21] unfortunately her work was never published.

# Glossary

**Note:** *italics* indicate a term that appears elsewhere in the glossary. Examples are given of sites where each term described can be seen.

## Abacus
A horizontal moulding inserted at the junction between the head and shaft of a cross. A good example is at Laneast (no. 48; Fig. 28a). The term derives from use of the feature in Classical architecture, where an abacus was used between the top of a capital and the architrave.

## Animal ornament
Decoration featuring animals. There are few examples on Cornish crosses. The two main examples, both very similar, are on the Penwith crosses at Lanherne and Sancreed (nos 43 and 87; Fig. 28b). Each of these features an interlacing serpentine creature, based ultimately on the biting beasts and ribbon animals of Anglo-Saxon art.

## Asterisk
An asterisk, as in *\*lann*, indicates a hypothetical or unrecorded name.

## Bead
A moulding cut down the sides and around the head of a cross. Also referred to as an *edge-moulding*. This is mainly a feature of the earlier crosses, but an excellent example can be seen on the post-Conquest cross St Kew 2 (no. 47).

## Borre ring-chain
A decorative motif that came from Scandinavia and was introduced into England during the tenth century. The Borre ring-chain is a plait made of a band that splits into two and then reunites. The pattern is common on stone sculpture

of the Isle of Man (hence it is sometimes known as the Manx ring-chain) and is also found in Cumbria. The only example in Cornwall is on the Cardinham Cross (no. 15; Fig. 28c).

## Boss

A circular convex projection, used decoratively to add emphasis to key points on a monument. In Cornish crosses, bosses are used most commonly at the centre of the cross-head, but crosses of the Penwith group feature five bosses, one at the centre of the head and one in each of the cross-arms (Fig. 28e). Phillack and Wendron 3, Merther Uny (nos 84 and 99) have bosses on the shaft as well as on the head.

## Bracelet cross

A cross formed of four open circles resembling bracelets joined together.

## Carrick bend

Also known as a *figure-of-eight* knot. An example in Cornish sculpture is seen on the side of the Four Hole Cross (no. 74; Fig. 28f)

## Chalice

Cup used in mass. The incised double-triangle motifs seen, for example, on the cross at St Dennis, may represent chalices (no. 28; Fig. 28g)

## Chamfer

An oblique surface cut on the four corners of a cross-shaft, to blunt its angles and add texture. In later monuments, chamfers replace the edge-moulding or bead as the most common way of adding ornament to the edges of a shaft or column. With time, chamfers become more complex, but the examples seen on Cornish crosses are all very simple. See for example the Treslea Cross, Cardinham (no. 17).

## Chevron

Zig-zag decoration consisting of rows of triangles, which may be incised or sunk into the surface of the stone. Chevrons are characteristic of *Romanesque* decoration. Chevrons are a notable feature of crosses in and around the parish of Wendron. The Tretheague Cross (no. 92; Fig. 28h) features chevrons in its decoration.

**Chi-rho**
A monogram made up of the first two letters, *chi* and *rho*, of the name Christ written in Greek. This early Christian symbol is occasionally found on early inscribed stones in Cornwall, for example the Long Cross at St Endellion (no. 32).

**Conquest**
Unless otherwise specified, the Conquest referred to in this book is the Norman Conquest, 1066. Although cross carving in Cornwall took place both before and after the Norman Conquest, the Conquest represents a watershed between the more elaborate and generally larger early monuments and the smaller and more simply carved and more ubiquitous later medieval monuments.

**Crucifixion**
A representation of the death of Christ on the cross. Examples carved on Cornish crosses of the early medieval period generally feature the Triumphant Christ, in which he is shown alive on the cross (the cross not being represented, except in the form of the cross-head), with arms held horizontally and head facing forwards. Christ is normally shown wearing a short tunic. Images of the crucifixion are common on medieval wayside crosses of the later medieval period in west Cornwall; these are usually a simplification, sometimes to a doll-like form, of the early medieval examples. Only a few show a later form, with Christ drooping and dead on the cross. The St Buryan Churchyard cross (no. 11) has one of the finest early medieval examples in Cornwall, and good examples on wayside crosses are to be found in St Buryan parish, for example on the Boskenna, Chyoone and Churchtown crosses (see the parish page, and Fig. 28i).

**Disc-headed**
Alternative term for a *wheel-headed* or round-headed cross.

**Dot decoration**
Rows of incised dots feature as decoration on monuments of the transitional period between the early medieval and later medieval styles of cross carving. Fine examples can be seen on St Piran's Cross (no. 83) and in panels on the Lanivet 2 and Penzance Cross (nos 53 and 82; Fig. 28j).

Fig. 28. Illustrations of some of the individual features described in the glossary. Note they are not shown to scale.

a. Abacus below the cross-head of Laneast 1 (no. 48).

b. Animal decoration on Gwinear 2, the Lanherne Cross (no. 43).

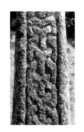

c. Borre or Manx ring-chain on Cardinham 1 (no. 15).

d. Bead or edge-moulding on St Kew 1 (no. 46).

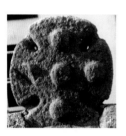

e. Five bosses on Paul 1 (no. 78).

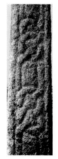

f. Carrick bend or figure-of-eight knot on St Neot 3 (no. 74).

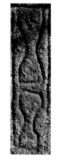

g. Possible chalices on St Dennis cross (no. 28).

h. Chevrons on Tretheage cross, Stithians (no. 92).

i. Simple crucifixion on the Chyoone Cross, St Buryan (see parish page).

j. Dot decoration on Lanivet 2 (no. 53).

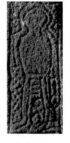

k. Figure ornament on Lanivet 2 (no. 53).

l. Fleur-de-lys on the head of Prior's cross, Egloshayle 3 (no. 31).

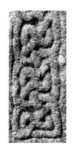

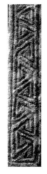

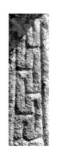

m. Simple Hill of Calvary on Cury cross (no. 27).

n. Interlace on St Neot 1 (no. 73).

o. Diagonal key pattern or fret on Sancreed 2 (no. 88).

p. T-shaped key pattern or fret on Cardinham 1 (no. 15).

q. Plaitwork panel on St Cleer 2 (no. 19).

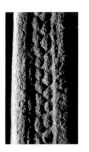

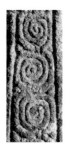

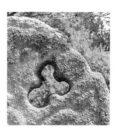

r. Three-strand plait on Lanivet 1 (no. 52).

s. Spiral plant scroll on Cardinham 1 (no. 15).

t. Plant trail on the Waterpit Down Cross, Minster (no. 69).

u. Trefoil hole in St Breward 1 cross-head (no. 8).

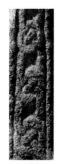

v. Ring-twist on Cardinham 1 (no. 15).

w. St Andrew's cross on Lelant churchyard cross (no. 58).

x. Stafford knot on Gwinear 2 (no. 43).

y. Triquetra knot on St Neot 3 (no. 74).

**Early medieval**
The period of time extending broadly from the departure of the Roman army from Britain in AD 410, up until the Norman Conquest in 1066.

**Edge-moulding**
The moulding used to define all edges of a cross; it may also be known as a *bead*. The edge-moulding on Cornish crosses may occasionally be a rounded roll-moulding or a simpler incised edge-moulding. Edge-mouldings or beads are invariably used on pre-Norman crosses, but may be omitted on post-Norman Conquest monuments (Fig. 28d).

**Entasis**
The gentle outward curve intended to correct the visual illusion of concavity seen on a tall parallel-sided column or shaft. Entasis is rarely regularly executed on Cornish crosses, but a clear example can be seen on the St Neot churchyard cross-shaft (no. 73).

**Figure ornament**
Apart from the crucifixion, only a few examples of figure carving are found on Cornish crosses. These include two simple stick figures on the Market Cross, Penzance (no. 82), and a possible figure of St Peter on Lanivet 2 (no. 53; Fig. 28k). The Four Evangelists are depicted as tiny heads on the Tintagel Cross (no. 94) and as crouched figures on the cross-base at Gulval (no. 41).

**Figure-of-eight**
A simple knot, which is also known as the *Carrick bend* (Fig. 28f).

**Fleur-de-lys (Fleur-de-lis)**
The fleur-de-lys is a stylized lily or iris. Both flowers are metaphors for whiteness and purity and are used to symbolize the Virgin Mary. Egloshayle 3, the Prior's Cross, has a fleur-de-lys on each face of its wheel-head (no. 31; Fig. 28l).

**Foliated cross**
A cross with terminals like foliage.

**Fretwork, fret**
See *key pattern*.

## Geometric cross

A cross constructed using geometrical forms, including compass-drawn heads and arms. The arms have straight sides or are curving or arc-shaped. All four arms are symmetrical.

## Hill of Calvary

Stepped or triangular base of a cross representing the hill on which the crucifixion took place. The triangular base of the long-stemmed incised cross on Cury or St Levan crosses may be intended to represent the Hill of Calvary (nos 27 and 60; Fig. 28m).

## Insular script

A form of lower-case script used in the early medieval period.

## Interlace

Strands or cords woven together to form complex, repeating patterns that are carved in relief. Interlace is a form of decoration that is especially characteristic of early medieval ornament. Patterns seen in Cornwall are generally quite simple, probably because of the difficulty of carving much detail in granite. The finest example of interlace in Cornwall is seen on St Neot 1 (no. 73; Fig. 28n).

## Key pattern

Also known as *fret, fretwork, step pattern* or meander. These patterns are ultimately derived from classical models. Geometric triangular or square interlocking and repeating patterns are constructed from a continuous line; occasionally, square panels may be formed. The only example of the latter is seen on Lanivet 2 (no. 53). Sancreed 2 has the best key pattern in Cornwall (no. 88; Fig. 28o) and there is a rectilinear T-shaped key pattern on the side of the Cardinham Cross (no. 15; Fig. 28p).

## Knot, knotwork

Relief-carved strands worked together to form individual knots; the knots employed include the *trefoil, figure-of-eight* or *Carrick bend* and *Stafford Knot*. A series of knots may be joined together in a line, as on the side of the Four Hole Cross (no. 74; Fig. 28f).

**Later medieval**
The period of time from after the Norman Conquest up to the Reformation in the sixteenth century.

**Latin cross**
A cross formed from a vertical shaft, with horizontal arms. An example is on St Germans, the Carracawn Cross (no. 38).

**Moorstone**
Granite obtained from boulders at the surface rather than from a quarry. The deep quarrying of granite did not begin until the nineteenth century.

**Patriarchal cross**
A cross similar to a *Latin cross* but with an additional horizontal arm, often slightly smaller than the others.

**Plait, plaitwork**
A pattern made by weaving together a number of strands (three, four or occasionally more) to create a simple basket-work pattern. Two of the finest examples in Cornwall are seen on St Cleer 2, the Other Half Stone (no. 19; Fig. 28q) and on St Neot 1 (no. 73). A simple three-strand plait, following the method for braiding hair, is seen on the side of the Cardinham and Lanivet Churchyard crosses (nos 15 and 52; Fig. 28r).

**Plant decoration**
This may be in the form of either a scroll or a leafy trail. Plant decoration is usually based on a climbing plant that curls up the shaft, rising from a root at the base of the cross-shaft; the main stem alternates from side to side of the shaft and side shoots hang down in the volutes or spaces between the curves.

In a **plant scroll**, the stems are leafless and spiralling, the only addition to the plant being small buds that appear at the point where the side stems branch off. The classic example of a plant scroll in Cornwall is on the Cardinham Cross (no. 15; Fig. 28s).

In a **plant trail**, the plant is normally a type of acanthus, with fleshy three-lobed leaves hanging down in the volutes. The earliest and finest examples of this in Cornwall can be seen on the Four Hole Cross (no. 74). Most commonly, the plant trail is used to decorate the sides of crosses in mid and east Cornwall,

and a good example can be seen on the south side of the Waterpit Down Cross (no. 69; Fig. 28t).

## Ring-headed

A cross-head whose arms are supported by a carved ring. This form of cross-head is most typical of pre-Norman monuments. The spaces between the ring and the cross-arms are usually pierced by four simple holes, but some are more elaborate and have holes cut in the shape of *trefoils*. The latter seems to be an innovation developed in Cornwall; a good example is St Breward 1 (no. 8; Fig. 28u).

## Ring-knot

A simple knot formed by inserting and interlacing two oval rings into one or two circles, to create a knot. An example with one circle is seen on the Doniert Stone (St Cleer 1, no. 18) and with two circles on the St Neot churchyard cross-shaft (no. 73).

## Ring-twist

Two strands rising up the side of a cross-shaft, crossing at intervals and interlaced by closed rings at the point they cross. There are clear examples on the side of the Padstow 2 cross-shaft and Cardinham 1 cross (nos 76 and 15; Fig. 28v).

## Romanesque

The style of decoration introduced into Cornwall after the Norman Conquest. The style is so-called because many of the decorative elements employed are derived from Roman art and architecture. The most typical elements of Romanesque decoration seen on Cornish crosses are *chevrons*, diamonds and zig-zags.

## St Andrew's cross

A form of the cross in which the cross-arms are placed diagonally, rather than horizontally and vertically. A well-known example is St Piran's Cross (no. 83), where the diagonal cross is given definition by the positioning of the four holes at the top and sides of the head; another is the churchyard cross at Lelant (Fig. 28w).

**Saltire cross**
A cross with the arms placed diagonally; also known as a *St Andrew's cross*.

**Stafford knot**
A simple three-looped knot usually formed with only one strand, although on the Lanherne Cross the strand is made of three cords (no. 43; Fig. 28x).

**Step pattern**
See *key pattern*.

**Suppedaneum**
The small ledge on which Christ's feet rest in *Romanesque* depictions of the crucifixion dating to the twelfth century. This feature can be seen on the crucifixion on the St Levan Cross (no. 60).

**Tenon**
A protruding or projecting portion of the shaft, carved to fit the corresponding mortice in its base-stone (that is, a mortice and tenon joint).

**Trefoil**
A three-lobed shape, like a clover leaf; this is most commonly used in Cornish crosses to create the distinctively shaped holes of Cornish crosses in mid and east Cornwall such as St Columb or Quethiock (nos 24, 85; Fig. 28u).

**Triquetra**
A simple three-lobed closed knot, similar to the Stafford knot. The triquetra is most commonly seen decorating the arms of ring-headed crosses, where its triangular shape fits neatly into the triangular shape of the individual arms of a splay-armed cross. Very clear examples can be seen on the head of the Four Hole Cross (no. 74; Fig. 28y) and St Breward 1 (no. 8).

**Wheel-headed**
The solid circular cross-head with a cross carved on it that is typical of Cornish wayside crosses. This form of head is generally known outside Cornwall as *disc-headed*. The cross on the head may be carved either in relief or incised. Types of wheel-headed crosses and the crosses carved on them are illustrated in Fig. 17.

# Using this book to visit crosses

The main portion of this book consists of a catalogue of the stone crosses arranged in alphabetical order. Each cross is listed under its original ecclesiastical parish, although today some crosses have been moved to other locations. For example, the Lanherne Cross from Gwinear parish is now in St Mawgan in Pydar (no. 43) and the cross from Connor Downs in Gwinear (no. 42) is now in Camborne churchyard. Please check each entry for the monument's present location before planning a visit. Please note also that where the parish name is that of a saint, as for example St Clement, the parish is alphabetically listed according to the saint's name, here 'Clement', not under 'S' for saint.

Postcodes as well as a national grid reference have been provided to help visitors to find the stones, but please note that not all the crosses are conveniently located close to a dwelling or church, and so the postcode will only be a guide to the general vicinity.

A few of the wayside and boundary crosses are accessed via public footpaths, where it would be beneficial to have up-to-date Ordnance Survey mapping of the area when visiting. During the summer months, some crosses may be more difficult to locate owing to increased vegetation.

The majority of the stone crosses in this catalogue are freely available to view, but one or two are on private ground and only visible from the public roadside. There is no free access to those on private or National Trust estates, and in these cases admission charges apply.

The authors have made every effort to ensure that the information provided about the location and access to each monument is accurate at the time of publication.

# A note on photography

All of the photographs in this book were taken by two of the authors, Ann Preston-Jones and Andrew Langdon, unless otherwise stated. As we know from many years of experience, it is very easy to take poor photographs of the stones. In contrast, it requires careful planning and timing to take photographs in which the sun shines at an oblique angle to the face of the monument. This is the only way to capture the detail of any carving. The best time for taking photographs is undoubtedly the spring, between March and May, when the light is likely to be clear and bright. An added bonus at this time of year is that the hedgerows and churchyards are awash with wildflowers, whose colour adds immensely to the interest of the photographs and makes the crosses a pleasure to a visit. In June, the long days add potential to photograph the north faces of monuments normally hidden in the shade, although this may require an early morning or late evening visit. Crosses under trees may need a visit in winter when there are no leaves on the trees. In extremely difficult conditions, lights or a flash may be the only solution, and laser scanning or photogrammetry has proved very successful in some cases.[1]

# CATALOGUE OF CROSSES

# 1. Advent, Tresinney

SX 1051 8124; PL32 9QW

The Tresinney cross stands two fields to the south of Advent church, beside a public footpath. There is full public access.

The cross was first briefly mentioned in 1858 by Blight,[1] and in 1876 Maclean described it in its present location.[2]

It is a tall and complete granite wayside cross standing 2.59m (8ft 6in) high. It has a wheel-head with an equal-armed cross in relief on each face, enclosed by a bead or roll-moulding. The arms are narrow and expanded at their ends. The shaft is plain and roughly executed. It stands in an oval base-stone, which is sunk into the ground so that only its upper surface is exposed.

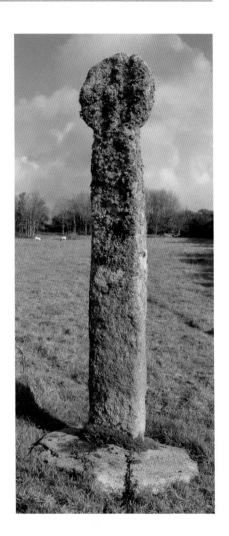

This is one of the tallest of the wayside crosses in Cornwall. It is still in situ beside an ancient track, the church path from St Breward in the south to Advent parish church, a path that also serves local farms and hamlets. The cross takes its name from the Tresinney estate, now a small hamlet south-west of the parish church. This cross, unlike so many others, has not been cut down or had part of its shaft removed to make a gatepost. It therefore demonstrates how many wayside crosses may once have looked.

The absence of any decoration on the shaft makes this monument difficult to date. Nevertheless, the simple geometric cross on the head can be compared with those from Wendron, including the Bonallack and Nine Maidens' Down crosses,[3] and suggests a possible twelfth-century date.

## References

Langdon, Arthur G. (1896), 55–6 and fig.;
Langdon, Andrew G. (1996b), 14, no. 1 and fig.

# 2. St Allen

SW 8225 5060; TR4 9QX

---

The cross stands in the churchyard of St Allen church, east of the south porch. There is full public access.

In 1928 the cross was discovered buried horizontally in a bank at the edge of the churchyard path by Rev. R.L. Glover.[4] In 1930, it was re-erected in its present position and mounted on the remains of two circular stones of different diameters. The upper stone may be the original base-stone, while the lower stone is part of the base of a cider press.

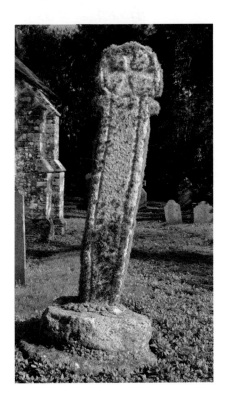

The cross is wheel-headed and now stands 1.91m (6ft 3in) high. When it was discovered in 1928, it measured 2.26m (7ft 5in) from the top of its head to the tenon, which then still remained intact. The cross symbol depicted on the wheel-head is unusual: the triangular areas between the cross arms are in relief, while the equal-armed cross itself is sunk, or rebated. Below the cross-head are small projections at the neck. The shaft is well shaped with a bead or roll-moulding down each side. The simple geometric cross and the absence of any other decoration suggest a post-Norman Conquest date, perhaps the twelfth century.

Henderson considered the cross to be the churchyard cross, suggesting that it might have been pulled down at the Reformation.[5] Although it is possible that it was indeed a churchyard cross, this cross is similar in style to other wayside crosses and has a plain shaft, in contrast with the more elaborately decorated early medieval monuments. The projections at the neck area also feature on a second cross in the churchyard and on the Trevalsa cross, which is situated to the north-west of the parish church.

See also the parish page.

## Reference

Langdon, Andrew G. (2002), 18, no. 2 and fig.

# 3. St Blazey, Biscovey

SX 0582 5358; PL24 2EE

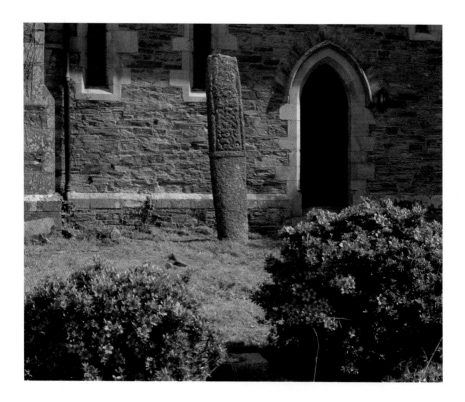

The Biscovey cross-shaft stands in the churchyard of St Mary's church, St Blazey Gate, beside the south-east wall of the church. There is full public access.

The shaft was first recorded in 1700 'by the Alms-House at *St. Blasey*',[6] and it was still there in 1838.[7] In 1867, it was in use as a gatepost,[8] and in September 1896, it was moved to its present location.[9]

This unusual cross-shaft, 2.38m (7ft 11in) high, is of rectangular section with a marked entasis. A flat raised band

at the widest point divides the shaft into two. The lower part is undecorated, but the upper portion contains very worn interlace decoration and inscriptions on front and back. Some panels in the upper part of the shaft appear to have been left empty, which may suggest that the cross was never finished.

The stone is very eroded. Its south face is the clearest and, in good light, a ring-knot can be made out and below it one of the two inscriptions, arranged in

three lines. This reads [CI]LRORON and is likely to be a personal name, probably starting with a Celtic name-element CIL-. The inscription on the back might possibly be read as a form of *filius*, 'son of'. The eroded state of the stone, together with its unique form, makes the cross-shaft difficult to date, but the style of decoration that can be discerned points to a tenth- to early eleventh-century date.

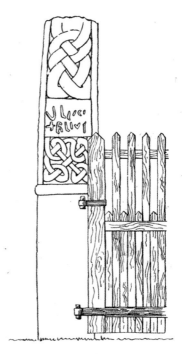

St Blazey cross-shaft depicted in use as a gatepost (Langdon, Arthur G., 1896, 369).

The back of the cross: the decoration is difficult to make out because the cross is so close to a wall; this image was taken with lights at night.

The original context of this unique cross is uncertain; it may have stood by a road or it may have been associated with a cemetery. When first recorded, it was close to almshouses on the main highway through St Blazey parish and around the southern side of the Hensbarrow granite upland; a report that many human bones had been found 'in a little meadow adjoining' suggests a cemetery.[10]

### References

Langdon, Arthur G. (1896), 368–72 and figs; Okasha (1993), no. 1, 63–67; Langdon, Andrew G. (1996c), 25; Langdon, Andrew G. (2002), 23, no. 10 and fig.; Preston-Jones and Okasha (2013), 119–20 and figs.

# 4. Blisland, St Pratt's Cross

SX 1037 7310; PL30 4JP

This cross is situated to the east of the parish church of SS Protus and Hyacinth, Blisland, beside a road entering the village from the A30. There is full public access.

Blight in 1858 was the first to record this cross, which had been buried up to its neck in the ground.[11] It originally marked St Pratt's (St Protus's) holy well, which today no longer exists, although the cross stands near its original site. A stone trough close to the cross, fed by water from a chute, is not the well, which was some 15m (50ft) away. According to Ellis, it was the local vicar, Rev. William Pye, who threw the cross down in 1829 in demonstration against the Catholic Emancipation Act.[12] When recorded by Langdon in 1896, the cross was still in this position;[13] however, in 1901, to commemorate the Coronation of Edward VII, the cross was dug up and erected in an old base-stone brought in from the moors.[14]

The cross is wheel-headed and stands 1.67m (5ft 6in) high. It has rectangular projections on either side of the head and the top, and an equal-armed cross carved in high relief within a shallow recess. The reverse face is similar. The shaft has been fractured and repaired about 0.25m (10in)

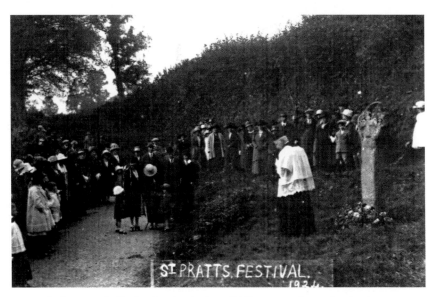

Each year on the first Sunday after the feast of St Protus on 22 September, the clergy, choir and congregation of the church, led by a band, process from St Pratt's church to the cross, where a short service is held. The image shows the event in 1924.

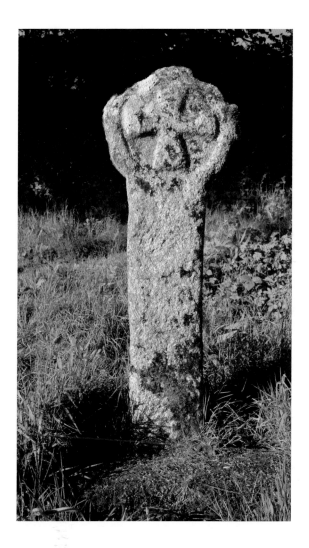

from the base. The projections above
and at the side of the head are a style
only found in Blisland and Cardinham
parishes; other examples include Peverell's
Cross and also Cardinham 2 (no. 16).
St Pratt's Cross is a simple geometric
cross and therefore probably of twelfth-
century date.

See also two crosses in the churchyard
and a third close to the village green, all
within close walking distance.

## References

Langdon, Arthur G. (1896), 171–72 and fig.;
Langdon, Arthur G. (1906), 432 and fig.;
Langdon, Andrew G. (2005), 21, no. 17 and fig.

# 5. Bodmin, Carminow

SX 0883 6568; PL31 1HD

The cross is set in the centre of Carminow Cross roundabout, at the junction of the A30 and the A38. There is full public access.

The cross was first recorded in 1858 'At Carminow, near Bodmin ... partly buried in a ditch'.[15] In 1873, Maclean described it as standing 'transversely to the hedge which has been built nearly over it'.[16] In 1890, it was removed from the hedge,[17] and in 1898, it was re-erected beside the road on a new shaft.[18] It was placed in its present position in 1977, after construction of the Bodmin bypass.[19]

This cross-head with a small section of the original shaft is set on a tall modern shaft and base, making an impressive monument that stands 3.65m (12ft) high. The cross-head is ring-headed and circular, with splayed arms and pointed projections at the neck. Both head and shaft are enriched with irregular incised dot decoration, within a double incised edge-moulding that curves inwards at the top. On one side of the head are small bosses in each of the arms and in the centre.

The size of this cross-head is similar to those of crosses at Cardinham and Prideaux Place, Padstow (nos 15 and 77), suggesting that originally it was a large and impressive monument. Although now mounted on a modern shaft, it is possible that the modern monument is close to the scale of the original. However, the dot decoration and the form of the cross are different from the Cardinham and Prideaux Place crosses, being closer to the monuments likely to be transitional between early and later medieval styles. The circular head, with protruding roll-mouldings at the neck, set on a tall slender shaft, can be compared with the much-eroded Perranzabuloe cross (no. 83) or with the combined Lanteglos by Camelford 1 and 2 (nos 56 and 57), while the cross on the head, indicated by triangular-shaped holes, is of similar shape to Lanivet 2 (no. 53). The decoration and form of the cross-head suggest a date in the second half of the eleventh century or the twelfth century.

In its original position, at approximately SX 0882 6558, the

Carminow Cross in the nineteenth century, when it was built into a hedge. Illustration by William Iago (Maclean 1873, 118).

cross marked the boundary between the parishes of Bodmin, Lanhydrock (a chapelry of Bodmin) and Cardinham.[20] Henderson suggested that it was the boundary stone referred to in a document of 1613 as 'Carmynowe's Crosse'.[21] It also stood at what is likely to have been one of the most significant crossroads in Cornwall, where routes along the length of the peninsula (now seen in the line of the modern A30) crossed the trans-peninsula route between the estuaries of the Camel and the Fowey rivers. The strategic significance of this location at earlier periods is indicated by the positioning of Castle Canyke, one of the largest hillforts in Cornwall, immediately to the north of this cross.

## References

Langdon, Arthur G. (1896), 311–13 and figs; Langdon, Andrew G. (1996c), 24; Langdon, Andrew G. (1996b), 17, no. 7 and fig.; Preston-Jones and Okasha (2013), 121–22 and figs.

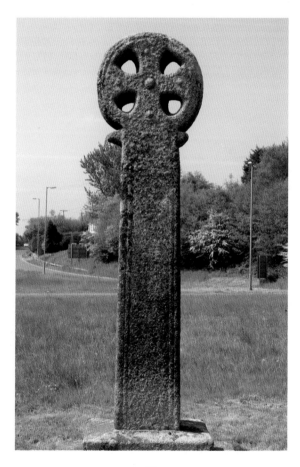

# 6. Breage

SW 6186 2844; TR13 9PD

The cross stands in the churchyard of St Breage's church, beside the porch. There is full public access.

The cross was first mentioned in 1865, discovered 'buried in the churchyard'.[22] By 1896 it had been set in a base, presumably its current base, in its present location.[23]

This unusual monument stands 0.68m (2ft 3in) high. It consists of the head and part of the shaft of a ring-headed cross of rectangular section, set in an octagonal base. The cross is extremely eroded and the surface of the stone pitted where small pebbles in the sandstone from which it is carved have fallen out. Hence, although the cross was once highly decorated, little of the decoration can now be made out.

The cross-head has a rounded edge-moulding, within which (possibly on both front and back) are traces of five bosses. Unusually, there is decoration on the ends of the cross arms, of which a rosette or star motif on the end of the south cross arm is clearest. Deeply cut patterns of narrow interlacing strands once decorated the shaft but, since only

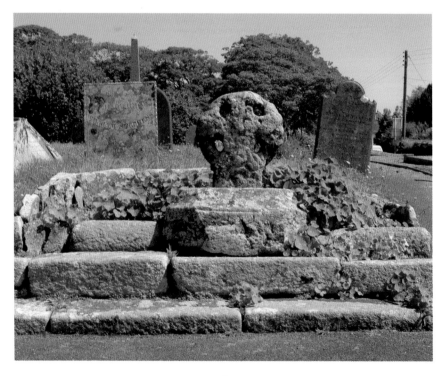

the top part survives, these cannot be fully interpreted. The base is plain but has a strongly chamfered edge.

The back of the cross is a strong red colour as a result of iron oxide staining, possibly caused by its having lain for a prolonged period in stagnant water. Langdon, however, repeats a local tradition that this colouration was the result of bloodstaining following a great battle at the foot of Godolphin Hill.[24]

Although small and highly eroded, this fragment seems to have been one of the more elaborately decorated of Cornish crosses. Few other crosses in Cornwall have decoration on the ends of the cross-arms. Other examples are the crosses at Lanherne (no. 43) and Cardinham (no. 15), which are among the finest of Cornish crosses. The decoration suggests a date in the tenth to the eleventh century. The base is octagonal and has a chamfered edge, which indicates that it is of later date than the cross. However, the fact that both are carved from the same unusual stone may be evidence to the contrary: the base might have been recut to suit the style of a later period.

The existence of what may once have been an impressive monument at Breage is not a surprise since it was a minster-like church, with chapelries at Germoe and possibly also at Cury and Gunwalloe, although the latter two may have been added in the thirteenth century.[25] In 1086, the Bishop of Exeter's manor of Methleigh lay within the parish of Breage and the chapelries were within the royal manors of Winnianton and Binnerton.[26] The church is said to have possessed its patron saint's shrine.[27] See also the remains of Spernon Cross from Godolphin inside the church.

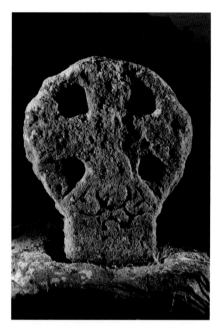

The back of the Breage cross, photographed with lights at night, showing the highly eroded remains of decoration in the bottom arm.

## References

Langdon, Arthur G. (1896), 380–82 and figs; Langdon, Andrew G. (1999), 10, no. 1 and fig.; Preston-Jones and Okasha (2013), 122–24 and figs.

# 7. St Breock, Whitecross

SW 9645 7201; PL27 7JB

The Breock cross stands beside a crossroads on the A39 road from Wadebridge to St Columb, at the village of Whitecross, 2.5km (1.5 miles) west of Wadebridge. There is full public access.

Blight illustrated the cross in 1858 and stated that it had given its name to the village of White-cross.[28] Langdon noted that the shaft had been fractured and then repaired securely by the village blacksmith with external iron staples on the front and back, and that the villagers kept the head whitewashed.[29] Over the years the road was widened and the cross became deeply buried, with only the head and a small part of the shaft visible. In 1994, it was dug up and set at its full height on a new base-stone, the iron staples being replaced with internal phosphor-bronze dowels or pins.

This wheel-headed cross stands 1.77m (5ft 10in) high. It displays an equal-armed cross in relief on both faces, enclosed by a bead or roll-moulding. Both crosses have been painted white, while leaving the remainder of the monument unpainted. As noted above, the shaft is fractured midway down. The Ordnance Survey bench mark has been cut low down on one side of the shaft. The simple geometrical cross on each face suggests a post-Norman Conquest date, perhaps the twelfth century.

Another cross beside the A30, at the village of Whitecross in Ludgvan parish, has been completely whitewashed,[30] while there are three other villages known as Whitecross (without stone crosses surviving) in the parishes of Cury, St Columb Major and Lanteglos by Fowey.[31] This suggests that whitewashing crosses to make them stand out in the landscape may once have been a common practice.[32]

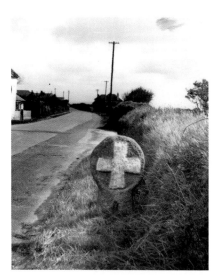

The Whitecross before 1994.
Photograph by the late Mary Henderson
(Andrew Langdon collection).

## References

Langdon, Arthur G. (1896), 57–58 and fig.;
Langdon, Andrew G. (1996b), 19, no. 11 and figs.

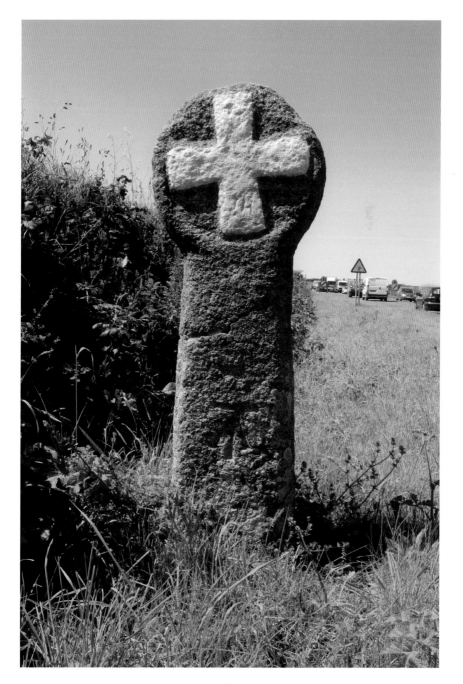

# 8. St Breward 1

SX 0974 7732; PL30 4PP

This cross-head stands in the cemetery of St Breward's church. There is full public access.

The cross-head was first mentioned in 1858 when Blight recorded that it had been 'Removed from the church-yard wall to its present situation on the wall adjoining the parish school'.[33] By 1891 it had been moved to its present location.[34]

Only the upper part of the head of this impressive ring-headed cross is original; it measures 0.52m (1ft 9in). The remainder was reconstructed in the nineteenth century, but it probably gives a fair idea of the original appearance and scale of the monument. The cross-head is cut in a medium-grained Bodmin Moor granite. It has wide-splayed arms linked by a narrow ring, and in the space between the arms and ring are three

cusps, forming trefoil-shaped openings. All the decoration is in very low relief and includes a large, flat central boss on one side of the head only, while in each of the cross-arms are the remains of triquetra knots. The ring is undecorated.

This is one of the small, dispersed group of crosses in Mid- and East Cornwall with trefoil openings in the head, which date from the late tenth to the eleventh century. Other characteristic features of the group include widely splayed arms with triquetra knots, a central boss, low-relief carving, and narrow cross-section.

The stone type and cross-section make it probable that this and the other fragment in St Breward (no. 9) were originally parts of the same monument. As both were found close to the parish church, an original association with the church seems likely. St Breward is dedicated to a Celtic saint who also has dedications in Brittany, Jersey and Wessex.[35] The church is located at a high altitude, on the edge of Bodmin Moor, in a parish whose settlement may represent a process of expansion and colonization within the early medieval period. The cross may therefore be the earliest evidence for a church site founded to cater for the needs of farming and settlement expansion on to the fringes of Bodmin Moor at this time.[36]

Arthur G. Langdon's (1896, 395) drawing of the cross-head, showing it before it was restored; the illustration shows how little of the modern monument is original.

## References

Langdon, Arthur G. (1896), 394–95 and fig.; Langdon, Andrew G. (1996b), 20, no. 13 and fig.; Preston-Jones and Okasha (2013), 124–25 and figs.

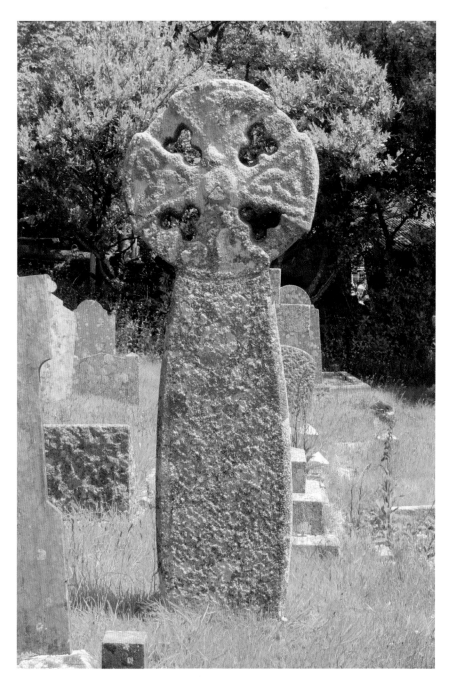

# 9. St Breward 2

SX 0969 7727; PL30 4PP

This cross-shaft stands in the front garden of the New Inn, St Breward. There is full public access.

The cross-shaft was first recorded in 1906 'In churchtown',[37] presumably in the same position as it was in 1935; that is, built into the wall of an outbuilding at St Breward.[38] In May 1952, the shaft was moved to the garden of the inn,[39] and subsequently erected in its present position.[40]

The cross-shaft is cut from Bodmin Moor granite and stands 0.94m (3ft 1in)

high. Only a small section of the cross-shaft survives, with foliage decoration on the main faces and knotwork and a plait on the narrower sides. All the decoration is in very low relief and very eroded, so it is difficult to make out, except in good light. On the face looking on to the road is a large, loose, foliage scroll, and on the back is a unique form of double plant scroll.

The New Inn is close to the parish church, and the proportions and stone type of the monuments make it likely

that St Breward 1 and St Breward 2 were originally parts of the same monument. The patterns on the shaft also indicate that, like St Breward 1, St Breward 2 is a member of the late tenth- to eleventh-century Mid- and East Cornwall group of crosses. Some of the decoration on it is similar to that on the crosses at Minster (no. 69) and at St Neot (no. 74), each less than 16km (10 miles) from St Breward. These two give an idea of the likely original scale of this monument.

## References

Langdon, Arthur G. (1906), 438; Langdon, Andrew G. (1996b), 21, no. 14 and fig.; Preston-Jones and Okasha (2013), 125–26 and figs.

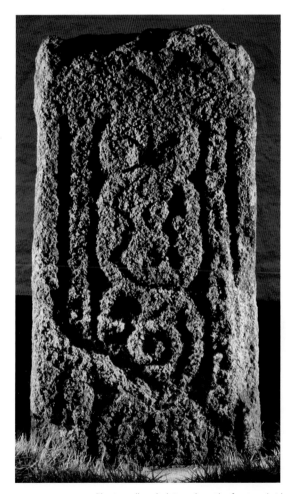
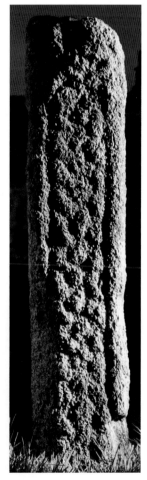

Plant scroll and plaitwork on the front and side of St Breward 2.

# 10. St Breward 3, Middle Moor Cross

SX 1250 7930; PL30 4PN

This cross stands in situ beside a track on the moors between Treswallock and Roughtor, near Camperdown Farm, 4km (2.5 miles) from St Breward. There is full public access.

In 1858, Blight noted the existence of a cross at 'Swallock', although he gave no details.[41] However, in 1873, Maclean first recorded this cross in detail and illustrated it.[42] He showed the cross lying beside its base-stone and noted that Dr Martin, vicar of St Breward, had undertaken to have it re-erected in its base; this was done in 1888. When seen by Ellis in May 1938, the cross had again fallen down but it was restored in June 1939.[43] At this time, a new tenon was cut on the bottom of the shaft

and the mortice enlarged to receive it, thus reducing the monument's overall height. It now stands 1.55m (5ft 1in) high.

A local tradition recorded by Langdon elaborates on the mishaps of the cross: 'whenever the cross heard the bells of "Semmenward" [= St Breward] ring it turned round, and did this so often that at last it tumbled down'.[44]

The cross is roughly hewn, with a poorly shaped wheel-head: a deeply incised equal-armed cross is cut into both faces of the monument. The shaft is plain. The base-stone is an irregular piece of moorland granite with a rectangular mortice. The simple incised cross on the head is difficult to date and the

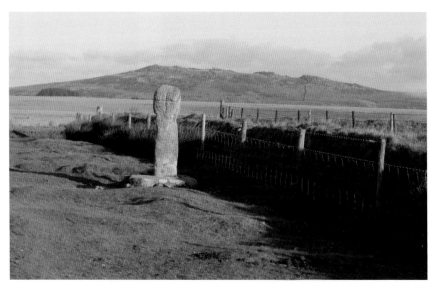

The Middle Moor Cross with Brown Willy forming a backdrop to the east.

The Middle Moor Cross in its moorland setting.

monument's rugged appearance does not necessarily indicate an early date. Its overall form and function suggest a post-Norman Conquest date, possibly the twelfth century.

Also known as the Mid Moor Post, the cross marks a route from remote farms on Bodmin Moor such as Fernacre and Louden to the parish church of St Breward, but it is also on a longer distance route onwards via St Tudy to a crossing-point on the River Camel, where Wadebridge now is.

## References

Langdon, Arthur G. (1896), 239–41 and fig.; Langdon, Andrew G. (1996b), 22, no. 17 and fig.

# 11. St Buryan 1

SW 4091 2569; TR19 6BX

This cross-head is in the churchyard of St Berian's church, to the south of the church. There is full public access.

The cross-head was first recorded in 1789, when it was probably in its present location.[45] It was certainly recorded in its present location in 1801: 'Near the south entrance ... elevated on four steps'.[46] Repair to the base in 2016 showed that the base had been extensively restored in the nineteenth century by building a new set of steps around the old ones.[47]

The only portion surviving of this superb cross is the ring-head and a very small part of the top of the shaft. It stands 0.8m (2ft 8in) high on a five-stepped square base. The top step, a single square slab of granite with a rectangular mortice, may be the original base of the cross, but the other steps are probably later.

Incised edge-mouldings surround the head and within this, on the main face overlooking the path to the church door, is a well-proportioned figure of Christ carved in moderately high relief and carefully designed to fit within the cross-head (See Introduction, Fig. 6). He has a halo and is wearing a knee-length garment. At the waist, a slightly raised line is probably a belt. The hands are clear, though no detail is visible. The feet are turned out and extend to the edge-moulding. On the back of the cross-head are five prominent bosses,

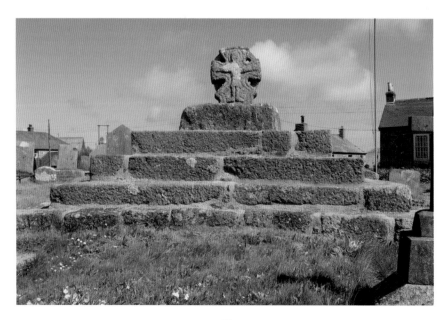

one in the centre, the others symmetrically placed around it, one in each of the cross-arms. No decoration can be seen on the sides of the cross-head, nor on the small surviving sections of the shaft, except possibly on the side facing the church.

This cross-head is a member of the Penwith group of pre-Norman sculpture, characterized by a crucifixion on one side of the head and five bosses on the other, and dating from the mid-tenth to the eleventh century. It is a particularly large and well executed example and may be one of the earliest of this group. The bold carving and the careful proportions of the figure are similar to those on the Lanherne Cross (no. 43). Compared to these, the crucifixions on other members of the group, for example at St Erth (no. 33) and Paul (no. 78), are cruder and simpler.

St Buryan was the principal pre-Norman church of the Land's End (Penwith) peninsula, and is first recorded in a charter of the first half of the tenth century.[48] In all probability, this charter represents a confirmation of the existence of a pre-existing religious house since the saint, Berion, is recorded earlier, in a tenth-century list of Cornish saints.[49] In Domesday Book, the church of St Buryan was held by the Canons of 'St Berrione', and it remained a collegiate church throughout the medieval period.[50] The monument is likely to have been carved and originally erected as a focal point of the refounded collegiate church. As a major feature of the most important church in the area, it is likely to have been influential in the development of sculpture locally. See also the parish page.

Comparison with other members of the Penwith group suggests that the decoration on the shaft is likely to have included interlace, a serpentine creature and possibly inscriptions, making loss of

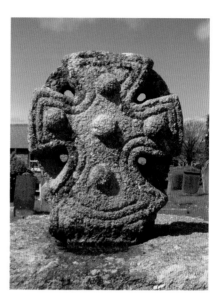

Five bosses on the back of the cross-head.

the shaft particularly sad. The shaft may have been cut off in the late medieval period, by which date its decoration might have been not only worn but also out of date, whereas the cross-head's recognizable imagery was suitable for reuse to meet contemporary ritual. The shaft with its redundant decoration was presumably discarded or, more probably, reused as building stone when the church was rebuilt in the fifteenth century.[51]

## References

Langdon, Arthur G. (1896), 189–90 and figs; Thomas, A.C. (1978), 78–79; Preston-Jones and Rose (1986), 159; Langdon, Andrew G. (1997), 12, no. 1 and figs; Preston-Jones and Okasha (2013), 126–27 and figs.

# 12. St Buryan 2, Crows an Wra

SW 3953 2762; TR19 6HU

The Crows an Wra cross stands at a staggered crossroads on the A30 in front of a former chapel (now a private house) on a triangle of land between the A30 and a minor road to St Just. There is full public access.

The cross was first noted and illustrated by Haslam in around 1845,[52] and again by Hingston in 1850;[53] however these illustrations are not very accurate. Blight has a sketch showing the cross leaning forward at an acute angle,[54] and in

1856 he illustrated one side of the cross,[55] while Langdon illustrated the other side in 1896.[56] By the time the 1880 Ordnance Survey map was published, the cross had already been moved to its present position; however, its former position a few metres to the east is also shown. Between 1896 and 1904, a modern stepped base of granite was built around the cross.

The cross stands 1.4m (4ft 7in) high. One face contains an equal-armed cross in relief formed by the cutting of four

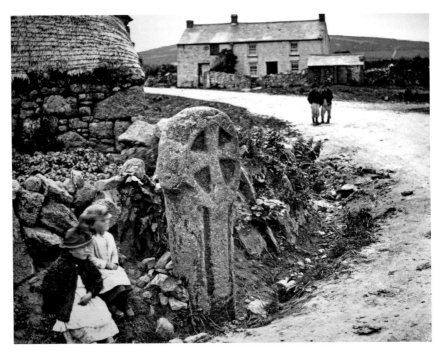

A photo at the Morrab Library Penzance shows the Crows an Wra in 1865 when it stood on the opposite side of the road.

The 'Witches Cross' with an early nineteenth-century milestone behind it.

The Crows an Wra, illustrated by J.T. Blight (1856, 4).

triangular recesses; the lower arm extends from the outer ring of the cross down the full length of the shaft. The other face depicts an equal-armed cross, which is recessed rather than carved in relief. The simple geometric cross suggests a twelfth-century date.

The name Crows an Wra is Cornish for 'Witch's Cross' or 'Hag's Cross',[57] although the reason for this appellation is not known. The cross is just east of the site of a medieval chapel at Chapel Carn Brea and stands close to the parish boundary between St Buryan and St Just.

## References

Langdon, Arthur G. (1896), 318–19 and fig.;
Langdon, Andrew G. (1997), 16, no. 8 and fig.

# 13. Camborne 1, Fenton-Ia

SW 6450 4002; TR14 7DF

The cross stands in the churchyard of St Meriadoc's church, Camborne, near the porch. There is full public access.

The cross was first recorded in around 1752–53, standing at Fenton-Ia chapel, Troon.[58] In 1896, it was rediscovered built into a well at Crane; in 1898, it was recorded as in its present location.[59]

The monument is a wheel-headed cross, 1.89m (6ft 2in) high, mounted in a modern base. On its head is a straight-armed cross with a small hollow at the centre. Between the head and shaft are slight remains of a projecting roll-moulding. The shaft has been severely mutilated and worn by reuse so that carving, consisting of a range of incised zig-zags, crosses and horseshoes, survives clearly on one side only.

The surviving decoration demonstrates that at one time the cross was highly decorated. It is one of the small but distinctive group in the Carnmenellis granite area bearing a simple geometric cross on the head and decoration of chevrons or zig-zags and other incised patterns on the shaft. The crosses in this group do duty as boundary stones and wayside crosses or (like this cross) marked chapel sites, but none is associated with a parish church.

Although Thomas suggested a pre-Norman date for all these crosses,[60] they are more likely to be post-Norman Conquest. This cross is probably twelfth century in date. The zig-zags suggest Romanesque work and the straight-armed cross on the head is similar to the Early Geometric crosses seen on medieval grave-covers elsewhere in Britain.[61] The horseshoe-like motifs on the shaft are likewise reminiscent of the emblems incised on medieval grave-slabs. Horseshoes would normally be taken to denote the grave of a blacksmith; here their meaning is uncertain.

In Camborne church is an altar stone, dating from the tenth or eleventh century, which might possibly have come from the same well-chapel site as the cross;[62] see also no. 42, the cross from Connor Downs, in the same churchyard. In addition there is a cross-head built into the east wall of the church and another in the church porch. Three further crosses are preserved in the town within walking distance of the church.

Fenton-Ia Cross in use as part of a well-head at Crane Farm in 1896. Image after Peter 1898, 76.

## References

Langdon, Arthur G. (1906), 445; Thomas, A.C. (1967), 68, 81, 88–90 and figs; Langdon, Andrew G. (1999), 15, no. 11 and fig.; Preston-Jones and Okasha (2013), 234–35 and figs (Camborne 4).

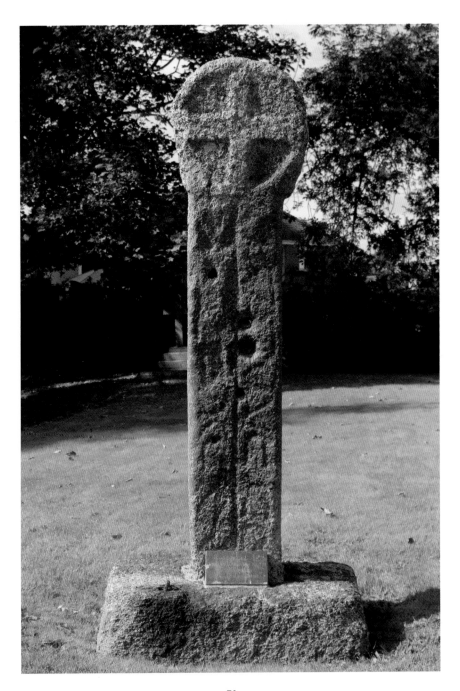

# 14. Camborne 2, Gwealavellan

SW 6022 4197; TR27 5EF

This cross stands beside the road to the east of Gwealavellan Farm. From the farm a footpath leads via Menadarva to Camborne church. There is full public access.

In 1998, the cross was first noticed lying beside the road by John Gould, although the farmer, a Mr Bawden, had known of it since 1966.[63] It had been in use as a gatepost and had been moved several times. In August 1999, the cross was erected in its present position.[64]

This fine granite wayside cross stands 1.78m (5ft 10in) high. It has a large compass-drawn wheel-head, with a rounded projection at the neck on one side only, the projection on the opposite side having been broken off. The head has a broad-armed cross carved in relief; it extends to the edges of the head and is expanded at the ends. The shaft is plain except for a narrow chamfer running down the sides of the shaft. Remains of holes used for previous gate-hangings are evident.

With its neatly cut and compass-drawn head, this wayside cross is rather more sophisticated than others in Cornwall, and this fact, along with its chamfers, may indicate a date from the thirteenth

Re-dedication of the cross by Camborne Old Cornwall Society in 2004.

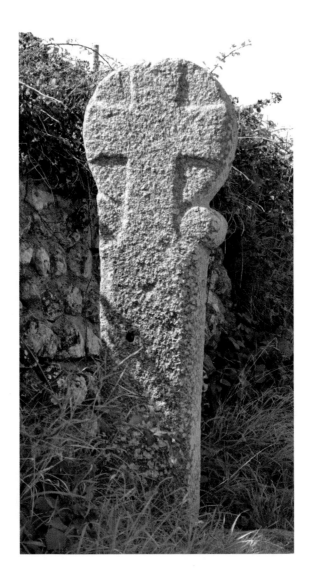

century. Its location, close to the site of the manor of Menadarva, suggests that it might have been in the mind of Sir Reginald de Mertherderwa when he left money in his will of 1447 for 'new crosses of stone' to 'be newly set up' in the parish.[65]

## References

Langdon, Andrew G. (1999), 18, no. 16 and fig.; Langdon, Andrew G. (2000), 18–19; Langdon, Andrew G. (2006a), 33.

# 15. Cardinham 1

SX 1230 6868; PL30 4BL

This fine cross stands in the churchyard of St Meubred's church, to the south of the church. There is full public access.

The cross-head was first recorded in 1858, built into the chancel wall of the church;[66] the shaft was also built into the church wall. In 1872, during the restoration of the church, both were removed, and by 1878 the complete cross was erected in its present location.[67]

Dominating the entrance to Cardinham church, this is one of the most impressive of Cornish crosses, standing 2.59m (8ft 6in) high. Although this almost-complete cross has the look of a monument that has been in place for hundreds of years, its present location and appearance are, as noted above, the product of nineteenth-century restoration. It is complete apart from a small section missing from the top of the shaft.

The cross-head has widely splayed cross-arms. A narrow roll-moulding encloses the decoration, which consists of linked triquetras in the cross arms and a small boss at the centre. On the shaft is a wider roll-moulding, within which all the carved decoration is deeply cut, although the inscription is shallower.

The decoration on the main (south) face is in three panels, of which the top panel contains an inscription, incised in three horizontal lines. The text is probably incomplete at the beginning where part of the shaft is lost. It reads [A]R[A]H + and is likely to have been a personal name, although of unknown origin. The middle panel contains an unusual although worn knot, while below this is a panel

of six-strand plait, separated by a space from a further knot, now hidden below ground level.

Moving around the cross anti-clockwise, the upper part of the narrow east side of the shaft contains a plait that merges lower down into a simple ring-twist. Langdon depicts a single Carrick bend on the cross arm,[68] but this is not now clear. The back (north) face of the cross has a fine spiral scroll, incomplete at the top where part of the shaft is lost and at the bottom where it is buried in the ground (see Introduction, Fig. 11). Finally, the fourth (narrow) side of the cross-shaft is filled by a simple T-shaped key pattern, with below it a striking example of the Borre or Manx ring-chain.

The use of the Manx ring-chain, a Viking-Age decorative motif, suggests a date from the tenth century.[69] The use of ring-knots and simple frets is also typical of work of this period. The tight spiral scroll bears some resemblance to that seen on Cumbrian crosses of the 'spiral-scroll school', which is also of Viking-period date.[70] The cross can thus be reasonably securely dated to the tenth century, perhaps the mid-tenth century, to allow for transmission of the ring-chain motif to Cornwall.

The Manx ring-chain indicates a place that, despite its relative seclusion on the edge of Bodmin Moor, was open to influence from artistic ideas current around the Irish Sea in the tenth century. Within Cornwall this cross was locally influential. Most notably, the spiral scroll

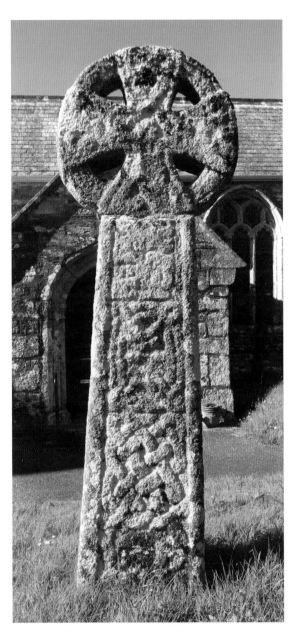

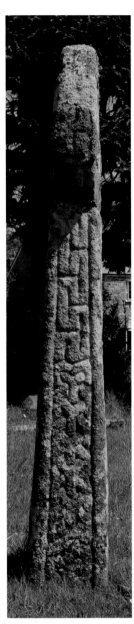

Main face of Cardinham 1, with inscription in the top panel of the shaft.

West side of the shaft, with T-shaped key pattern (above) and ring-chain (below).

(although not in such a tight form) is seen on various other monuments in the area, for example at Lanhydrock (no. 50) and Lanivet (no. 52).

The presence of such a prestigious monument at Cardinham is unexplained, although place-name, documentary and monumental evidence point to this as a site of both ecclesiastical and secular significance. There is no record of a religious community here, although an early Christian memorial stone of possibly sixth-century date provides evidence of the early origin of the site (see no. 16).[71] The early name of Cardinham church site is not known: Cardinham is the name of the castle whose earthwork remains survive in a field less than 0.7km (0.5 miles) to the south of the church. This latter was the centre of a major fiefdom established here after the Norman Conquest by Richard Fitz Turold, one of the chief landowners of Cornwall.[72] However, to the north of the church, the name of the farm of Trezance means the 'land of the saint',[73] which could refer to an ecclesiastical site at Trezance,[74] or to land that was formerly part of the endowment of the church. Either way, it implies the presence in the area of an early

Illustration by Arthur G. Langdon (1896, 354) showing the two parts of the cross, still built into the chancel wall, along with the cross-head, Cardinham 2.

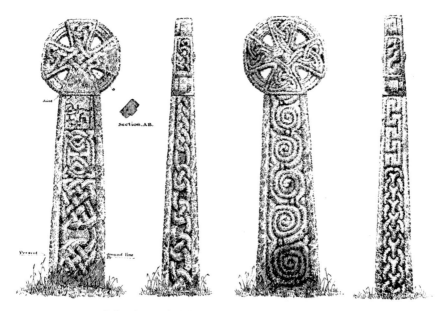

Arthur G. Langdon's (1896, 356) illustrations of Cardinham 1.

landowning ecclesiastical community
whose lands must have been lost before
the Norman Conquest, as there is no
record of the community in Domesday
Book. Thus the cross could be associated
either with an early religious community
at Cardinham church site or alternatively
with a secular patron who was a
predecessor of the powerful Norman
earls of Cardinham. Unfortunately, the
inscription is too worn to give a clue,
although it is likely to be a personal name
and possibly that of the patron.

## References

Langdon, Arthur G. (1896), 354–57 and figs;
Thomas, A.C. (1978), 78; Okasha (1993),
no. 8, pp. 85–87 and fig.; Langdon, Andrew G.
(1996c), 1 and fig.; Langdon, Andrew G. (2005),
28, no. 29, and fig.; Preston-Jones and Okasha
(2013), 131–32 and figs.

# 16. Cardinham 2

SX 1232 6869; PL30 4BL

The cross stands beside the south-east gate to St Meubred's churchyard, Cardinham. There is full public access.

Blight illustrated the cross-head along with Cardinham 1 in 1858, when they were built into the external wall of the chancel of the parish church.[75] When the church was restored in 1872, both cross-heads, along with the shaft of Cardinham 1, were removed from the chancel wall. When

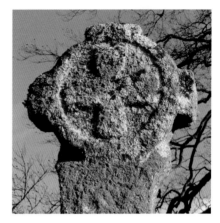

The cross-head sits on top of an earlier inscribed stone.

Very faint traces of an inscription on the north face of the inscribed shaft.

first seen by Langdon, this cross-head had been placed on the west side of the south porch and he considered it a gravestone.[76] In 1896, the cross-head was cemented on a tall shaft, which has an inscription carved down one face.[77]

The cross stands 3.1m (10ft 2in) high. The head is similar to the head of St Pratt's Cross at Blisland with rectangular projections on either side of the wheel-head and above it. Within a recess on the head is an equal-armed cross with slightly expanded ends. The cross-head when first seen by Langdon had a rectangular foot, which appears to have been an integral part of the monument, leading Langdon to assume it was a grave marker. When set up on the inscribed shaft, the rectangular foot below the cross-head was trimmed along with the

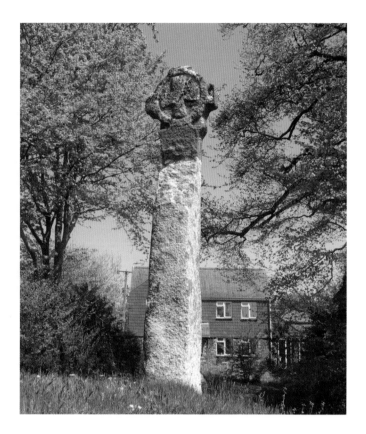

top of the shaft so they would fit together. Langdon recorded the inscribed shaft as being 3.24m (10ft 7in) in height with a further 1.2m (4ft) underground.[78]

If Langdon's description and illustration of the cross-head are correct, then this cross-head was a medieval grave marker, not a free-standing cross. It is probably of thirteenth-century date, although in style it is similar to earlier crosses in neighbouring Blisland parish, such as St Pratt's Cross (no. 4) and Peverell's Cross. The cross-shaft is in fact an inscribed pillar-stone and probably dates from the sixth to the eighth century. The inscription is on the face of the stone and reads downwards in one line. The letters are now very faint and only the last three, ORI, are really legible, with a possible N before them. It is likely to have been a personal name in the genitive, ending -NORI, indicating '(the stone) of'; however, the complete name is not now recoverable.[79]

## References

Langdon, Arthur G. (1896), 173 and 226 and fig.; Langdon, Arthur G. (1902), 51–52 and fig.; Okasha (1993), 88–90 and fig.; Langdon, Andrew G. (2005), 29, no. 30 and fig.

# 17. Cardinham 3, Treslea

SX 1305 6885; PL30 4DH

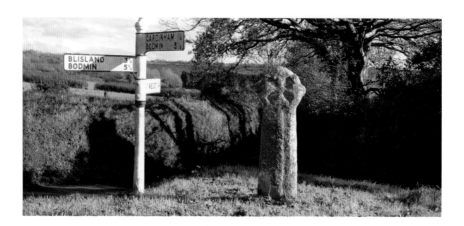

The Treslea cross stands on a grass island at a road junction just east of Cardinham churchyard. There is full public access.

The cross was first recorded in the 1613 Cardinham parish terrier as 'Wydeyeat Cross', marking the eastern boundary of the glebe.[80] In 1858, it was illustrated by Blight, who called it Treslay Cross and noted that it stood on a mound beside the road.[81] Langdon called the monument Treslea Cross, and considered that it had been previously used as a gatepost.[82] Nevertheless, the cross is supported in a base-stone, which appears to be in situ.

The wheel-headed cross stands 1.63m (5ft 4in) high. It has rectangular projections on the top and sides and displays a widely splayed cross in relief. An extension to the lower arm, albeit narrower, extends the full length of the shaft in relief. Both sides of the monument are similar. The edge of the shaft has a narrow chamfer, and the lower part is stained by the tar that was formerly painted on it.

This cross is one of four crosses that once marked the four sides of Cardinham glebe, although today only the north and east crosses survive. Poundstock Cross marked the north, Averies Cross the south, Peaches Cross the west and Wydeyeat or Treslea Cross the east. In 1613, a further four crosses were recorded also marking the parish boundary; these included Carminow Cross (see no. 5).[83] The projections on the top and sides of the cross are a local characteristic of both Cardinham and Blisland parishes (see also no. 4). The chamfered shaft suggests a date in the thirteenth century.

## References

Langdon, Arthur G. (1896), 174 and fig.;
Langdon, Andrew G. (2005), 32, no. 36 and fig.

# 18. St Cleer 1, Doniert Stone

SX 2361 6884; PL14 6RU

This inscribed cross-pedestal is set in a grassy enclosure, beside the unclassified road from Minions to Doublebois, about 1.5km (1 mile) north-west of St Cleer. It stands beside the Other Half Stone, St Cleer 2. There is full public access.

The monument was first recorded in 1600 in its present location.[84] Despite various vicissitudes over the centuries, the monument has remained in the same location. In around 1750, for example, Hals reported that some tin miners, looking for treasure, dug around the stone and found a 'Spacious vault'.[85] When the miners abandoned their attempt, earth fell into the pit and the monument fell over, where it lay until 1849 when it was re-erected.[86]

This stone stands 1.41m (4ft 8in) high and forms the pedestal section of a cross that would have been socketed together in sections. On three faces of the shaft, within a broad edge-moulding, are single panels with well-executed but simple knots; on the fourth face is an inscription. The shaft tapers upwards, and near the base, the lower, slightly rougher, part was presumably intended to be buried in the ground. The top of the stone contains

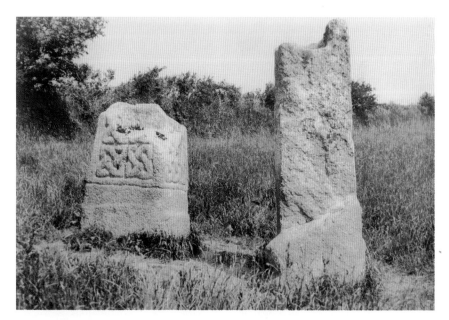

St Cleer 1 and 2 standing in an open field in 1936, before the present small enclosure was created. Photograph reproduced by permission of Liskeard Old Cornwall Society.

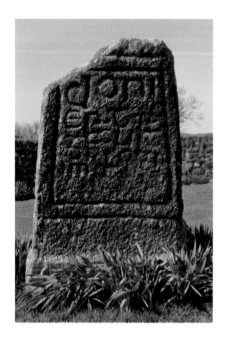
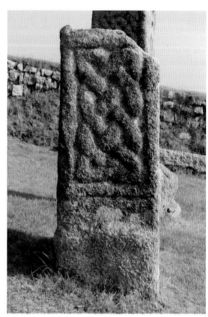
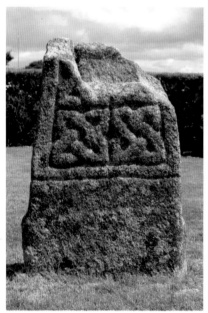
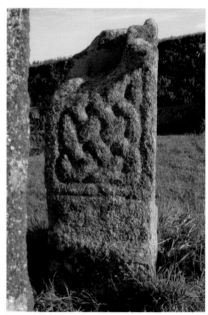

Inscription, interlace and knotwork on all four faces of St Cleer 1.

a rectangular socket, designed to take the tenon of a second section of cross-shaft. The monument is thus the bottom part of a composite cross, containing a socket into which further (now missing) sections would have been added. As such, it is comparable to composite monuments found in Wales, for example at Llantwit Major and Llandough in Carmarthenshire.[87] The monument is a member of the Cornish panelled interlace group of sculpture.

The front of the monument contains no decoration except for a text, incised in five lines inside a panel in a predominantly insular script. The text is complete and legible and reads DONIERT : ROGAVIT PRO A[N]IMA; 'Doniert requested for [his] soul'. What Doniert requested might have been prayers or might have referred to the actual monument. The form of the name 'Doniert' is a variant spelling of the Cornish/Welsh name 'Dungarth' or 'Dumnarth', and Doniert has often been identified as Dungarth, the last native king of Cornwall, who died in 875 or 876.[88] This identification is of course possible, perhaps even likely, but is not certain.

If the stone does commemorate Dungarth who died in 875 or 876, then this memorial is likely to have been set up fairly soon afterwards, in the late ninth century. However, other monuments with similar knotwork decoration are usually given slightly later dates in other parts of the country, so an early tenth-century date may be equally possible. Either way, the Doniert Stone is likely to be one of the earliest sculptured monuments in Cornwall.

Although the Doniert Stone and the Other Half Stone (St Cleer 2) appear to sit beside a quiet country lane in the middle of nowhere, the location is in fact remarkably well chosen. The stones are close to Liskeard, a *lys* ('court') and probable seat of Dungarth.[89] They also lie on routeways of some significance in the past, linking Launceston and Callington with Bodmin on the one hand and Liskeard to Camelford and the Tintagel area on the other.[90]

## References

Langdon, Arthur G. (1896), 377–79 and figs; Thomas, A.C. (1978), 76–79 and figs; Preston-Jones and Rose (1986), 159; Thomas, A.C. (1986), 67–68 and fig.; Okasha (1993), no. 43, 213–17 and fig.; Langdon, Andrew G. (1996c), 25; Langdon, Andrew G. (2005), 35, no. 41 and figs; Preston-Jones and Okasha (2013), 134–37 and figs.

# 19. St Cleer 2, Other Half Stone

SX 2361 6884; PL14 6RU

This uninscribed cross-shaft is set in a grassy enclosure, alongside the Doniert Stone (St Cleer 1) and beside the unclassified road from Minions to Doublebois, about 1.5km (1 mile) north-west of St Cleer. There is full public access.

The cross-shaft was first recorded in 1600 in its present location.[91] Despite various vicissitudes over the centuries,[92] the monument has remained in the same location.

This stone is part of the cross-shaft of an unfinished composite monument and stands 2.06m (6ft 9in) high. The shaft has been split in two from top to bottom, with the back entirely removed. The only part unaffected by this damage is the slightly bulging, uncut lower part of the stone, which would originally have been buried in the ground. Only a single panel of beautifully cut plaitwork survives, on the front of the stone, within a broad, flat edge-moulding. Below this is a single, uncarved panel defined by incised lines; this raises the question of whether the stone might be unfinished.

Like St Cleer 1, this cross-shaft is a member of the panelled interlace group of sculpture. Although the two monuments do not share the same patterns, they are comparable in the layout of the decoration in panels and in the use of only interlacing patterns. Exactly the same pattern to that of St Cleer 2 can be seen on the cross-shaft at St Neot (no. 73) and on a related monument at Copplestone in Devon.[93] Like other monuments in this panelled interlace group, notably its companion St Cleer 1, this may be among the earliest of

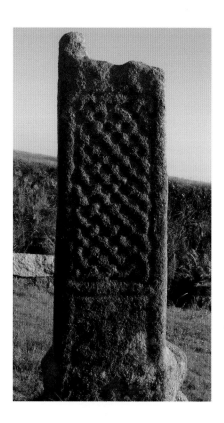

stone crosses in Cornwall, probably dating from the late ninth or early tenth century.

## References

Langdon, Arthur G. (1896), 377, 401–02 and figs; Thomas, A.C. (1978), 77; Thomas, A.C. (1986), 68 and fig.; Okasha (1993), 214 and fig.; Langdon, Andrew G. (1996c), 26; Langdon, Andrew G. (2005), 36, no. 42 and figs; Preston-Jones and Okasha (2013), 138–39 and figs.

# 20. St Cleer 3, Long Tom

SX 2554 7056; PL14 5LP

The Long Tom cross stands on Craddock Moor, on a high point close to the road from St Cleer to Minions village. There is full public access.

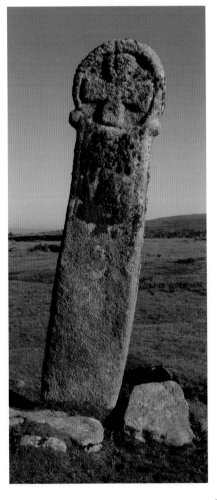

This monument's prominent position on the moor has caused it to be recorded by many travel writers and antiquarians. It was noted as 'the Longstone' by Cox in 1720,[94] and was first illustrated in the *Gentleman's Magazine* in February 1803.[95] Blight wrongly recorded the cross under Linkinhorne parish.[96]

This massive monument stands 2.9m (9ft 6in) high. Carved on its head is an equal-armed cross in relief, within a bead or roll-moulding. Directly below the cross-head at the neck of the monument are small projections that protrude from the shaft on either side. The shaft is plain except for an incised rectangle, cut on each side at the top of the shaft, just below the projections.

The cross is also known as the Longstone and the St Cleer Common Cross. Britton suggested that it may have been a 'pagan pillar' originally converted into a Christian symbol.[97] This could well be true as, unlike most Cornish crosses, the head of Long Tom does not extend beyond the full width of the shaft. The projections at the neck are a characteristic found on many Cornish crosses, especially in the parish of St Clether. The simple geometric cross on each side of the head suggests a post-Norman Conquest date, perhaps of the twelfth century.

## References

Langdon, Arthur G. (1896), 301–02 and fig.; Langdon, Andrew G. (2005), 37, no. 43 and fig.

# 21. St Cleer 4, Holy Well

SX 2495 6832; PL14 5DT

J.T. Blight's illustration of St Cleer holy well and cross, before restoration (1856, 95).

The cross stands adjacent to the St Cleer holy well, 150m (approx. 180yd) north-east of the parish church. There is full public access.

The cross stands 2.18m (7ft 2in) high. It was noted by Stockdale in 1824,[98] and illustrated beside the holy well in 1809 by Prout.[99] Along with the well, the cross was restored in 1864 by Henry Rogers of Penrose near Helston, in memory of his grandfather Rev. John Jope, vicar of St Cleer between 1776 and 1843.[100]

This monument, in the shape of a Latin cross, has another Latin cross carved in relief on both the front and reverse

faces of the head and shaft, following the outline of the monument, and formed by rebating the edge of the stone. Another cross with equal arms is carved in relief on both faces; its lower arm extends down the shaft to the base-stone, with two incised parallel lines, one on either side.

The cross is considered by Langdon to be in situ and supported by its original base-stone.[101] Similar examples of Latin crosses, with additional Latin crosses superimposed in relief upon them, can be seen at Triffle in St Germans, Tresmeer, and Trerank in Roche. The rebating of the edge of the stone may be considered similar to chamfering and could suggest a thirteenth-century date or a little later. However the adjacent well-house is of fifteenth- or sixteenth-century date and it is also possible that the cross is contemporary with it. Part of a four-holed cross survives in the churchyard at St Cleer, within walking distance of the holy well.

## References

Langdon, Arthur G. (1896), 208–09 and fig.; Langdon, Andrew G. (2005), 34, no. 39 and fig.

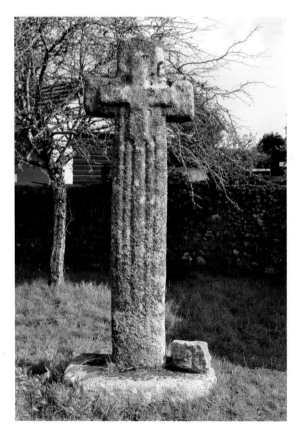

# 22. St Clement

SW 8509 4386; TR1 1SZ

The cross stands in St Clement churchyard near the south door of the church. There is full public access.

The cross was first recorded by Borlase in use as a gatepost at the vicarage.[102] In 1845, the then vicar, Rev. C.M. Gibson, had it moved to the rectory garden,[103] where it remained until 1938, when it was placed in its present position.

The monument is a large monolith standing 2.66m (8ft 9in) high. It is uncarved except for the top of the main face on which is cut a wheel-headed

The stone in 1847, when it was in use as a gatepost at the vicarage (Haslam 1847, 309).

cross. This is an equal-armed cross with narrow parallel arms enclosed by a bead or edge-moulding. Beneath this, filling all the cross-shaft, is incised a legible and complete inscription, reading vertically downwards in one line in a predominantly capital script.

The text reads IGNIOC VITALI FILI TORRICI, 'Ignioc. [The stone] of Vitalus, son of Torricus'. Torricus is a Celtic name and the -oc of Ignioc suggests that it might be so also. The name Ignioc seems separate from the rest of the text in that the script is smaller and is not all in capitals; moreover, the name does not fit well with the rest of the inscription. It is possible that it was a later addition.

Given its great height, it may be that this monument originated as a prehistoric standing stone. The granite of which it is cut has been brought some 10 miles from the St Austell granite area. The inscription is the earliest evidence for the early origin of the St Clement church site, whose estuarine location is very similar to that of many other early Christian sites in Cornwall. It seems likely that the monument was originally an inscribed pillar-stone of the sixth to the eighth century, to which the second name may have been added at a later date. Later still, in Norman times, the stone was re-formed into a cross.

## References

Langdon, Arthur G. (1896), 6, 22; Okasha (1993), 224–28 and fig.; Thomas, A.C. (1994), 245, 270, 297 and figs; Langdon, Andrew G. (2002), 24, no. 12 and fig.

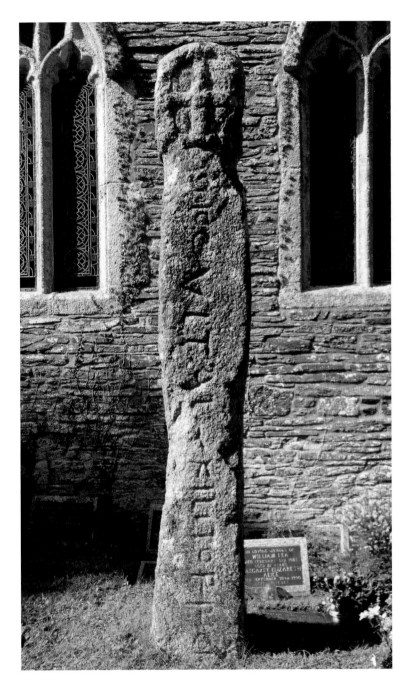

# 23. St Clether, Cross Gates

SX 1889 8400; PL15 8PX

The Cross Gates Cross standing beside a quiet crossroads in St Clether parish.

The cross stands at a crossroads, a mile west of Basil Farm. There is full public access.

The cross is probably one of the four granite crosses on the Barton of Basil noted by Polsue in 1867,[104] although the first detailed record of it was by Langdon in 1896.[105] Langdon noted that it was built into a hedge at a crossroads known as Cross Gates. There it remained in situ until it was hit by a lorry in June 2004.[106] The cross was repaired and repositioned on the opposite side of the crossroads in 2005.[107]

The cross stands 2.24m (7ft 4in) high. It has a large wheel-head with an equal-armed cross in very low relief on each face. There is a narrow bead or roll-moulding around the edge of the head, which has small projections at the

The Cross Gates Cross, illustrated by Arthur G. Langdon (1896, 158). At this time, only the top half of the cross was visible, the remainder being buried in the hedge.

neck. The simple geometric cross on each face suggests a post-Norman Conquest date, probably of the twelfth century.

The name Cross Gates suggests that there were once gates across the road here, dividing the enclosed farmland from the moorland. When the cross was broken in 2004, it was found to have been much taller than it originally appeared when the hedge was around it. The lower portion of the shaft had to be excavated from the centre of the hedge, and was found to be deeply buried and still set in its original base-stone of local slate. The two parts of the shaft were pinned together, with external stainless steel brackets fixed across the joint for additional stability and safety.

See also the parish page.

---

## References

Langdon, Arthur G. 1896), 158 and fig.; Langdon, Andrew G. (1996b), 25, no. 22 and fig.; Langdon, Andrew G. (2006a), 33–39 and fig.; Preston-Jones (2007), 1–29 and figs.

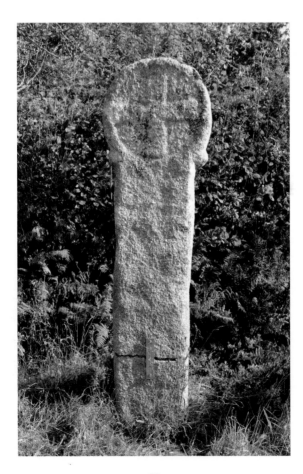

# 24. St Columb Major

SW 9132 6368; TR9 6AE

The cross-head stands in the churchyard of St Columb's church, to the east of the church. There is full public access.

The cross-head was first mentioned in 1853, in its present location.[108]

Only the cross-head and a small part of the shaft, together 0.95m (3ft 2in) high, survive of this once fine four-holed cross. It is carved from a thin slab of greisen (an unusual rock, an altered granite). The wide splayed arms are linked by a narrow ring and in the space between the arms and ring are three cusps, forming trefoil-shaped openings. The shaft is plain and all decoration on the head is in very low relief.

At the centre of the head on both front and back is a large, flat boss, possibly containing a small central hole, surrounded by a concentric, flat-moulded band. At the end of each cross-arm are two flat bands. Between these bands and the central boss, in each of the cross-arms except one, there is a triquetra knot. The left cross-arm on one face contains two linked Stafford knots set back to back.

This monument is one of the small but dispersed group of crosses in Mid- and East Cornwall, characterized primarily by the trefoil openings in the head, and dating from the late tenth to eleventh century. Other characteristic features of the group include the large boss and the widely splayed arms with triquetra knots. In crosses of this type where the shaft survives, the decoration normally includes foliage scrolls or trails, and interlace.

The wide-splayed arms indicate a late pre-Norman Conquest date, but since only the head survives it is impossible to be more precise than the eleventh century. The cross is the earliest known dating evidence for the church-site where, to

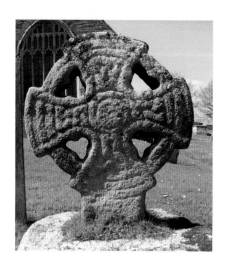

The west face and the side of the St Columb cross, showing the very narrow cross-section.

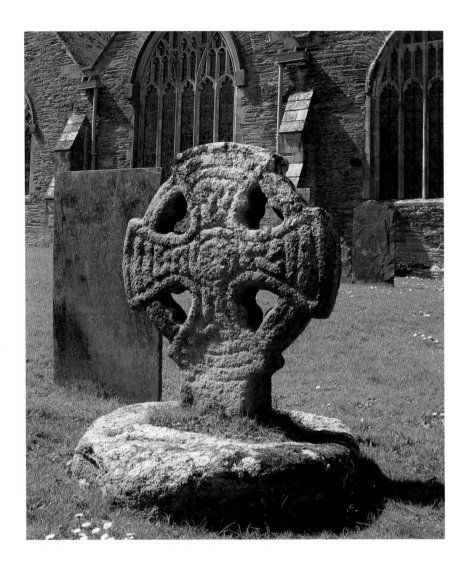

judge from the size of the head, it must have been an impressive feature. At 0.84m (2ft 9in) across, the cross-head is similar in size to those of the cross at Prideaux Place, Padstow (no. 77) and the Four Hole Cross (no. 74), and so may have been of comparable scale, perhaps originally over 3m (approx. 9ft) high.

See also an inscribed cross-slab on the south side of the churchyard.

## References

Langdon, Arthur G. (1896), 395–96 and fig.;
Langdon, Andrew G. (2002), 26, no. 16 and fig.;
Preston-Jones and Okasha (2013), 140–41 and figs.

# 25. Constantine 1, Trewardreva

SW 7296 3040; TR11 5QD

The cross stands in a hedge beside a minor road near Trewardreva Mill, about 1.5km (1 mile) north of Constantine. There is full public access.

The cross was first recorded in 1896 by Langdon. He stated that he had been fortunate to meet a man who, with his father, had re-erected the cross in around 1865 after it had lain on the ground for many years. No base-stone was found, but Langdon considered the cross to be close to its original site.[109]

This large wheel-headed cross stands 2.16m (7ft 1in) high. It is decorated with incised crosses on both faces, with additional incised lines and crosses on the shaft. On the front, within a bead formed by an incised circle, is an equal-armed incised cross, inclined to the left. Below this on the shaft is an incised rectangular panel, which forms a bead or moulding down the top half of the shaft. Within this rectangle is a saltire (a St Andrew's cross), and below that a Latin cross. On the reverse side of the monument is incised a star-like cross with six arms, the lower two arms joined by a horizontal line to form a triangle. Three irregular parallel incised lines extend a short distance down the shaft. The simple wheel-head with incised cross suggests a post-Norman Conquest date, probably of the twelfth to thirteenth century.

Although the monument's original position is uncertain, it may always have stood near where it is now. The minor road from Treverva to Brill, beside which the cross stands, is intersected by a bridleway from Constantine, which continues as a footpath north to Edgcumbe, while another footpath from the west also meets at the cross. The cross is similar to another in the area and on the same road, at Helland (no. 63), and also to the cross at Predannack in Mullion (no. 71).

## References

Langdon, Arthur G. (1896), 281–82; Langdon, Andrew G. (1999), 24, no. 27 and fig.

# 26. Constantine 2, Trevease

SW 7209 3151; TR11 5QU

The cross stands beside a public footpath between Little Trevease and Treculliacks on the south side of Trevease Farm, 2.7km (1.7 miles) north of Constantine churchtown. There is full public access.

The Trevease cross was first recorded in 1896 by Langdon; it stood in a rough circular base and Langdon considered it to be in situ.[110] Henderson noted that it stands in a valley where an old church path crossed the ford.[111]

This wheel-headed cross stands 1.52m (5ft) high. On one face it contains a crucifixion carved in relief. The figure's arms are outstretched and the legs are together. A narrow bead or roll-moulding around the head of the monument encloses the crucifix figure, who stands on a patriarchal cross in relief that extends down the shaft of the cross. On the reverse face, a broad-armed Latin cross is carved in relief, its lower arm extending three-quarters of the way down the shaft, while the top of the cross is enclosed by a bead or roll-moulding.

This is the only monument in Cornwall that depicts a patriarchal cross; this is similar to a Latin cross but with a second horizontal arm. The Trevease cross is similar to no. 68 St Michael's Mount, a cross that contains a crucifix figure directly above a Latin cross and is dated to the twelfth century. The Trevease cross is likely to be of a similar date.

---

## References

Langdon, Arthur G. (1896), 147–48 and fig.;
Langdon, Andrew G. (1999), 23, no. 26 and fig.

# 27. Cury

SW 6777 2126; TR12 7BW

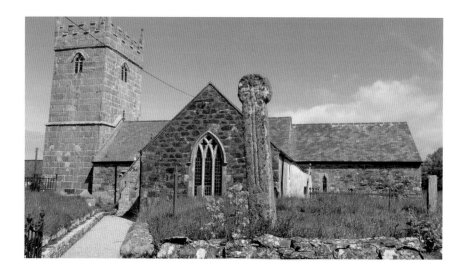

The cross stands on the south side of Cury churchyard. There is full public access.

The cross was first recorded and illustrated by Blight in 1856, who noted that it was 9ft tall.[112] Langdon gave a full account of its discovery. He stated that the cross was found, with its base-stone beside it, lying in a ditch within the boundary hedge of the churchyard.[113] On 16 May 1849, the cross was placed in its present position in the presence of Rev. William Broadley, vicar of Cury, J.D. Enys and others.[114]

The cross stands 2.58m (8ft 6in) high. It is wheel-headed and has an incised equal-armed cross carved on its front face. An extended lower arm, consisting of parallel incised lines and terminating in a triangular end, runs down two-thirds of the shaft. The back of the cross is uncarved.

Although the cross is not actually in situ, Langdon considered it to be close to its original position. It is a post-Norman Conquest churchyard cross, and the lower extension to the carved cross can be closely associated with the style of decoration on thirteenth-century grave-slabs: these often depict a foliated cross with a long lower arm or stem terminating in a Calvary or stepped base. The triangular termination on this cross is likely to be a simplified version of a Calvary base, suggesting that the cross is probably thirteenth century in date.

## References

Langdon, Arthur G. (1896), 267–68 and fig.;
Langdon, Andrew G. (1999), 28, no. 34 and fig.

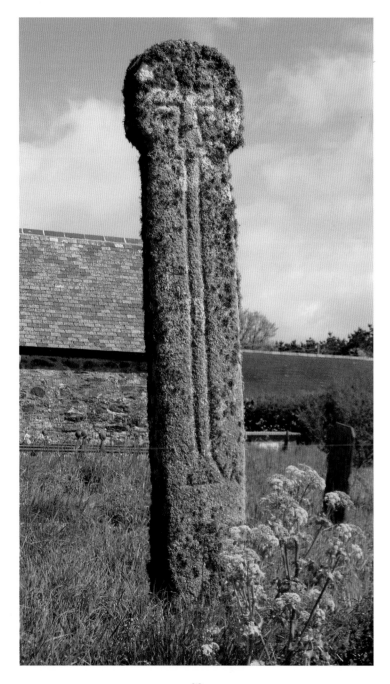

# 28. St Dennis

SW 9507 5829; PL26 8BA

The cross stands in the churchyard of
St Denys's church, beside the porch. There
is full public access.

The cross was first mentioned in 1858
in its present location.[115]

The cross stands 2m (6ft 6in) high.
It has an oval or horseshoe-shaped head
above a flat band or collar and there are
incised edge-mouldings on all faces.
The front and back contain Latin crosses
incised in outline on the cross-head.
The shaft is decorated with large incised
chalice- or hourglass-like motifs on both
the front and the back, and with smaller
ones on one narrow side. The simple
round granite base into which the cross is
socketed is believed to be original.

This is an unusual monument. Latin
crosses incised in outline are very rare in
Cornwall, while the collar is unique and
the decoration is unparalleled. The origin
of the hourglass motif is uncertain. The
only other example that is anything like it
in Cornwall is on the incised cross from
Nine Maidens Down,[116] a member of the
distinctive Carnmenellis area group. On
the latter cross, the 'hourglass' is teamed
with a wafer, so probably represents a
communion chalice.[117] Here at St Dennis,
their profusion is less easy to explain.
The decoration may suggest a date in
the twelfth century, though this is far
from certain.

St Dennis church is dedicated to
St Denys of Paris, a dedication first
recorded in the fourteenth century.
The dedication appears to have arisen
from a misinterpretation of an original
place-name in *dinas*, hill fort,[118] since the

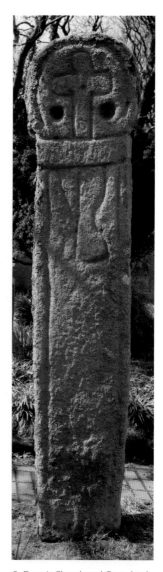

St Dennis Churchyard Cross, back.

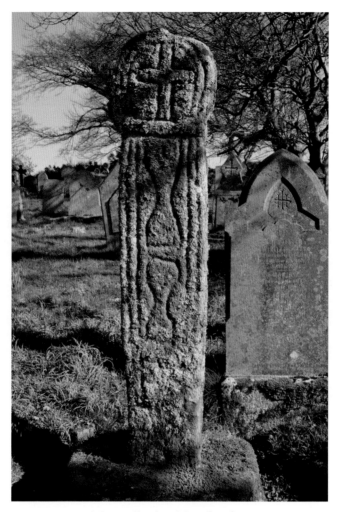

St Dennis Churchyard Cross, front face.

church is located on a hilltop overlooking Goss Moor, within a large churchyard with a circular rampart-like enclosing wall. There is no reason to suppose that this probable Iron Age fort was reused as a religious enclosure at an early date: the cross and the Norman font are the earliest tangible evidence for a Christian use.

## References

Langdon, Arthur G. (1896), 293–95 and figs; Thomas, A.C. (1965), 31–35; Langdon, Andrew G. (2002), 33, no. 28 and fig.; Preston-Jones and Okasha (2013), 235–36 and figs.

# 29. Egloshayle 1, Pencarrow

SX 0404 7094; PL30 3AG

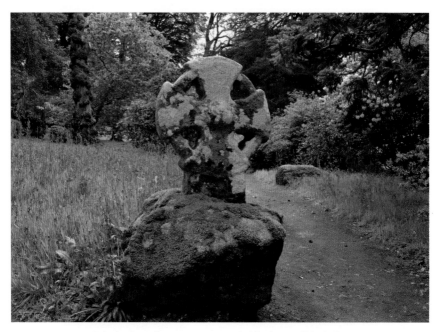

Egloshayle 1 in late spring, surrounded by sheets of bluebells.

The cross-head stands in the grounds of Pencarrow House, to the south-east of the house, at a fork in a wooded pathway. There is limited public access with an entrance fee.

The cross-head was found in around 1870 in a hedge at Trescowe and was then moved to its present location.[119]

The monument stands 1.1m (3ft 7in) high. Only the massive ring-head and part of the shaft survive of this cross. The ring-head has trefoil-shaped openings in the space between the arms, an incised moulding around the edge of the arms and a large central boss on each side. Otherwise the cross is undecorated.

This cross is one of the small but dispersed group of crosses dating from the mid-tenth to the eleventh century found in Mid- and East Cornwall with trefoil-shaped openings in the head. Other characteristic features of the group include the large boss, the widely splayed arms and the narrow cross-section. It is also linked to others in the group in being carved of greisen (an altered granite), also used for the crosses at Padstow (no. 75) and St Columb Major (no. 24). However, this is the only example

in the group that contains little decoration. It is also the largest, suggesting that originally the monument must have been extremely impressive, perhaps between 3m and 4m (10–13ft) high.

A shaft at Trescowe, noted by Langdon but now possibly lost, may have belonged to this cross.[120] This cross-head, having been found built into a hedge at Trescowe (possibly part of the pale of the old deer park associated with Pencarrow), is the only one of the trefoil-headed group that is not in an ecclesiastical setting. At Trescowe, however, it would have been close to the parish boundary between Egloshayle and St Mabyn, and might also have stood close to the road from Bodmin to Camelford around the north-west edge of Bodmin Moor. It could therefore have originally acted as a wayside cross and parish boundary marker. It might also have had some significance in relation to St Petroc's monastery at Bodmin, less than 6km (4 miles) distant, perhaps marking the approach to lands owned and controlled by the monastery. A similar suggestion has been made for the later medieval cross with a fleur-de-lys emblem on its head at nearby Washaway (no. 31).[121]

## References

Langdon, Arthur G. (1896), 194–96 and fig.; Langdon, Andrew G. (1996b), 31, no. 33 and fig.; Preston-Jones and Okasha (2013), 141–42 and figs.

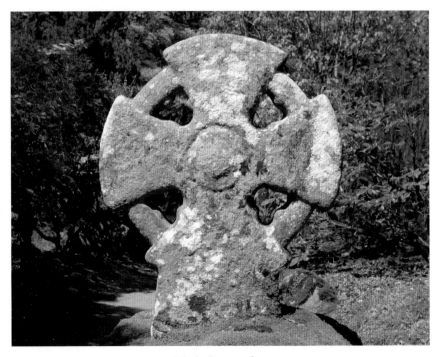

Egloshayle 1, main face.

# 30. Egloshayle 2, Three Hole Cross

SX 0117 7366; PL27 6EL

The Three Hole Cross stands on the grass-covered triangle at the junction of the A39 and a minor road from Chapel Amble to Pencarrow, 2.4km (about 1.5 miles) north-east of Wadebridge. There is full public access.

The cross was first recorded in 1867 'on the road leading to Camelford, at a place called Three-hole-cross'.[122] In 1871 it was thrown down and broken,[123] but by 1873 it had been 're-erected, as nearly as possible in its original position'.[124] In October 1937, the stone was moved owing to road widening and, after some vicissitudes, was re-erected in January 1939 in its present location, '65 feet west-north-west from its position of 1871'.[125]

The cross, which is set into a modern base, stands 1.73m (5ft 8in) high. It has a plain round head pierced by three holes, with a projecting roll-moulding at the neck. One side of the shaft is not straight, which might be owing to later damage.[126] Langdon described the cross as 'a most quaint and irregularly executed monument'.[127] The narrow sides are undecorated, but the two broad faces of the head both contain a St Andrew's Cross indicated, but not actually carved, by piercing three elliptical holes through the head at the top and sides; at the bottom of the head the hole, which is slightly off centre, is not completely cut through. Just off the centre of the head on each face is a small low boss. In addition, one broad face contains a small panel of incised holes in five irregular lines.

With its three-holed round head, St Andrew's Cross, roll-mouldings at

the neck, and irregular dot decoration on the shaft, this cross is remarkably similar to St Piran's Cross (no. 83). It is, however, much smaller and more crudely executed. It may be a copy of St Piran's Cross, although the distance of some 30km (20 miles) from Egloshayle to Perranzabuloe is difficult to explain. Its decoration suggests that it dates from the late eleventh or twelfth century.

The cross is located on an important route from Wadebridge to Camelford around the north side of Bodmin Moor and is close to the boundary between the parishes of Egloshayle and St Kew, so it may have done duty as a boundary marker as well as a wayside cross.

## References

Langdon, Arthur G. (1896), 180 and fig.; Langdon, Andrew G. (1996b), 30, no. 32 and fig.; Langdon, Andrew G. (1996c), 17; Preston-Jones and Okasha (2013), 236–37 and figs.

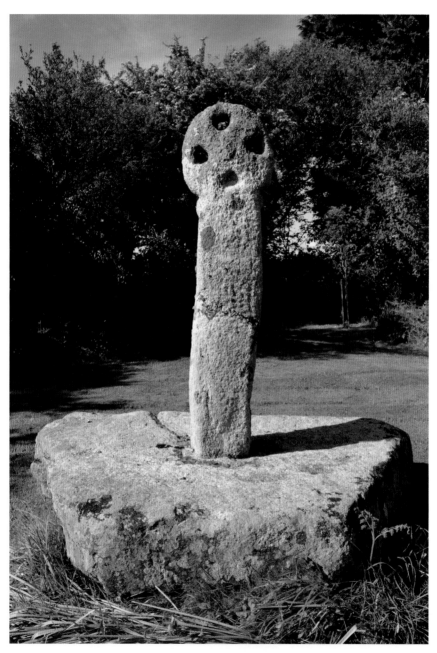

Three Hole Cross: main face, with remnants of dot decoration visible in the middle of the shaft.

# 31. Egloshayle 3, The Prior's Cross

SX 0376 6976; PL30 3AD

The cross is situated close to the A389 from Wadebridge to Bodmin in the village of Washaway. There is full public access.

In 1736, Hals mentioned a moorstone cross called the Prior's Cross, near Mount Charles.[128] Quoting Hals in 1838, Gilbert stated that this land was once under the jurisdiction of Bodmin Priory.[129] Blight was the first to illustrate the cross in 1858, and he showed the cross-head built into the foot of a hedge by the roadside at Washaway,[130] apparently where Langdon described it, against the garden hedge of the Washaway Inn.[131] In 1935 the cross-head was set up on a modern shaft of suitable proportions by Sir Hugh Molesworth St Aubyn of Pencarrow and H.C. Babbington of Croan.[132]

The cross stands 3.24m (10ft 7in) high, but only the cross-head is original. It does not have the usual symbol of a cross upon it, but on both faces there is carved a fleur-de-lys in relief enclosed in a narrow bead.

The cross is located at a point where a minor road from St Mabyn and St Kew meets the main Wadebridge to Bodmin highway. Maclean conjectured that the fleur-de-lys on this cross may have marked land of the Priory of Bodmin, as the priory was dedicated to St Petrock and the Blessed Virgin Mary, the fleur-de-lys being a symbol of Mary.[133] Another cross, from Penwine at Longstone in St Mabyn parish, also has a fleur-de-lys and may have marked the northern limit of the priory. The fleur-de-lys symbol was popular for decorating medieval grave-slabs during the thirteenth century, and this cross is probably of a similar date.

## References

Langdon, Arthur G. (1896), 337–38 and fig.;
Langdon, Andrew G. (1996b), 30, no. 31 and fig.

The cross-head before it was set up on its present shaft (Langdon, Arthur G., 1896, 337).

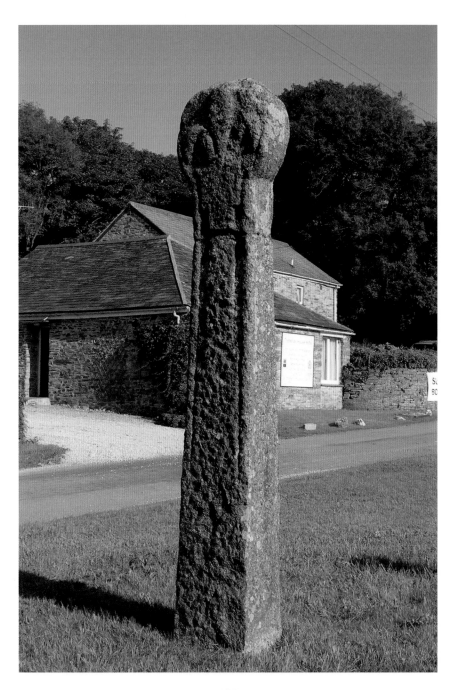

# 32. St Endellion, Long Cross

SW 9900 7972; PL29 3TF

The Long Cross on the right, with finger post and eighteenth-century guidepost to the left.

The Long Cross stands on a piece of grass at the road junction where a track to Roscarrock leaves the road from Portquin to St Endellion, about 1.5km (1 mile) from St Endellion. There is full public access.

The cross was first certainly recorded in 1821, in its present position, in the diary of J.A. Trevan, at which time it had been 'thrown down and broken'.[134] In 1873, Maclean noted that the stone had been moved to Doyden Head, near Portquin.[135] It remained there until 1932, when it was returned to its present location.[136]

Although it is known as the Long Cross, this monument is a simple monolith of granite carved with

inscriptions, a chi-rho and (on the reverse) a simple, rough and barely visible relief-carved cross. It stands 1.49m (4ft 11in) high. It has been broken but mended and is now cemented into a circular base. On the face of the monument is a large incised chi-rho, 33 cm (13 in) in height, set on top of the arc of a circle that encloses the top of the inscription. The inscription is incised in two lines reading downwards. The letters appear to be largely in capitals, but the text is highly weathered and may not be complete. The first line could be read as BR[..]ACNI IH/C/ IAC/IT, '[the body] of Br..acnus lies here' with IHC for HIC. In 1895, Langdon and Allen read the text

as BROCAGNI IHC IACIT NADOTTI FILIVS, where the last two words are on the second line; however, the accompanying drawing suggests that their reading of the second line was largely conjectural.[137] If the name were Brocagnus, this would be a Celtic name. The use of the chi-rho suggests that the date of the inscription, and hence the monument, is likely to be from the sixth to the eighth century.

On the back of the pillar, near the top, are the very eroded traces of a relief-carved equal-armed cross. This cross can be compared with those on the cross at St Clement (no. 22) and on the Tristan Stone, Fowey (no. 37). In each case the cross almost certainly represents reuse of the early memorial stone as a wayside cross after the Norman Conquest. In the top of the St Endellion monument is a small socket, perhaps resulting from the stone's one-time use as a gatepost.[138]

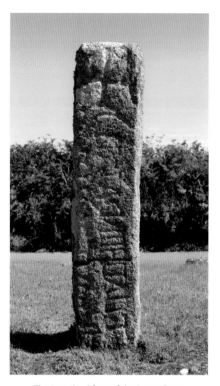

The inscribed face of the Long Cross.

On the reverse are very faint traces
of a relief-carved cross.

Close to the stone is a wooden finger-post of twentieth-century origin and an eighteenth-century granite direction post, bearing the names of Port Isaac, Padstow, Roscarrock and Port Quin. These show that the road junction here, though on quiet country lanes, was formerly of greater significance than it now appears.

## References

Langdon, Arthur G. and Allen (1895), 51, 58, 59 and figs; Okasha (1993), 232–35 and fig.; Thomas, A.C. (1994), 263–64 and fig., 293–5 and fig., 307; Langdon, Andrew G. (1996b), 32, no. 35 and figs.

# 33. St Erth 1

SW 5497 3502; TR27 6HP

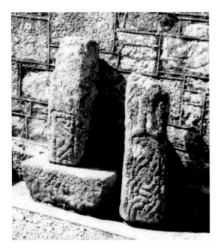

St Erth 1 cross fragments in the churchyard, before they were moved into the church in 1998. Photograph by the late Mary Henderson (Andrew Langdon collection).

is undecorated and tapers to a rounded end, which was presumably inserted into a socket or directly into the ground.

On the cross-head is a badly worn and mutilated figure of Christ. The head and ends of the arms are missing. The figure stands on top of a single panel of double-strand interlace on the shaft. The decoration on all other sides of the shaft is either worn, mutilated or hidden, but on the right (east) side are the remains of a diagonal key pattern.

The cross stands inside St Erth's church, fastened to the north-west wall of the south aisle. There is full public access.

The cross was recorded in 1888 in the churchyard,[139] having been removed from a wall of the church in 1875 during renovations.[140] It remained in the churchyard until 1998 when it was erected in its present location.[141]

The cross now stands 1.74m (5ft 8in) high. It consists of two pieces of a relatively small cross-shaft along with part of the cross-head. The cross-head has been trimmed to roughly the same width as the shaft and the top broken off, presumably to make it suitable for reuse as building stone. The bottom of the shaft

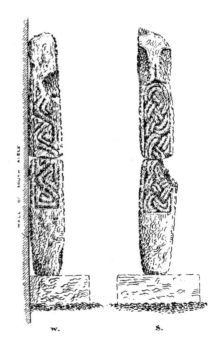

Drawings of the cross fragments by Arthur G. Langdon (1896, 402).

This cross is a member of the Penwith group of pre-Norman sculpture, characterized by a crucifixion on one side of the ring-head and five bosses on the other, and dating from the mid-tenth to the eleventh century. No bosses survive on this mutilated monument, but it has decorative features in common with other members of the group. For example, the key pattern is also seen on Sancreed 1 (no. 87) and the double-strand interlace appears on the Lanherne Cross (no. 43). It is a small monument, of comparable size to the Lanherne Cross, and like it may perhaps have been a personal memorial.

St Erth is a site of early medieval origin with a place-name in *lann*, a dedication to a Celtic saint (of possibly Irish origin),[142] and a curvilinear churchyard located in a valley bottom at the lowest crossing point on the River Hayle, before it broadens to an estuary.[143] However, the two early crosses here are the only tangible remains of the pre-Norman period.

There is also another cross, the Battery Mill cross, on the north-west side of the churchyard.

## References

Langdon, Arthur G. (1896), 402–03 and figs; Langdon, Andrew G. (1996c), 26; Preston-Jones and Langdon, Andrew G. (1998) and figs; Langdon, Andrew G. (1999), 30, no. 37 and figs; Preston-Jones and Okasha (2013), 142–43 and figs.

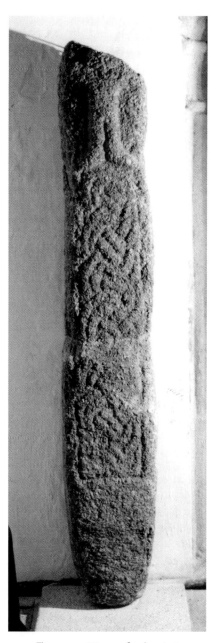

The cross as it is now, fixed against the wall of the church.

# 34. St Erth 2

SW 5499 3501; TR27 6HP

The cross-head in its base-stone is fastened to a wall in the churchyard of St Erth's church, to the south of the church. There is full public access.

This cross-head is probably the cross recorded in 1838 'In the churchyard',[144] but it was first certainly recorded in 1856, in its present location.[145] At some time between 1896 and 1953, the cross-head was taken down, rotated and reinserted in the same place but facing the other way.[146]

Only the worn cross-head, standing 0.61m (2ft) high, survives. On the main face is a truncated and ill-proportioned figure of Christ, without a halo. He has an unusually thick neck, which curves outwards to the arms. The horizontal arms reach right to the edge of the cross-head, where a slight broadening of the arms at the ends may represent the sleeves of a tunic. A very slight depression at the waist may represent the top of a loincloth or a belt. On the back are five very large bosses.

With a characteristic crucifixion on one side of the head and five bosses on the other, this cross-head belongs to the Penwith group of pre-Norman sculpture dating from the mid-tenth to the eleventh century. It is too large to have belonged to St Erth 1, the shaft in the church. These two pieces of early sculpture may suggest that St Erth was of some importance in the pre-Norman period, but there is no record of a religious house here before the Norman Conquest.

## References

Langdon, Arthur G. (1896), 191–92 and figs;
Langdon, Andrew G. (1999), 29, no. 36 and figs;
Preston-Jones and Okasha (2013), 144 and figs.

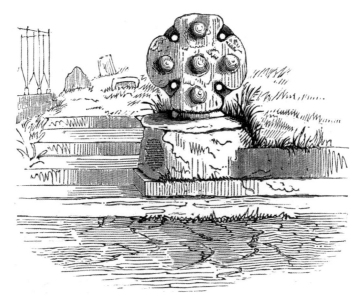

This etching by J.T. Blight (1856, 24) shows the cross on the churchyard wall. At this time it was facing in a different direction from now.

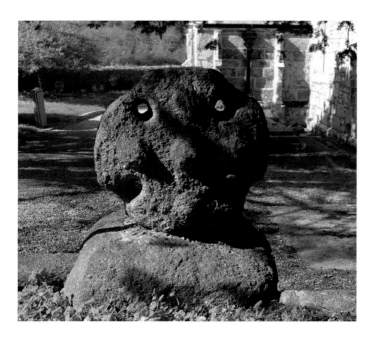

# 35. St Ewe, Lanhadron

SW 9894 4783; PL26 6HB

The cross-base is in a hedgerow on Nunnery Hill, Lanhadron Farm, on the right (east) side of the unclassified road from St Ewe to Polgooth. There is full public access. The cross-shaft is now lost.

The cross was probably first recorded in 1803 in its present location when base and shaft both still existed.[147] By 1880, only the base remained, buried in its present location;[148] it was probably unburied by 1895.[149] An eighteenth-century manuscript in the British Library contains a drawing of the cross-base and, beside it, a drawing of a vertical column containing lettering; this was presumably the text from the shaft.[150]

The roughly square cross-base measures 1.16m (3ft 10in). Only the upper face of the stone is now visible and it contains a rectangular socket-hole sunk halfway through the thickness of the stone. Incised between the edge of the stone and the socket are two parallel lines, 13cm (5in) apart, forming a frame for the inscription. There is no further decoration. The letters measure 6–7cm (2.5in) in height and are set anti-clockwise around the stone in four lines, the letters facing outwards. The text may be complete, but it is now too highly deteriorated for this to be sure. The script used was probably predominantly insular. The text reads [LU. . . .E-] [CR]VCEM [+-], the only legible word being apparently *crucem*, 'cross'. The eighteenth-century drawing mentioned above shows what was probably the text on the lost cross-shaft. This text appears to have ended FMIANCINOINOMINE+. The last word might have been *nomine*, 'in the name',

but the rest is not now interpretable. Regrettably, the inscription is of no help in dating the monument, other than in a general attribution to the pre-Norman period. As the stone is presumably the base of a cross, and since the earliest Cornish crosses fall between the late ninth and eleventh centuries, with most in the tenth and eleventh centuries, this is the suggested date range for the stone.

As an inscribed cross-base this stone is unique in Cornwall, although it can be compared to the Doniert Stone (no. 18). The shaft with vertically set inscription that accompanied the St Ewe base has a parallel, however, in Lanteglos by Camelford 1 (no. 56), although the inscription on the latter is in Middle English, not Latin. Cross-shafts with

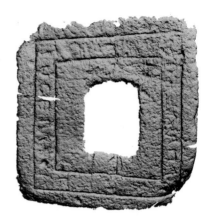

Laser scan of the Lanhadron cross-base by Orla Murphy of University College, Cork, and Thierry Daubos, reproduced with permission.

vertically set inscriptions of this general period can be paralleled in Wales but not in other parts of England, presumably because this vertical layout reflects that of the earlier inscribed memorial stones of Cornwall and Wales.

The base, which represents the place where the cross once stood, is now beside a quiet minor road. There is no obvious explanation for its position, though it was presumably a wayside memorial and it is on a boundary between farms.

## References

Langdon, Arthur G. and Allen (1895), 51, 57, 60; Langdon, Arthur G. (1906), 412, 420 and fig.; Okasha (1993), no. 19, pp. 129–32 and figs; Langdon, Andrew G. (2002), 37, no. 34 and figs; Preston-Jones and Okasha (2013), 145–46 and figs.

The cross-base in the late nineteenth century, by William Iago (1878–81, 398) (picture reproduced courtesy of the Courtney Library of the Royal Institution of Cornwall).

# 36. Feock

SW 8248 3841; TR3 6SA

The cross stands on the south side of St Feock's parish churchyard. There is full public access.

This cross was first noted by Penaluna in 1838.[151] He stated that the cross was rudely sculptured with ornament, while in 1868 Polsue noted that it had a crowned

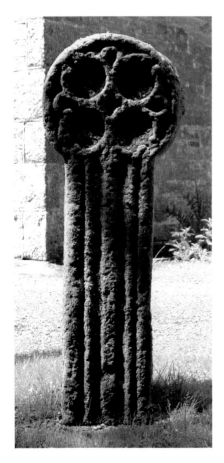

figure and a cross flory.[152] Blight was the first to illustrate both faces of the cross, in 1858.[153]

The cross is wheel-headed and stands 1.22m (4ft) high. It is carved from a fine grey elvan stone and displays a crowned figure of Christ on its front face. The arms are outstretched and raised, while the legs are together and merge into bead or roll-mouldings running in parallel down the shaft. The figure is also enclosed by a bead or roll-moulding, which runs around the top of the head and down both sides of the shaft. The reverse face has a similar roll-moulding, enclosing a bracelet cross, the lower arm of which extends down the full length of the shaft.

Feock is one of the few wheel-headed crosses that can be quite closely dated. It is the only wheel-headed cross to have a crowned figure of Christ and, according to Ó Floinn, crowned figures of Christ are rarely seen before 1100 and are not common after 1200.[154] The bracelet cross on the reverse face is a style commonly found on medieval grave-slabs: three grave-slabs outside Bodmin church contain this motif. Ryder suggested a late twelfth-century to thirteenth-century date for bracelet crosses,[155] and the Feock Cross is likely to be of a similar date.

## References

Langdon, Arthur G. (1896), 153–54 and figs; Langdon, Andrew G. (2002), 38, no. 35 and fig.

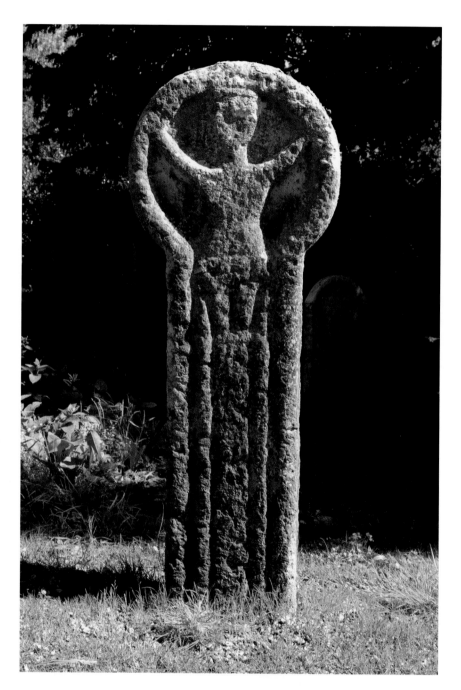

# 37. Fowey, Tristan Stone

SX 1123 5212; PL23 1HQ

The monument now stands in a modern base at the side of the B3415, the Par to Fowey road, about 1.5km (1 mile) from Fowey. There is full public access.

The monument was first mentioned by Leland as early as around 1540. He described it as 'a broken crosse' and said it was 'A mile of' from 'Casteldour'.[156] It was then moved several times and spent some years lying in a ditch.[157] In 1894, the monument was moved to the middle of the road outside Menabilly Lodge gates,[158] and in 1971, it was moved 0.4km (440yd) to its present position.[159]

The monument stands about 3.0m (10ft) high. It is a large, partially broken monolith, which is uncarved except for a T-shape in relief on one face and an inscription on the other face. The inscription is probably complete but is rather deteriorated. It reads vertically downwards in two lines in a predominantly capital script. The first line is badly weathered but can be read [CIRV.V.NC] [IACIT]. The second line reads CV[N]OMORI FILIVS, and the whole text means '[here lies Cirv-], son of Cunomorus'.

Early drawings imply that even when first recorded the first line of the inscription was difficult to read and various names have been suggested, including Drustanus (Tristan).[160] The second name is Celtic and is well attested in Cornwall.[161] Much has been written on the supposed identity of this Cunomorus. He has been taken as Welsh (Kynwawar), as Breton (Chonomor) and as Cornish (Quonomorius), in the last case as the name given in the ninth century to the

The main face of the Tristan Stone, with inscription.

earlier King Mark.[162] However, there is probably insufficient evidence to identify Cunomorus with any actual person; rather, it may be the presence of these names on the stone that has led to the localization of the legends in this area.[163]

Close inspection of the T-shape carved on the top of the stone, on the opposite face to the inscription, shows that there are slight traces of an upper arm extending vertically above the cross-bar of the T. It appears likely that this feature began life as an equal-armed, relief-carved cross, whose top arm was later chiselled away to form a letter T. (This may explain why Leland described it as a 'broken crosse'.) A possible explanation for this is that the stone was adapted for use as a parish boundary stone, the T representing Tywardreath parish; at Castle Dore, the stone would have stood on or close to the boundary between Tywardreath and St Sampson Golant parishes.

This monument can therefore be seen to have had a varied life. Such a tall and tapering stone may have started life as a standing stone or menhir. Then, perhaps in the sixth century, the inscription was added, commemorating local people of importance. After the Norman Conquest, a cross was cut at the top of the shaft, similar to that on the stone at St Clement (no. 22), thereby converting the monument for use as a wayside cross. Then later again, the top arm of the cross was cut away to form a letter T, leaving only the very slight traces that can be seen today, in all likelihood so that it could be used again, as a boundary marker for the parish of Tywardreath, at the time when it was still close to Castle Dore. Finally, it was moved closer to Fowey, to the position it now occupies and where its prominent location and legendary associations make it one of the best-known inscribed stones in Cornwall.

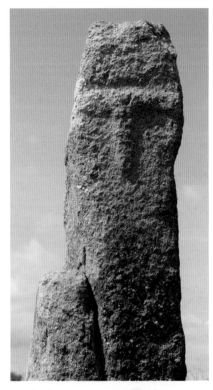

On the reverse side of the Tristan Stone is a T, created by cutting back the top arm of a simple relief-carved cross. Slight traces of the upper arm of the cross can be seen.

## References

Langdon, Arthur G. (1896), 6, 24; Padel (1981), 77–79; Okasha (1993), 91–96 and fig.; Thomas, A.C. (1994), 279–80 and fig.; Langdon, Andrew G. (2002), 39, no. 37 and fig.

# 38. St Germans, Carracawn Cross

SX 3219 5732; PL12 5BT

This cross stands beside a minor road just north of a crossroads on the A387 from Hessenford to St Germans. There is full public access.

Langdon was the first to record and illustrate this cross in 1896 when it was standing on a hedge near the Carracawn

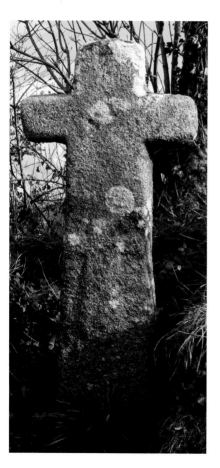

turnpike gate.[164] When Ellis recorded the cross in 1954, the road had been widened and the cross set deeper in the hedge, so that although Langdon recorded the height as 4ft 6in (1.37m), Ellis found that it was only 3ft 4½in (1m) above the hedge.[165] By 1984 the cross had been repositioned in a recess in the hedge at its full height of 1.78m (5ft 10in).[166]

This Latin cross consists of a broad shaft and rather long horizontal arms. Although thought by Langdon to be undecorated, there is in fact a small Latin cross in shallow relief carved on the front of the shaft. The Carracawn Cross is of simple design and has no chamfered sides; it probably dates from the twelfth or thirteenth century.

The cross is similar to, although larger than, the Treglines Cross at St Minver churchyard. The Carracawn Cross along with Triffle Cross,[167] marked the ancient route into Cornwall from the Cremyll Ferry, following the high ground through Crafthole before turning inland to Menheniot and Liskeard.[168]

## References

Langdon, Arthur G. (1896), 201 and fig.;
Langdon, Andrew G. (2005), 38, no. 46 and fig.

120

# 39. Gerrans

SW 8728 3516; TR2 5EA

The cross stands on the south side of Gerrans churchyard, close to the south porch. There is full public access.

Blight was the first to record and illustrate this cross, noting that in around 1850 it was used as a coping stone for the churchyard wall.[169] Although considered by Polsue to be 'a fine old granite cross, in good preservation',[170] Langdon described the crosses on both faces as very worn, this being possibly the result of the monument's previous use. When viewed by Langdon, it had already been mounted in a modern base-stone in its present position.[171]

This granite cross stands 2.05m (6ft 9in) high. It has a large wheel-head and a plain shaft. An equal-armed cross with flaring arms, cut in shallow relief, is carved on both faces of the stone. The simple geometric cross on each face, with no further embellishment of the shaft, suggests a post-Norman Conquest date, possibly of the twelfth century.

This is the only surviving medieval stone cross to be found on the Roseland peninsula. The fact that it was used as a coping stone on the churchyard wall may imply an original association with the church site, although it is possible that it was brought from elsewhere for this function. It is difficult to know how it was used as coping, other than being simply laid on the top of the wall. It has certainly not received such harsh treatment as St Teath (no. 93), a cross that was split up and cut into many pieces for a similar purpose.

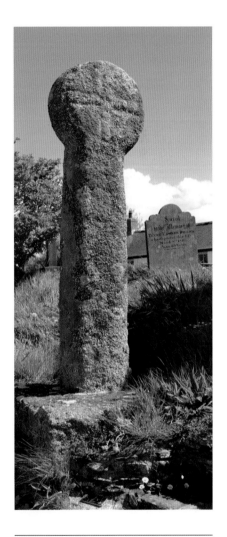

## References

Langdon, Arthur G. (1896), 263–64 and fig.;
Langdon, Andrew G. (2002), 39, no. 38 and fig.

# 40. Gulval 1

SW 4845 3174; TR18 3BB

Gulval 1 (centre) and Gulval 2 (to the right of Gulval 1), gathered together with other carved stones, beside the church porch.

This cross-shaft stands in the churchyard of St Gulval's church, to the left of the porch and near other fragments of carved stone, including Gulval 2 (no. 41). There is full public access.

The cross-shaft was found in September 1885 during demolition of part of the east wall of the chancel.[172] In April 1887, it was recorded in the churchyard, 'west of the porch'.[173] It was certainly recorded in its present location in 1896.[174]

The monument forms the bottom section of a cross-shaft and stands 1.34m (4ft 5in) high. It is mounted upside down, with the tenon (which would have been socketed into a base-stone) pointing up. The shaft has a single panel of decoration on all sides, and on one side (the west) there is an inscription. The edges of the shaft are enriched by cable-moulding, and

the decoration includes simple knotwork and step patterns in broad flat strands.

The letters of the inscribed text on the west face appear to read horizontally in two lines but they are now very worn. In the past the text was read either as VN VI,[175] or as VRI VI.[176] In view of these differences, and of the illegible state of the text today, the original reading cannot now be recovered. Although the shaft is in an area with a very distinctive style of pre-Norman sculpture (the Penwith group), this monument is of different style. The types of patterns on the cross do not indicate a specific date, but it may be of the late tenth or eleventh century.

With a name in *lann* and a large curving churchyard located on a gently sloping coastal plain above Mounts Bay, Gulval church is a site of early medieval

122

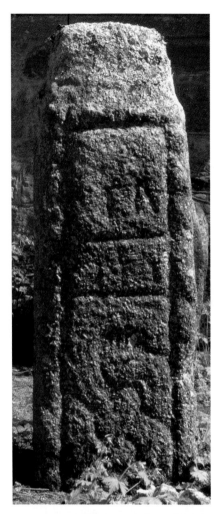
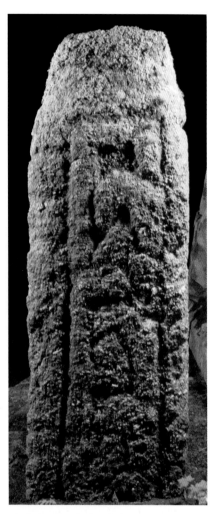

The two main faces of Gulval 1 cross shaft, showing the inscription, and the interlacing patterns worked with broad strands.

origin. This cross, however, is the earliest tangible feature on the site. By the time of the Norman Conquest, the estate of Landicle (Gulval) was in the ownership of the Bishop of Exeter,[177] perhaps through appropriation of the site of an earlier church here.

## References

Langdon, Arthur G. (1896), 357, 372–74 and figs; Okasha (1993), no. 15, pp. 113–15 and fig.; Thomas, A.C. (1994), 328; Langdon, Andrew G. (1997), 21, no. 19 and fig.; Preston-Jones and Okasha (2013), 146–47 and figs.

# 41. Gulval 2

SW 4845 3174; TR18 3BB

Gulval 2 cross-base illustrated by Blight (1856, 50).

depicted as zoo-anthropomorphic images: human figures with the head of the animal that is the Evangelist's symbol.

Most obvious, on the stone's south face, is Matthew, the man, with angel's wings and halo, holding a book in very large hands. Incised on the book, in tiny script, are the letters MT, an abbreviation of Matthew. Lightly cut on the west face of the stone is a figure with a halo, kneeling and holding a small book with outstretched fingers. This figure's muzzle-like mouth betrays it as Mark,

This cross-base stands in the churchyard of St Gulval's church, to the left of the porch and near other fragments of carved stone, including Gulval 1 (no. 40). There is full public access.

The cross-base was first recorded by Blight in 1856. At this date it acted, as now, as a support for a late medieval lantern-head, but it then stood on the south-east side of the churchyard.[178] The date the base and lantern-head were moved was probably around 1900.

This large pedestal or base of a cross stands 0.88m (2ft 11in) high, with the later lantern-head incongruously cemented onto it. It has a cement-filled mortice in the top and, most unusually, figures carved on each of its four faces. The carving on the south and west sides is most easily seen, but that on the north and west sides is more difficult to make out, because of the cramped location.[179] These figures represent the Four Evangelists,

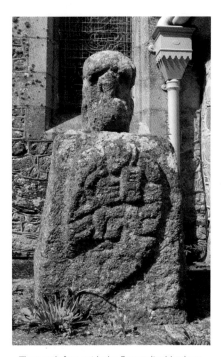

The south face, with the Evangelist Matthew.

symbolized as a lion. The carving on the north face of the stone depicts a haloed figure facing right and holding a book on which the letters LS are incised. This is Luke, the calf or bull. Least easy to decipher is the image of St John on the east face, shown as half man, half eagle.[180]

This stone has been mistaken in the past for the base of a later, Gothic cross. However, its significance as a decorated early medieval cross-base was recognized by Mick Aston and Teresa Hall in 2013.[181] As such, it is unique in Cornwall; it can be compared to the Doniert Stone (no. 18, St Cleer 1), but the decoration is of a very different character. The best parallels are in Ireland, where decorated cross-bases are relatively common, although none is quite like this.

Figure sculpture, other than the crucifixion, is rare in early medieval sculpture in Cornwall. Cornish architectural sculpture of the Norman period features lively animals on several Norman tympana and fonts, but figure sculpture is limited to the heads at the corner of certain fonts and two carved panels at Launceston.[182] It is not until the end of the medieval period in Cornwall that figure sculpture becomes more common. However, the Four Evangelists are named on the Tintagel cross of the late eleventh or early twelfth century (no. 94).

The Gulval images compare most closely with the very simple depictions of the Evangelists with animal heads seen in Breton manuscripts of the late ninth and tenth centuries. This is of special interest since examples of Breton Gospel books are known to have existed in Devon at Exeter Cathedral (the diocesan centre until the nineteenth century) and in Cornwall at Bodmin.[183] The remote possibility that one such gospel book might have been at Gulval is suggested by the fact that the

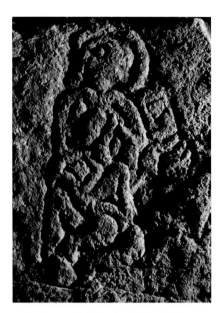

The Evangelist Luke, depicted as half-man, half-bull, on the back of the cross-base.

manor that included Gulval church was owned by the Bishop of Exeter just before the Norman Conquest.[184]

Since this base is unique in Cornwall, it is difficult to speculate on the type of cross that it may have supported. However, further figure sculpture, especially a crucifixion, might have been expected, given the iconography of the base and the fact that crucifixions are a feature of early medieval sculpture in this area.[185] It is also difficult to date more closely than to between the late ninth and the twelfth century.

## References

Langdon, Arthur G. (1896), 426; Langdon, Andrew G. (1997), 22, no. 20 and fig.; Preston-Jones and Okasha (2013), 147–52 and figs; Preston-Jones (2017), 31–40.

# 42. Gwinear 1, Connor Downs

SW 6449 4004; TR14 7DF

This cross stands in the churchyard of St Meriadoc's church, Camborne, outside the west door of the tower. There is full public access.

Thomas suggested that this cross was to be identified with one seen by Borlase in May 1755, but this is far from certain.[186] The cross is first definitely recorded in 1856 in a drawing by Blight, captioned a 'Gate-way on Connor Down, Gwinear'.[187] The cross was described and illustrated in use as a gatepost on Connor Down in

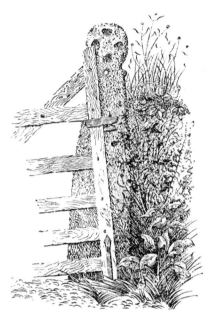

The Gwinear 1 cross in use as a gatepost, by Arthur G. Langdon (1896, 307).

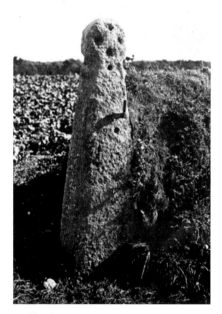

The Gwinear 1 cross in use as a gatepost on Connor Downs c.1890 (image courtesy of the Courtney Library of the Royal Institution of Cornwall).

1896,[188] but comparison of these drawings suggests that it may have been moved slightly. It was placed in its present location in 1907.[189]

The cross stands 2.11m (6ft 11in) high. Its most notable feature is its highly tapering form; although broad and thick at the base, it narrows to a very small round head. On both sides of the head is a St Andrew's cross, formed by sinking four roughly triangular areas. At the junction between head and shaft is a projecting roll-moulding, and on the shaft

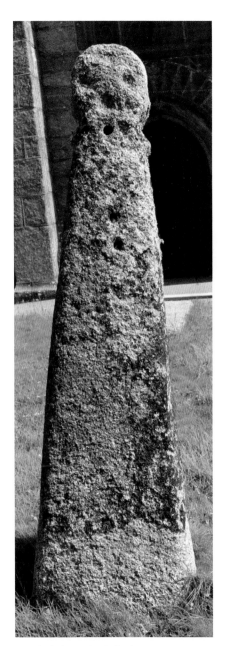

the decoration consists of rows of small incised dots.

It has been suggested that this cross is a converted menhir,[190] and its highly tapering shape makes this likely. The minimum appears to have been done to 'convert' it; a head has been fashioned and some crude decoration added, but the basic shape is virtually unchanged. The St Andrew's cross is rare but not unknown in Cornwall, appearing elsewhere, for example, on St Piran's Cross (no. 83). St Piran's Cross also has simple dot decoration and a roll-moulding at the neck. Presumably the Connor Downs cross is a crude copy of similar but better executed monuments such as this. Since St Piran's Cross may date from the late eleventh century or early twelfth century, the Connor Downs cross may date from the twelfth century.

When standing on Connor Downs, the cross is likely to have acted as a wayside cross on the main spinal road through Cornwall (originally the A30, which has now been diverted to the north). It would also have marked the parish boundary between the parishes of Gwithian and Gwinear.

See also no. 13, the Fenton-Ia cross, in the same churchyard.

### References

Langdon, Arthur G. (1896), 22, 24–25, 306–8 and figs; Thomas, A.C. (1967), 96–97 and fig.; Langdon, Andrew G. (1996c), 24; Langdon, Andrew G. (1999), 16, no. 12 and fig.; Preston-Jones and Okasha (2013), 237–38 and figs (Gwinear 2).

The holes in the shaft of Gwinear 1 are a legacy of its days in use as a gatepost.

# 43. Gwinear 2, Lanherne Cross

SW 8721 6592; TR8 4ER

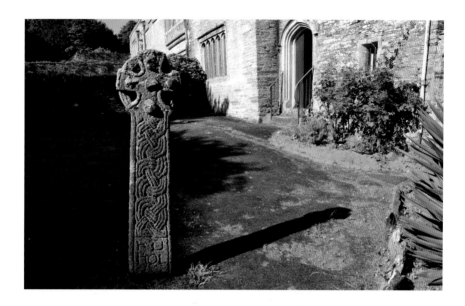

This cross stands in the garden of the convent at Lanherne, St Mawgan. There is public access at reasonable times.

The cross was first recorded in 1777 in 'the ruins of an Antient Chapel in a Field called the Chapel Close' in Roseworthy, Gwinear.[191] By 1814 the cross was in 'the garden of Lord Arundell's mansion-house, at Lanherne',[192] its present location. It may well have been brought to the garden before 1794 when Lanherne was given to Carmelite nuns.[193]

The Lanherne Cross is small, standing only 1.49m (4ft 11in) high. It is in perfect condition except for some slight damage to the head, and epitomizes in miniature the best of early Cornish sculpture. It is cut from a Pentewan-type stone. The four-holed cross head, beaded at the angles and on the ring, has curved armpits and arms whose shape is designed to enclose its main feature, the crucifixion. Hence the horizontal arms, into which Christ's arms extend, are narrower than the upper arm, which contains his head; the lower arm is widest as it curves outwards to fit on to the shaft.

All the carving on the shaft is deeply cut and individual chisel marks can still be seen. On three sides of the shaft are double- and triple-strand knots and interlace, including the Carrick bend, Stafford knots and ring-knots. Running down the side of the shaft is a single panel occupied by a creature with a sinuous ribbon-like body. Its head, at

the bottom of the shaft, has mouth, eye and ear visible, and just above this a small foot (see Introduction, Fig. 8). The body rises up the shaft in waves and at the top returns, interlacing the body with Stafford knots.

Two panels at the bottom of the cross contain inscriptions. On the main face, a double incised moulding separates a panel that contains an inscription in four lines, while on the back is an inscription in two lines. Both texts are complete and legible and are incised in a predominantly insular script reading horizontally. The text on the front reads

+ BREID [E/T I]MAH; its meaning is not altogether clear, but it could be two personal names joined by *et*.[194] The text on the back reads RŪHOL, presumably for RUNIIOL. This could be a personal name containing the Brittonic element *run* (of uncertain meaning), although, if so, the second part of the name, *hol*, would be obscure and unparalleled. Since this same word seems also to appear on the similar cross at Sancreed (no. 87), it has been suggested that it was the name of the person who carved both crosses, although it could also be the name of the person who commissioned the cross, or of the

The front and two sides of the Lanherne Cross.

person commemorated. Alternatively, it could be a word in Old Cornish, meaning 'inherited' or 'inheritance'.[195]

With a crucifixion on one side of the cross-head and five bosses on the other, this cross is a fine example of the Penwith group of pre-Norman sculpture dating from the mid-tenth to the eleventh century. This may be an early example in the group. Other features characteristic of the group are the use of simple interlace patterns in double or triple strands and the serpentine beast entwined by Stafford knots. On no other cross in this group is the sculpture so clear, probably because a more easily carved Pentewan-type stone was used here instead of granite.

Although now at Lanherne Convent in the parish of St Mawgan in Pydar, the cross came originally from the site of a chapel of St Gwinear at Roseworthy in Gwinear. Roseworthy was a demesne manor of the king in 1086.[196] The chapel's

Detail of the inscription on the back of the Lanherne Cross.

legendary associations with the local saint and the presence there of a holy well may point to an early origin for the chapel site,[197] although it is likely that by the date the cross was carved it was serving as a manorial chapel. The cross could perhaps have originated as the memorial of a (Cornish) steward associated with the manor.

Further investigation is needed of the Pentewan-type stone of which the cross is carved. If Pentewan is the source, this indicates transportation of some 40km (25 miles). However, the stone may have come from a dyke in the Roseworthy area of similar lithology.

See also three additional crosses in the neighbouring churchyard.

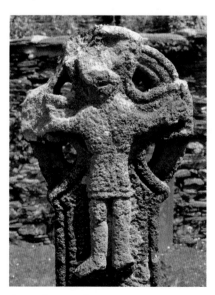

Detail of the crucifixion on the Lanherne Cross.

## References

Langdon, Arthur G. (1896), 357–59, 365 and figs; Thomas, A.C. (1967), 90, 104–05; Preston-Jones and Rose (1986), 159; Okasha (1993), no. 20, pp. 133–37 and figs; Thomas, A.C. (1994), 329; Langdon, Andrew G. (1996c), 1 and fig.; Langdon, Andrew G. (2002), 57, no. 70 and fig.; Preston-Jones and Okasha (2013), 152–55 and figs.

# 44. St Juliot

SX 1289 9120; PL35 0BT

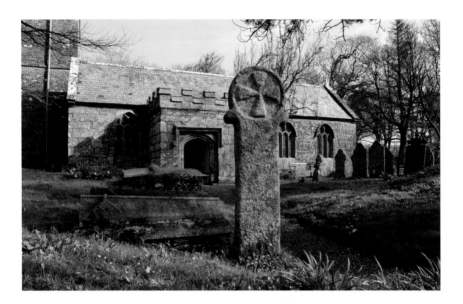

This cross stands just inside the south gate of St Juliot churchyard, 3km (2 miles) east of Boscastle. There is full public access.

Blight was the first to note this cross in 1858,[198] but Langdon was the first to illustrate the cross, which he considered to be in situ.[199] Ellis recorded his view that the cross was one of the most beautifully executed wheel-crosses found in Cornwall.[200]

This wheel-headed cross stands 1.94m (6ft 4in) high. It contains an equal-armed cross with splayed, almost triangular, arms, which are enclosed by a narrow bead or roll-moulding around the head. Both faces are similar. The shaft, which is undecorated, has small projections at the neck and a slight entasis.

The carved cross on the head is in such good condition that it may perhaps have been recut in the nineteenth century. The simple geometric cross suggests a twelfth-century date.

This is one of three stone crosses in St Juliot churchyard; this may be the original churchyard cross, whereas the other two are wayside crosses brought into the churchyard for preservation, one from Anderton Mill in Lesnewth parish and one from Tregatheral in Minster parish.[201]

---

## References

Langdon, Arthur G. (1896), 162–63 and fig.; Langdon, Andrew G. (1996b), 35, no. 41 and fig.

# 45. St Just-in-Penwith

SW 3715 3145; TR19 7EZ

This cross-shaft is inside St Just's church, built into the inside of the north wall of the north chancel aisle, where it is used as a lintel for an opening in the wall. There is full public access.

The cross-shaft was first recorded in 1868, in its present location.[202] It may well have been found during the church restoration of 1866.[203] According to Peter, a portion of the stone was cut away by the architect 'because it projected across the window arch'.[204]

The surviving section of this cross-shaft measures 1.51m (5ft). It is decorated with beautifully executed interlace work, in two panels. One half of the larger panel contains rows of holes, which may be the marking out of the grid for an unfinished pattern,[205] or may be the result of trimming back the stone for later reuse. In the square lower panel is a ring-knot consisting of two circular rings interlaced with two diagonal oval rings. There is no carving beneath this, most likely because this was the bottom of the shaft. On the underside of the stone, traces of further decoration can be detected, but no coherent pattern. The other two sides of the shaft are buried in the church wall and are invisible.

The decoration on this shaft is different from that on other pre-Norman sculpture in Penwith. Instead, its closest parallels are with the crosses of the panelled interlace group in east Cornwall; in particular, a similar ring-knot can be seen on the cross-shaft St Neot 1 (no. 73). The St Just shaft is probably of a similar date to the panelled interlace group, that is, the late

ninth to the tenth century, and may be slightly earlier than crosses of the Penwith group.

The presence of this monument in the far west of Cornwall, remote from other members of the panelled interlace group, is difficult to explain. St Just's early origin is indicated by a place-name in *lann and a sixth- to eighth-century inscribed stone.[206] In the later medieval period, the church had a shrine containing relics of its patron saint.[207] These factors may point to an early religious house of local importance in the far west, but do not explain the apparent connection with east Cornwall.

See also three further crosses in the churchyard.

## References

Langdon, Arthur G. (1896), 23, 404–05 and fig.;
Langdon, Andrew G. (1997), 24, no. 25 and fig.;
Preston-Jones and Okasha (2013), 156 and figs.

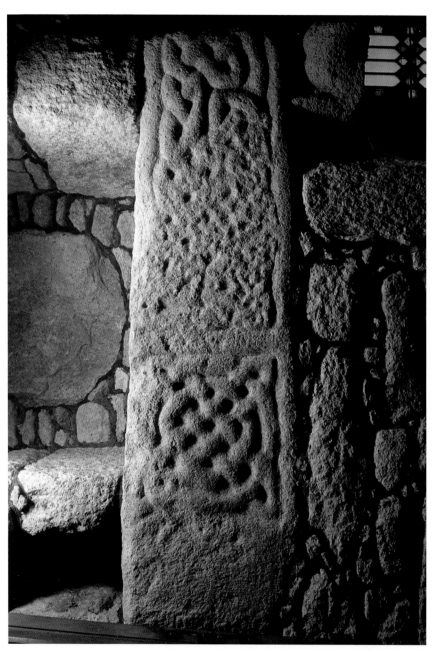

St Just's pre-Norman cross-shaft is shown here in vertical orientation, as it would have stood originally.

# 46. St Kew 1, Job's Cross

SX 0116 7672; PL27 6ER

Job's Cross stands on elevated ground beside a staggered crossroads, 1km (0.5 miles) west of St Kew churchtown. There is full public access.

The cross was first noticed in 1906 by Nicholas Bray of St Kew, in use as a gatepost beside an old path leading from Carclaze Farm to Job's Tenement.[208] In 1915, it was photographed by Stephens.[209] The cross remained in use as a gatepost until the 1930s, when it was rescued by Mr Bray and Wadebridge Old Cornwall Society.[210] In 1952, stonemasons at De Lank Quarry at St Breward restored the monument and set it up in its present position in a modern base-stone.[211] Sadly, Mr Bray did not live to see this event.

The cross stands 1.93m (6ft 4in) high. When in use as a gatepost, it was utilized head-uppermost, and a large segment of the wheel-head was hacked off. Nevertheless, enough of

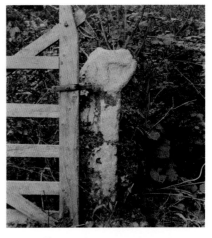

The cross in use as a gatepost in 1915 (photograph by W.J. Stephens, Andrew Langdon collection).

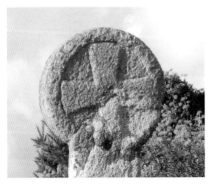

The east face of St Kew 1 showing the joint between the original and restored parts of the head.

the original cross design survived to allow stonemasons to skilfully replicate the missing segment and restore the monument. The west face depicts a narrow equal-armed cross carved in relief, while the east face has a broad equal-armed cross carved in relief and enclosed by a bead or roll-moulding. The simple geometric cross suggests a twelfth-century date.

Today, the footpath between Carclaze and Job's Tenement is no longer in use; however, it formerly linked up with a track leading north-east directly to the parish church.

## Reference

Langdon, Andrew G. (1996b), 40, no. 50 and fig.

134

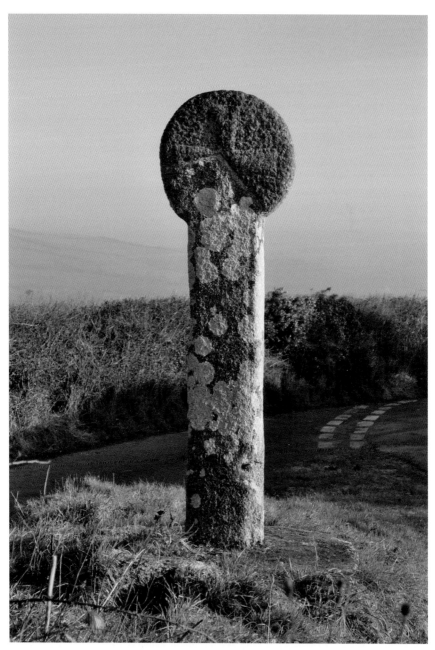

St Kew 1 stands at a road junction with a view over rolling countryside.

# 47. St Kew 2, Polrode Cross

SX 0218 7689; PL30 3EP

The cross stands at the south-east end of St Kew churchyard, close to the east entrance. There is full public access.

In 1876, Maclean first recorded and illustrated the cross-head and upper portion of shaft, while it was forming part of a rough stone bridge across a stream at Polrode Mill in the Allen valley.[212] In 1908 it was rescued by Major Braddon of Skisdon and stonemason Nicholas Bray of St Kew Highway and set up in the churchyard on a two-stepped base to the east of the south aisle.[213] In 1926, Mr Bray discovered the lower part of

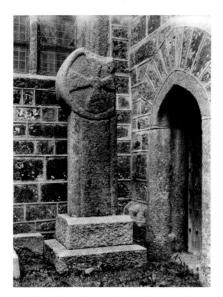

The Polrode Cross in the early twentieth century, before the discovery of the lower half of the shaft (photograph by W.J. Stephens, Andrew Langdon collection).

the cross in use as a jamb to the kitchen fireplace at Higher Polrode Farm in neighbouring St Tudy parish.[214] The owner, a Mr Fortescue, agreed to allow the cross-shaft to be removed, and the two parts were reunited in their present position later in the same year.

The cross stands 2.95m (9ft 8in) high. It has a large wheel-head with an equal-armed cross carved in relief on each face. The cross-arms are expanded at the ends and are within a bead or roll-moulding. At the centre of the cross is a small indentation, possibly used to form the wheel-head with a compass. The cross-head has a piece broken off on the top and has been deliberately trimmed down one side, erasing part of the relief cross. The shaft is plain except for a broad roll-moulding that runs down each edge of the shaft. The cross probably dates from the twelfth century.

The wheel-head was laterally trimmed flush with the shaft so that it would fit tightly against the next stone in the bridge. It is interesting to note that half the monument was discovered in St Kew parish and half in St Tudy, one on either side of the River Allen that marks the parish boundary. Could this cross have marked the parish boundary as well as perhaps a safe fording place across the river?

See also another cross on the north side of the churchyard and a lantern cross-head in the church.

## References

Langdon, Arthur G. (1896), 77–78 and fig.;
Langdon, Andrew G. (1996b), 36, no. 43 and fig.

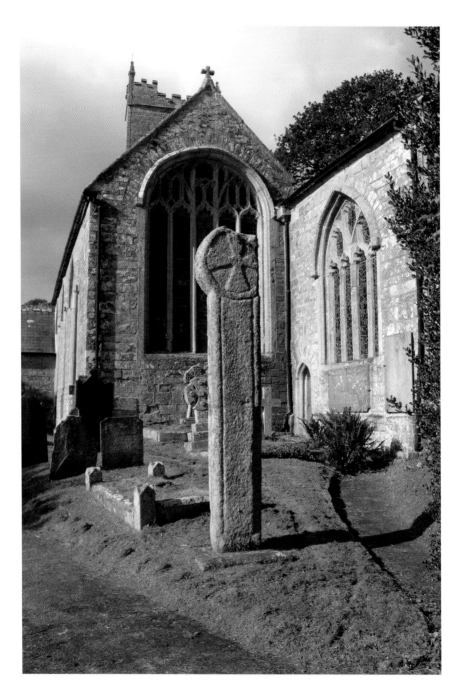

# 48. Laneast 1

SX 2281 8397; PL15 8PN

The cross stands in the churchyard of St Sidwell's church, opposite the south porch. There is full public access.

The cross-head and upper part of the shaft were discovered by the parish sexton, Thomas Sleep, while digging a grave on 19 June 1952.[215] They were found among discarded building material 1m (3ft) below the ground. The cross was restored in 1954 by Launceston Old Cornwall Society, who provided a new section of shaft and mounted the restored monument on a modern base.[216]

The cross stands 2.54m (8ft 4 in) high. It is a four-holed cross, the cross-arms being slightly raised in relation to the outer ring which links the arms. Directly below the head at the neck is an abacus or raised collar which encircles the shaft. The small portion of original shaft has traces of simple incised decoration. The original stone has been skilfully fitted to a new piece of granite shaft of slightly rougher texture, the whole being supported by a new base-stone. The abacus or raised collar can also be seen on two further north Cornwall crosses at Lawhitton and Michaelstow (no. 67). All three of these crosses are undecorated four-holed crosses, suggesting a post-Norman Conquest date in the twelfth century.

Ellis suggested that the cross might have been thrown down or discarded when the church was rebuilt or when the south aisle was built.[217] Laneast church site is first recorded in 1076 and a church was built here in Norman times,[218] but the place-name, which contains the element *lann*, implies there has been a Christian

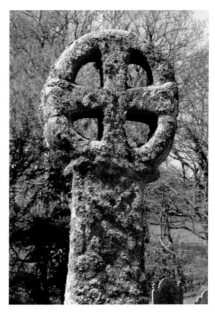

On this face of the Laneast Cross, simple decoration in the form of large incised diamonds can be seen on the shaft.

site here since the early medieval period.[219] Comparison with the cross at Tretheague, Stithians (no. 92), suggests that the Laneast cross-head may belong to the twelfth century and could perhaps have marked the church site before work began on the Norman church.

## Reference

Langdon, Andrew G. (1996b), 40, no. 51 and fig.

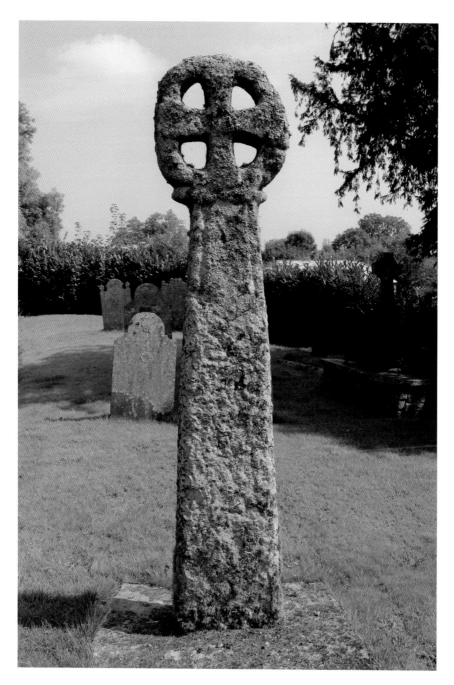

# 49. Laneast 2, Laneast Downs

SX 2350 8551; PL15 8TA

This cross stands on Laneast Downs close to a minor road leading from the A395 to Tresmeer, just south of High Hall Farm. There is full public access.

The cross was first noted by Polsue in 1870,[220] although Langdon was the first to illustrate it.[221] In July 2006, the cross was hit by a vehicle and left leaning over, but on 31 August 2006, it was straightened again with the help of Roger Francis of High Hall Farm.[222]

The cross stands 1.96m (6ft 5in) high. It has an unusual elliptical head, with a Latin cross carved in relief enclosed by a bead or roll-moulding on each side. The shaft is plain with no decoration except small projections at the neck. The simple geometric cross suggests that the cross may have been set up in the early part of the Norman period, the twelfth century.

This cross is unusual in being carved from local greenstone, which Langdon suggested is Polyphant, a stone quarried just a few miles to the south near the village of that name. Langdon also suggested the cross was in situ; however, when the ground at the foot of the shaft was excavated in 2006 in order to straighten the monument, no base-stone was found, suggesting that the cross had been moved at some time. Small stones found in the ground at the foot of the cross perhaps represented wishes or prayers or, more mundanely, stone clearance.[223]

## References

Langdon, Arthur G. (1896), 163 and fig.;
Langdon, Andrew G. (1996b), 41, no. 52 and fig.;
Langdon, Andrew G. (2009), 29–30 and fig.

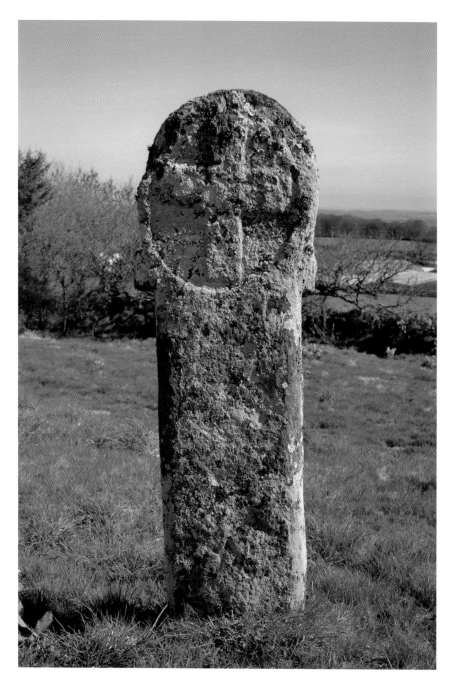

# 50. Lanhydrock 1

SX 0851 6361; PL30 4DE

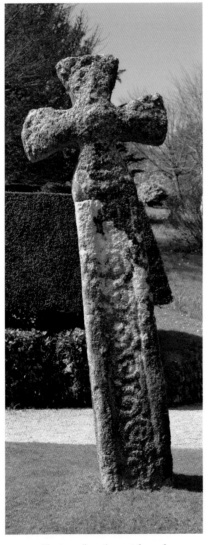

Plant scroll on the east face of the Lanhydrock cross.

The cross stands in the gardens of Lanhydrock House, outside the south door of St Hydrock's church. There is public access, but with an entrance fee.

The cross was first recorded in 1794, apparently at the entrance to the churchyard.[224] Several times between 1827 and 1870, it was described as being in the churchyard, presumably standing in its present location; however, in 1896, Langdon recorded that it had been thrown down and had remained so 'for many years', although it was by then again erect.[225]

The cross stands 2.38m (7ft 11in) high. It is almost complete, although mutilated, with a small section missing from the top of the shaft. It once had a four-holed cross-head with widely splayed arms but the ring has been cut off. On the head is a central boss and worn remains of triquetra knots in the cross-arms. The shaft has a disproportionately wide and prominent flat-band moulding down the sides. Within this, the carving is in low relief and is very worn, particularly at the top. On the two main faces are a plant scroll and a continuous panel of interlacing of figure-of-eight knots, executed in broad flat bands, while on the narrow sides are a very worn plant trail and a simple plait.

The Lanhydrock cross is a member of the Mid- and East Cornwall group of foliage-decorated crosses dating from the mid-tenth to the eleventh century. It particularly resembles the cross at Lanivet (no. 52) in an adjoining parish, about 5km (3 miles) away. It therefore seems likely that the Lanhydrock cross, like the Lanivet

cross, had a plain ring, even though some others in the group, for example those at Quethiock (no. 85) and Prideaux Place, Padstow (no. 77), have cusped rings with trefoil holes.

The ring has been so neatly cut off that it looks like a deliberate act designed to make the monument look more 'cross-like'. Given the intimate association of the cross with the Lanhydrock estate, its remodelling is likely to have been linked to this. Unattributed information in the church suggests that the cross may have been restored in the early nineteenth century by Anna Maria Hunt (1771–1861), and this could well have been the context both for the remodelling of the head and for the restoration implied by Langdon,[226] and possibly also for moving it from the churchyard entrance to its present location to the south of the church.

Today, it is difficult to divorce the Lanhydrock cross from its setting, adjoining a mansion now in the ownership of the National Trust. Yet Lanhydrock was originally no more than a chapelry, and the 'whole parish constituted one of the oldest possessions of the Monastery of St. Petroc at Bodmin'.[227] The name, which contains the element *lann and a saint's name, Hydrek, indicates a site of early medieval origin.[228]

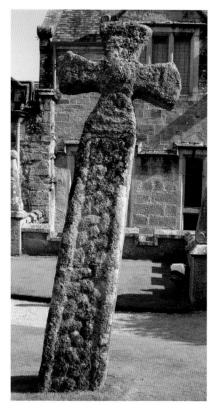

Plaitwork on the west face of the Lanhydrock cross.

### References

Langdon, Arthur G. (1896), 382–83 and figs; Langdon, Andrew G. (2002), 41, no. 42 and fig.; Preston-Jones and Okasha (2013), 158–59 and figs.

# 51. Lanhydrock 2, Treffry

SX 0852 6346; PL30 4DE

The cross stands on a grassy mound at the top of Scotland Hill, in the higher part of the National Trust's Lanhydrock Garden. There is public access, but with an entrance fee.

In April 1874, Iago first noted and illustrated this fragment of a cross-head in a hedge at a crossroads at Treffry turnpike gate.[229] Both he and Langdon were present in 1890 when workmen uncovered it.[230] Lord Robartes of Lanhydrock had the fragment incorporated into a new cross designed by Iago, which was set up in the higher gardens.

The cross stands 3.53m (11ft 7in) high, but only a small fragment of it is original. The original part consists of the upper part of a four-holed cross, with only the upper two holes and a very

Arthur G. Langdon's (1896, 183) illustration of the cross, made shortly after it was discovered, shows that only a small portion of the modern monument is original.

small indication of the lower two holes remaining. The fragment is plain with no bead, mouldings or decoration. The plain design of the four-holed head suggests a post-Norman Conquest date, perhaps of the twelfth century. The proportions of the restored cross designed by Iago suit the small surviving fragment so well that it seems likely the original monument was of a similarly impressive size.

It is possible that this cross originally marked the crossroads at Treffry, where a road from Lanivet to Cardinham (also marked by crosses at Reperry and St Ingunger in Lanivet parish) is intersected by the main road from Bodmin to Lostwithiel. Presumably the shaft of the cross either remains buried in the hedge or has perhaps been reused, for example as a gatepost nearby.

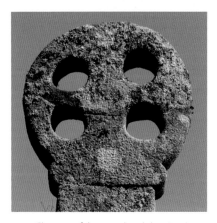

Close-up of the cross-head showing the joint between the original and new parts of the monument. The old section has a greater covering of lichen.

### References

Langdon, Arthur G. (1896), 183 and fig.;
Langdon, Andrew G. (2002), 42, no. 43 and fig.

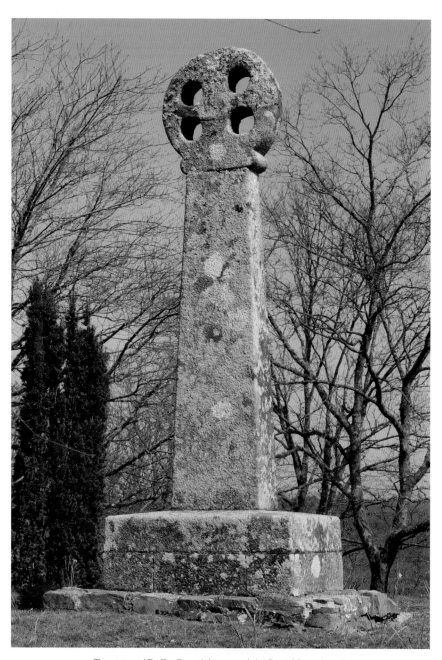

The restored Treffry Cross (photograph by Daniel Rose-Jones).

# 52. Lanivet 1

SX 0391 6421; PL30 5NA

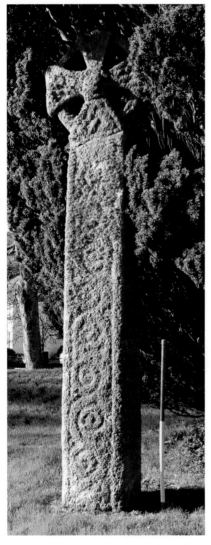

Spiral foliage scroll on the main face of Lanivet 1 (photograph by Graeme Kirkham).

This cross stands in Lanivet churchyard, to the west of the church. There is full public access.

The cross was first recorded in 1801 in 'Lanhivet church-yard',[231] presumably in its present location; it is probably in situ.

This tall complete cross stands 3.2m (10ft 8in) high, crowned by a ring-head with wide-splayed arms. The carefully shaped shaft has a slight entasis and wide, plain mouldings on all four angles. On the main face of the shaft is a simple, spiralling, plant scroll, with small drop-leaves filling the space between the edge-moulding and the plant stem. A loose acanthus-like plant trail and a simple plait fill the sides of the shaft and on the back is a continuous panel of interlace work.[232]

This cross at Lanivet is a member of the Mid- and East Cornwall group of foliage-decorated crosses dating from the mid-tenth to the eleventh century. It particularly resembles no. 50 Lanhydrock 1, in an adjoining parish, about 5km (3 miles) away. The similarities between the two are very striking, and encompass the overall size, the layout and type of decoration. Their obvious differences are due to later modification and different settings.

Lanivet has a name in *lann, which, along with the presence of two inscribed stones, indicates a site of early medieval origin. At Lanivet, *lann is combined with the element *neved, a 'pagan sacred place', which Padel suggests is here used as a place-name, so meaning 'the lann at the place called Neved'.[233] No saint is

Four-strand plait on the back of Lanivet 1, normally hidden behind a tree.

known to have been associated with the site. Lanivet is one of the few church sites in Cornwall with an abundance of early sculpture, suggesting that this was once an important site, although its later history gives no indication of any particular significance.[234] Only the inscribed stones and the sculpture now bear witness.

See also the parish page.

## References

Langdon, Arthur G. (1896), 383–85 and figs; Langdon, Andrew G. (2002), 44, no. 47 and fig.; Preston-Jones and Okasha (2013), 159–61 and figs.

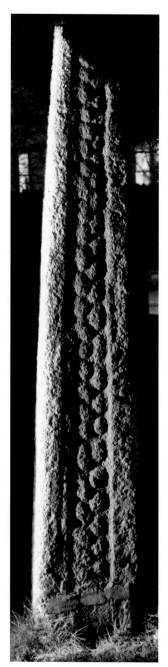

Simple plait on the side of Lanivet 1, photographed at night with lights.

# 53. Lanivet 2

SX 0395 6424; PL30 5NA

This cross also stands in Lanivet churchyard, to the north of the church, in the middle of the graveyard enclosure. There is full public access.

The cross was first recorded in 1801 in 'Lanhivet church-yard',[235] presumably in its present location; it is probably in situ.

The cross stands 2.92m (9ft 9in) high. It has a simple wheel-head (broken on one side) with a central boss and a shaft with marked entasis, richly covered in a mass of incised decoration in panels. The decoration includes panels of dots, diagonal crosses, a round-headed cross, two key patterns (fretwork) and, most notably, the large figure of a man on the east side. The figure has a rounded body, with short stick-like arms hanging down his sides and thin legs with both feet turned to the right. Parallel lines incised around the head might represent a halo or might just be space-fillers, as are, presumably, the incised dots below the right arm and the horizontal lines, small boss and diagonal cross between the legs. There are hints of two incised eyes, but otherwise there is no detail visible on the body. Hanging from the figure's left arm is a stick-like object terminating in three cross-bars with a ring in the centre. This may be a key, in which case the figure may represent St Peter, holding the keys to heaven.

This impressive cross contains an interesting mixture of decoration, with attempts at fretwork and knotwork, alongside panels of dots and other more eccentric incised patterns. This decoration suggests that it is transitional between

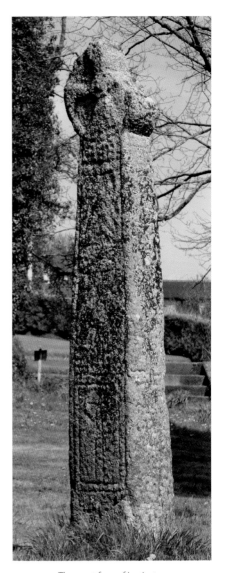

The west face of Lanivet 2.

early and later medieval styles of cross-carving. For example, the fretwork would normally be regarded as pre-Norman, but is misunderstood and poorly executed and so may be a later copy, while the simple disc- or wheel-head is of a type normally associated with the continuing tradition of medieval wayside crosses. It may date from the second half of the eleventh to the early twelfth century. Although they are of similar size, the two crosses at Lanivet are very different in style, with Lanivet 2 being the later.

The incised figure can be compared with the much smaller examples on no. 82 Penzance, which is also an incised cross. However, simple figures can also be found in Wales, for example in Brecknockshire on the cross-carved stones at Llandyfaelog Fach, Llanfrynach and Llanhamlach.[236] The feature on the Lanivet figure's left-hand side was considered by Langdon to represent a tail,[237] and by Dexter to have pagan symbolism.[238] Alternatively, as suggested above, the figure may represent St Peter.[239]

## References

Langdon, Arthur G. (1896), 295–97 and figs; Langdon, Andrew G. (2002), 43, no. 46 and fig.; Preston-Jones and Okasha (2013), 161–63 and figs.

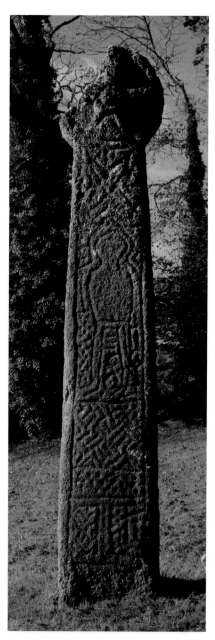

The east face of Lanivet 2, with its prominent figure, possibly St Peter.

# 54. Lanivet 3, Lesquite

SX 0665 6268; PL30 5HT

The cross stands at the entrance to Lesquite Farm, 1km (0.5 miles) south-east of the hamlet of Fenton Pits. There is full public access.

In 1858, Blight first recorded and illustrated this cross under the name Fenton Pits and also recorded a second cross nearby (now known as Fenton Pits Cross);[240] in 1870, Polsue also noted the

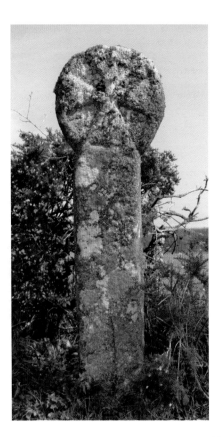

Lesquite cross.[241] In around 1885, it was removed to Lanke in St Breward parish by a Mr Collins, although its base-stone was left in situ in Lanivet. At Lanke the cross was set up directly in the ground as a garden feature, where it was recorded by Langdon.[242] In 1926, the cross was returned to Lesquite and set up again in its original base-stone, through the influence of Lord Clifden of Lanhydrock, the landowner.[243]

This wheel-headed cross stands 2.24m (7ft 4in) high. It displays an equal-armed cross in relief, formed by carving triangular recesses, with the arms of the cross extending to the edge of the stone. The cross has a small indentation in the centre of the arms, suggesting that the wheel-head could have been compass-drawn. The reverse face has a similar cross, although less well executed. The shaft of the cross is undecorated. The simple geometric style suggests a twelfth-century date.

This is one of four Lanivet wayside crosses within about 3km (2 miles), and this has led to some confusion, with Blight and Langdon both recording this monument but under different names. The Lanivet wayside crosses are all similar in style but are cut from different sizes of stone.

## References

Langdon, Arthur G. (1896), 58–59 and figs;
Langdon, Andrew G. (2002), 47, no. 52 and fig.

# 55. Lanlivery, Milltown

SX 0966 5189; PL24 2TL

The cross stands on the south side of Tregaminion churchyard in Tywardreath parish. There is full public access.

This cross was discovered in the summer of 1889, forming part of a footbridge across a small brook at Milltown, Lostwithiel.[244] Langdon recorded that the monument was in a dilapidated condition with one side of the head having been knocked off. It was speedily purchased by the monks of Buckfastleigh, but a Mr Rashleigh, the landowner, claimed the monument and had it set up in its present position on an old pivot stone from Pridmouth.[245]

This wheel-headed cross stands 1.83m (6ft) high. It is worn and mutilated, having been laterally trimmed down one side of its head in line with the shaft. On each face of the monument is an irregularly shaped cross with widely expanded arms extending to the edge of the head. On the northern side of the cross, an extension to the lower arm runs down the shaft in shallow relief, emphasized by incised lines. The simple geometric cross suggests a twelfth-century date.

It appears likely that the cross-head was trimmed to make it fit alongside the next piece of granite in the footbridge. The excessive wear on the shaft may be the result of traffic passing over the bridge.

See also another cross in the churchyard at Tregaminion.

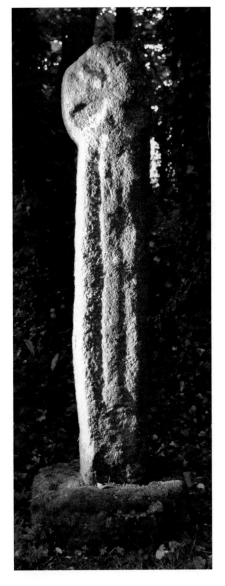

## References

Langdon, Arthur G. (1896), 273–75 and fig.;
Langdon, Andrew G. (2002), 69, no. 90 and fig.

# 56. Lanteglos by Camelford 1

SX 0881 8232; PL32 9RG

The cross-shaft stands in the churchyard of St Julitta's church, to the east of the south porch. There is full public access.

The cross-shaft was first recorded in 1858, propping up a barn wall at Lanteglos.[246] This is probably where Polsue described it, in 1870, in the farmyard on Castle Gough estate,[247] this being 200m (650ft) north-west of the church site. In 1875, it was in the rectory garden at Lanteglos,[248] where it was photographed in 1890, supporting the cross-head of Lanteglos 2.[249] It was moved to its present location in 1900 when Rev. R.J. Roe was clergyman;[250] see also no. 90 Sennen, Trevear.

The cross-shaft stands 1.95m (6ft 5in) high. It is neatly shaped, tapering slightly towards the top. In the top is a small socket, 4.5cm (1.77in) in diameter and now 3cm (1.18in) deep; however, since the top of the shaft is broken, the socket could originally have been deeper. Presumably a cross-head was originally fixed into this socket, and it seems likely that the cross-head no. 57 Lanteglos by Camelford 2 was originally attached to this shaft. Their proportions, style and the material from which they are both carved all fit this theory;[251] the 1890 photo helps to support it too. Antiquarian illustrations show that the shaft has a tenon on the bottom that would once have fitted into a base, although this is not now visible and the base is lost.[252]

The shaft is undecorated except for one small incised Latin cross on one face. This face contains most of the inscribed text, the rest being on one narrow side of the shaft. The four lines of text read vertically downwards using a predominantly capital script. The text is now rather difficult to read but earlier drawings and photographs suggest a reading of ÆLSEL[Ð] 7 GENE[REÐ] WROHTE ÞYS[NE] [SYBSTEL] FOR ÆLWYNEY[S] [SO]UL 7 [FOR] HEY[SEL]. This is a Middle English text, possibly of the late eleventh or twelfth century, and the names appear to be English in origin.[253] A possible translation is 'Aelselth and Genereth made this ?family-stone for the soul of Aelwine and for ?themselves.'

This stone is important because the dating of the inscription places it in a transitional period at the very beginning of the Norman period, the late eleventh or early twelfth century. Yet the stone has features that look back to older types of monument. For example, the absence of decoration and the vertical inscription liken it to the early medieval (broadly fifth- to eighth-century) inscribed memorial stones. On the other hand, the well-cut shaft, socketed head and tenon are features common to many of the decorated early medieval crosses in Cornwall. In contrast, the simple cross-head (no. 57 Lanteglos by Camelford 2) is of a style that has much in common with the later medieval wayside crosses, of which examples can be seen in the churchyard at Lanteglos.

The name 'Lanteglos' is *nant-eglos, 'church valley',[254] and the location and Celtic dedication, to St Julitta, are suggestive of an early medieval origin. By the eleventh century, if not earlier, it was

associated with the important manorial centre of Helstone, which later became a principal manor of the Earls and then Dukes of Cornwall, with the church lying on the edge of their deer park. It is possible that the stone commemorates an early steward of this manor.

See also the parish page.

## References

Langdon, Arthur G. (1896), 22, 169; Okasha (1971), no. 69, pp. 90–91 and figs; Okasha (1993), no. 22, pp. 141–45 and figs; Langdon, Andrew G. (1996b), 42, no. 54 and fig.; Preston-Jones and Attwell (1997) and figs; Preston-Jones and Okasha (2013), 164–66 and figs.

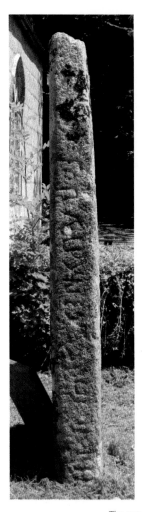

The two inscribed faces of the Lanteglos 1 cross-shaft.

# 57. Lanteglos by Camelford 2

SX 0882 8233; PL32 9RG

The cross-head is in the churchyard of St Julitta's church, to the east of the south porch, set into a modern granite base. There is full public access.

The cross-head was first recorded in 1858 in the rectory grounds,[255] the rectory being immediately north-east of the church. In 1870, Polsue recorded it in the rectory grounds, 'on a rockery in the centre of an ornamental sheet of water'.[256] In around 1900, it was fastened on to the top of Lanteglos by Camelford 1 in the rectory garden;[257] but by 1906 it had been moved to the churchyard.[258]

This monument is the head only of a wheel-headed cross standing 0.62m (2ft) high. It has a roll-moulding around the edge and, within this, widely splayed arms and a small central boss. In the sunken spaces between the cross-arms are four small bosses. The cross-head probably dates from the late eleventh or early twelfth century.

The narrow cross-section, overall proportions and careful layout of this cross-head, along with its stone-type, suggest that it may originally have been fixed to the top of the inscribed cross-shaft Lanteglos 1. A past rector of Lanteglos certainly believed this to be the case, for the two were united for a short time at the end of the nineteenth century, as a feature beside a pond in the rectory garden,[259] where they were photographed by Sir Thomas Franklen in 1890.[260]

## References

Langdon, Arthur G. (1896), 169–70 and fig.; Okasha (1993), 141; Langdon, Andrew G. (1996b), 42, nos 54, 55 and figs; Preston-Jones and Attwell (1997) and figs; Preston-Jones and Okasha (2013), 166–67 and figs.

Illustration showing the two stones, Lanteglos 1 and 2, combined, as they may have been originally (illustration by Daniel Rose-Jones, based on Langdon, Andrew G., 2020, fig. 19).

# 58. Lelant

SW 5477 3773; TR26 3DY

The cross stands in the middle of the cemetery 50m (182ft) west of the parish church. There is full public access.

In 1850, Hingston was the first to record and illustrate one face of this cross, which then stood in Lelant village.[261] In 1856, Blight illustrated the opposite face;[262] Blight also noted that the cross stood on Lelant Lane, between Longstone and Lelant church.[263] Lelant Lane was on the main route between Hayle and St Ives by

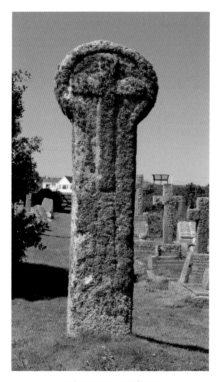

Lelant cross, east face.

ferry, before the causeway was built in 1826.[264] Miners passing by are said to have attacked the cross with their pick-axes,[265] while fishermen daubed it with paint; it also had 'popery' painted on it.[266] In the spring of 1878, the cross was removed to the centre of the new cemetery and set up on a grass mound at a point where four paths meet.[267]

The wheel-headed cross stands 2m (6ft 7in) high. It has a crucifix carved in relief on one face with a Latin cross carved in relief on the reverse. Enclosed by a bead or roll-moulding, the crudely carved, doll-like crucifix figure is depicted with the head leaning slightly to the right, a rounded body, arms outstretched and elongated legs. The Latin cross on the back is well executed, with broad parallel arms, the lower of which extends almost halfway down the shaft. The simple geometric style suggests a twelfth-century date.

This is one of nine surviving crosses in the parish. Until the middle of the sixteenth century, Lelant was the mother church of St Ives and funeral processions would walk the church paths to Lelant church for burial. Some of these paths, including Lelant Lane, were marked by wayside crosses, guiding the way to the parish church, and this cross might have had such a function.

See also the parish page.

## References

Langdon, Arthur G. (1896), 144–45 and figs;
Langdon, Andrew G. (1997), 32, no. 40 and fig.

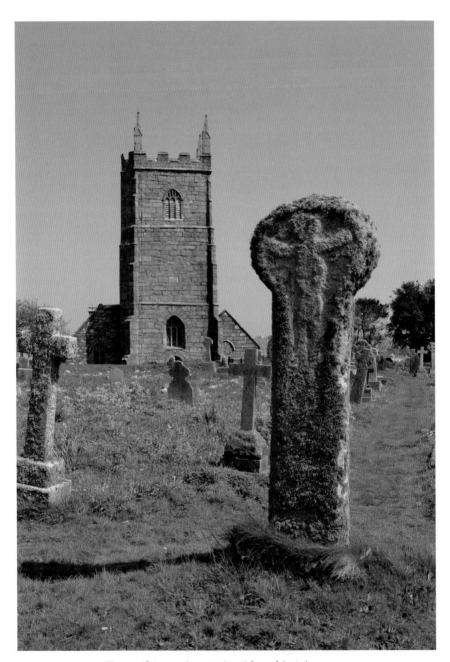

The crucifixion on the main (west) face of the Lelant cross.

# 59. Lesnewth

SX 1306 9030; PL35 0HR

The cross is situated opposite the south porch of St Michael's parish church, where a footbridge crosses a stream and leads towards Tregrylls. There is full public access.

Polsue was the first to record this cross and he observed that the head had been desecrated.[268] In 1873, Maclean recorded that the cross-head had lain for a considerable time on a piece of waste ground on the east side of the churchyard, having been rescued by Rev. G.W. Manning from a neighbouring farmer who had hollowed out one side for use as a pigs' trough.[269] His illustration shows that by then the ancient cross-head had been set up on a modern shaft and base.

The restored cross stands 2.26m (7ft 5in) high and contains an irregular cross carved in relief. The arms extend from an almost diamond-shaped centre and are widely expanded at their ends. At the bottom and sides, the arms merge into the prominent moulding or bead around the perimeter of the head. There are projections at the neck, but the reverse face has been completely hollowed out, erasing all decoration. The simple geometric style of the carved cross-head suggests a twelfth-century date.

Maclean believed that the cross-head may have belonged to the decorated shaft on Waterpit Down (no. 69 Minster), but Langdon disagreed, suggesting that the Waterpit Down shaft was more likely to have had a four-holed cross-head.[270] The Lesnewth monument is not the only cross-head that has been hollowed out for mundane, secular use: others exist, for example in the parish of Altarnun.[271]

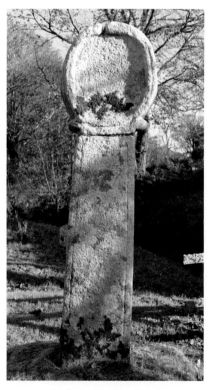

The back of the cross-head, hollowed out to form a trough.

## References

Langdon, Arthur G. (1896), 165 and fig.;
Langdon, Andrew G. (1992a), 47, no. 68 and figs.

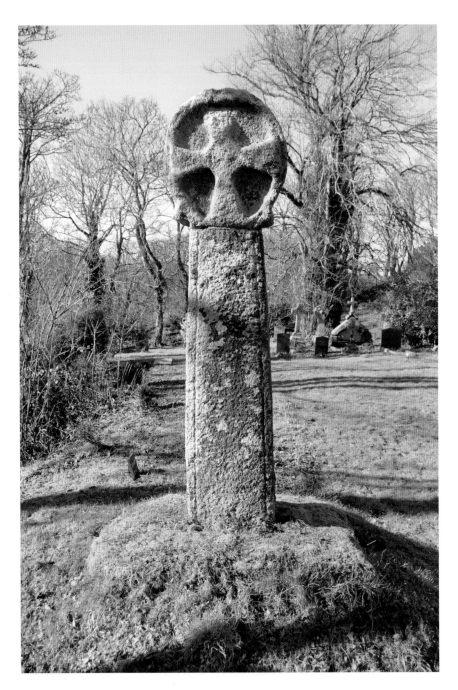

# 60. St Levan

SW 3803 2219; TR19 6JT

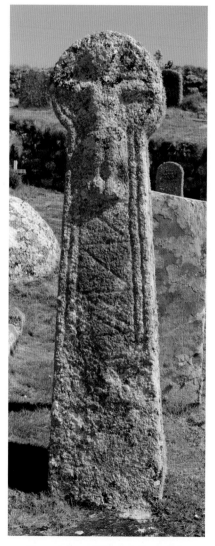

The main face of St Levan's Cross, with crucifixion and incised decoration.

The cross stands in the churchyard of St Selevan's church, near the south door. There is full public access.

The cross was first recorded in 1842 in the churchyard,[272] and it was certainly recorded in its present location in 1861.[273] Langdon considered it to be probably in situ.[274]

This complete cross stands 2.15m (7ft 1in) high and is set in a rough granite base, which may be original. The tapering rectangular shaft supports the simple round cross-head. Incised edge-mouldings frame the decoration on the shaft. A crucifixion and cross on the head are carved in shallow relief, but the decoration of simple zig-zags and diamonds on the shaft is all incised. The figure of Christ on the main face stands alone, without any supporting cross. His head is inclined very slightly to the right and has a hint of a halo. He wears an unusually full knee-length garment. The legs are slightly apart and the feet, which are projecting forwards, rest on a small ledge. On the back is a relief-carved cross with square terminals, whose long shaft runs all the way down the cross-shaft to terminate on an incised triangular pedestal.

The cross dates from the twelfth century. The crucifixion is typical of Romanesque representations, with arms outstretched, head slightly inclined to the right, feet side by side, on a suppedaneum, or ledge, and with a knee-length loincloth.[275] The form of the carved cross on the back is unusual, the only other example in Cornwall being on the churchyard wall north of St Levan church;

160

it is a late example of a wayside cross, with a chamfered shaft, presumably copied from this cross. The carved cross with long shaft resembles a medieval processional cross, while its triangular base is similar to the stylized hills of Calvary seen on some medieval grave-slabs.

Set in the bottom of a small remote valley close to the coast, with a Celtic dedication and a small curvilinear churchyard, St Levan is likely to be a site of early medieval origin. It is a chapelry of St Buryan, whose early medieval land-owning church retained collegiate status throughout the medieval period. This fine cross may possibly be attributed to St Levan's relationship with its mother church.

See also two further crosses in the churchyard, as well as two more beside footpaths within walking distance of the church.

## References

Langdon, Arthur G. (1896), 298–99 and figs; Langdon, Andrew G. (1997), 35, no. 47 and fig.; Preston-Jones and Okasha (2013), 239–40 and figs.

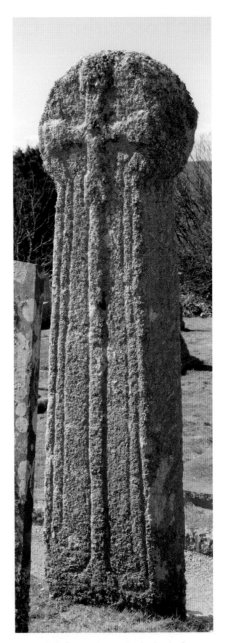

Relief-carved cross on the back of St Levan's churchyard cross.

# 61. Lostwithiel, Crewel Cross

SX 0893 5909; PL22 0DZ

The cross is situated on a grass island in front of No Man's Land cottages, at the junction of the A390 St Austell to Liskeard road with the B2269 Bodmin to Fowey road. There is full public access.

The cross was first noted by Gough in 1765; he stated that a mile from Lostwithiel on the road to St Austell is 'a cross being a long stone surmounted with a disk on which is cut a cross, raild round at a trivia'.[276] In 1870, Polsue recorded that the cross had been reused in a stile at No Man's Land.[277] A drawing by Langdon shows that while the cross-head and upper part of the monument were used as the bottom step, the remainder of the shaft was used as the stride bar.[278] However, through the efforts of Richard Foster of Lanwithan, St Winnow, the two parts of the cross were removed from the stile,

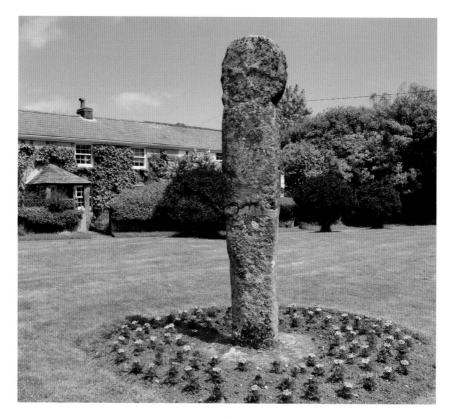

pinned together and set up on the green at No Man's Land on 2 October 1901.[279]

The cross is wheel-headed and stands 2.79m (9ft 2in) high. It has an equal-armed cross in relief with widely splayed curved arms extending to the edge of the stone. The reverse (west) face is similar, and includes a small central hole between the cross-arms. On the east side, an extended lower arm is carved with incised lines; it runs midway down the shaft, terminating with circles at each end. The cross-head has been trimmed down one side, damaging part of the equal-armed cross, while the lower part of the shaft has been bevelled or chamfered, perhaps to create a smoother top for the stride bar of the stile. The simple geometric cross on each face suggests a post-Norman Conquest date, probably the twelfth century.

This is one of several crosses that have been discovered built into stiles; another was found at Chapel Moor in Gwennap,[280] while the cross at Brane in Sancreed, no. 89, still forms an upright to one side of a stile.[281] The extended lower arm is a feature also found on a cross at Tregaminion in Tywardreath which formerly came from Lanlivery parish (see no. 55 Lanlivery, Milltown).[282] The stile where the Crewel Cross was discovered is close to the parish boundary between Lanlivery and Lostwithiel.

## References

Langdon, Arthur G. (1901–09), fig.; Langdon, Arthur G. (1901), 130–34 and figs; Langdon, Andrew G. (2002), 52, no. 63 and fig.

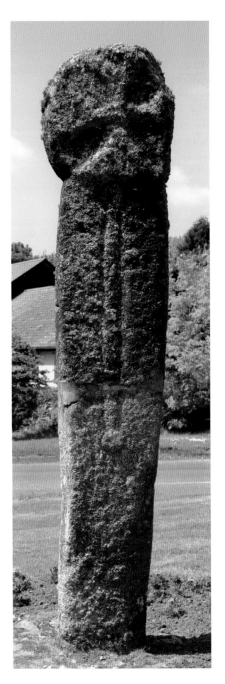

# 62. Ludgvan

SW 5053 3302; TR20 8EY

The cross stands on the south-east edge of the churchyard of the parish church. There is full public access.

This cross was first mentioned by Blight in 1856, who only noted its similarity to the cross at Brane in Sancreed.[283] In 1896, Langdon recorded and illustrated the cross, where it still stands today; he considered it to be in situ.[284] Henderson thought that only the base-stone was in situ and that the cross was too small for the socket in the base-stone,[285] The base-stone may therefore have supported the original churchyard cross, a fragment of which may be the stone built into the belfry steps of the church tower.[286]

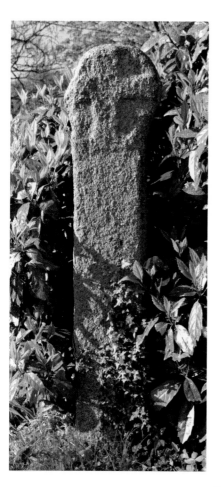

The monument stands 1.78m (5ft 10in) high. It is a wheel-headed cross from which part of the wheel-head has been chipped away. On its face is carved a broad-armed Latin cross whose lower arm runs a third of the way down the shaft, while the remainder of the shaft is plain. The back contains another broad-armed cross, separated by a bead or roll-moulding placed diagonally across the neck. On both faces, the arms of the cross extend to the full width of the cross-head. The simple geometric cross design, with the absence of any further decoration, suggests a twelfth-century date.

As Henderson noted, the base into which the cross is fixed has too large a mortice for this monument, which is therefore assumed to have been a wayside cross brought into the churchyard for preservation.

See also the parish page.

## References

Langdon, Arthur G. (1896), 114–15 and figs;
Langdon, Andrew G. (1997), 39, no. 54 and fig.

# 63. Mabe, Helland

SW 7526 3141; TR10 9BP

The cross stands on a grass bank in a garden at Helland, close to the road from Treverva to Constantine. The cross is on private property but can easily be viewed from the public roadside.

The cross was first recorded and illustrated by Langdon, who noted that there was once an ancient chapel at Helland.[287] He stated that the cross had been found by a farmer, William Rail, along with an old font and a quantity of roofing slates thought to be from some ancient buildings. Henderson recorded that the area where the monuments were discovered was formerly known as the 'graveyard'.[288]

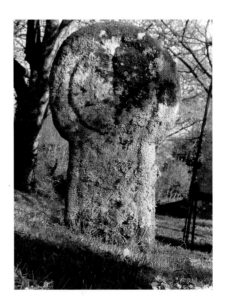

The wheel-headed cross stands 1.12m (3ft 8in) high. It contains a sunken equal-armed cross, formed by four raised triangular areas and a bead or roll-moulding. The moulding continues down the shaft, and within it there is an incised square containing incised diagonal lines. The reverse has an equal-armed incised cross within a bead or roll-moulding that encloses it. The ends of the incised cross-arms terminate in small sunken circles and a bead or roll-moulding runs down the sides of the shaft. At the neck of the monument there is a small circular projection on each side. The incised and probably compass-drawn cross on each face suggests a post-Norman Conquest date, probably of the twelfth or thirteenth century.

The name Helland is from Cornish *hen-lann*, meaning 'ancient church site' or 'old cemetery'.[289] Today, the 'graveyard' is an oval enclosure that forms the front garden of Helland House.[290] The incised cross on the monument is similar in style to one on two small crosses in nearby Budock churchyard,[291] and to another at Trewardreva in Constantine (no. 25), suggesting this is a local style. It can also be compared with the cross at Predannack in Mullion (no. 71).

## References

Langdon, Arthur G. (1896), 323–24 and figs; Langdon, Andrew G. (1999), 48, no. 70 and fig.

# 64. Madron 1, Boscathnoe

SW 4543 3150; TR20 8SP

The cross is situated two fields south of the parish church and stands beside a footpath leading from Penzance to Madron churchtown. There is full public access.

In 1856 the cross was illustrated by Blight beside the footpath with St Madernus's church in the background.[292] In 1896, Langdon recorded and illustrated the monument suggesting that it was in situ in a field called Cross Close.[293] During September 1995, the cross was illegally dug up by a person who did not realize that it was a protected monument; however, the cross was quickly brought back and re-erected in its former position.[294]

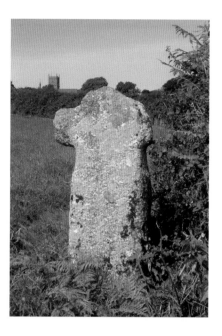

This Latin cross stands 1.4m (4ft 7in) high. In the past, it has been damaged, having had part of one horizontal arm and one upper arm broken off. Langdon illustrated the cross with an incised panel and additional diagonal lines forming a cross within the panel. However, prior to the cross being re-erected in October 1995, a close examination was made, but no decoration could be discerned. This simple Latin cross is difficult to date precisely, although the absence of any decoration may suggest a twelfth- or thirteenth-century date.

This wayside cross apparently marked the path from Penzance, via Heamoor, to the parish church. It was repositioned by a few feet during the 1960s,[295] but is probably still close to its original position.

## References

Langdon, Arthur G. (1896), 313–14 and fig.;
Langdon, Andrew G. (1997), 43, no. 62 and fig.

# 65. Madron 2, Boswarthen

SW 4450 3253; TR20 8PA

The cross stands beside a minor road leading to Boswarthen Farm, 1.2km (0.7 miles) north-west of Madron. There is full public access.

According to Cooke,[296] this cross may be the one mentioned in 1844 as having been vandalized by miners.[297] In his sketchbook, Blight illustrated the cross broken, with the upper part of the shaft and head lying against the base-stone, which had the lower part of the shaft still fixed in it.[298] In 1856, however, Blight showed the shaft complete with no fractures,[299] which Cooke suggested could be artistic licence. Langdon illustrated both faces of the monument showing the

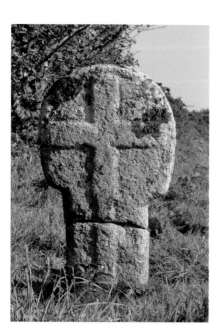

fracture in the shaft, and stated that the cross was in situ.[300]

The cross stands 1m (3ft 3in) high. Both sides contain a neatly cut Latin cross carved in relief, with a slightly narrower lower arm running down the entire length of the existing shaft. Each face has an enclosed bead or roll-moulding around the wheel-head. However, the east face shows a cross that has expanded ends to its arms and a central depression between the arms, whereas the west face shows a narrow parallel-armed cross in relief. The bottom of the shaft is socketed through a circular base-stone. The simple geometric style suggests a twelfth-century date.

The stumpy proportions of this cross suggest that it may originally have been taller, but without removing the shaft from its base-stone and confirming whether a tenon exists, it is not possible to be certain. The cross marks the old church path from Boskednan, through Boswarthen to Madron Churchtown.

## References

Langdon, Arthur G. (1896), 115–16 and figs;
Langdon, Andrew G. (1997), 49, no. 73 and fig.

# 66. Menheniot, Tencreek

SX 2542 6438; PL14 3AQ

The cross stands on the south-east side of St Martin's churchyard, Liskeard. There is full public access.

This cross was first recorded and illustrated by Langdon in 1903, when it was in use as a gatepost on Tencreek Farm in the neighbouring parish of Menheniot.[301] Langdon again illustrated the cross in 1906,[302] but by 1908 it had been restored and set up in its present position on a new base-stone.[303]

This Latin cross stands 2.1m (6ft 10in) high. It is well proportioned, with short upper and horizontal arms, and additional incised Latin crosses are carved on both faces, their lower arms extending the full length of the shaft. When first discovered at Tencreek Farm, the horizontal arms of the monument had been cut off to enable the cross to be used as a gatepost; however, a local stonemason restored the cross with new arms. As the Latin cross has no chamfers, it probably dates from between the twelfth and thirteenth centuries.

A footpath runs from Liskeard through Tencreek to Menheniot churchtown, changing to a minor road near Tregrill. The cross may have marked this route between parishes or a route to a medieval chapel or oratory, which was licensed in 1385 at Trencreek.[304] A field under Tencreek is recorded as 'Cross Park', no. 396 on the 1840 Tithe Apportionment map for Menheniot at SX 2650 6340.

See also another cross in the churchyard.

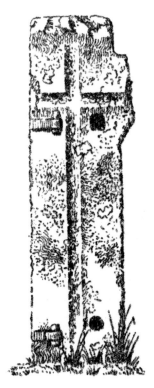

This illustration of the cross by Arthur G. Langdon (1906, 430) shows it before restoration. Gate hangings are still in place and the arms cut off to enable the stone to be reused as a gatepost.

## References

Langdon, Arthur G. (1901–09), fig.; Langdon, Arthur G. (1906), 438–39 and fig.; Langdon, Andrew G. (2005), 47, no. 62 and fig.

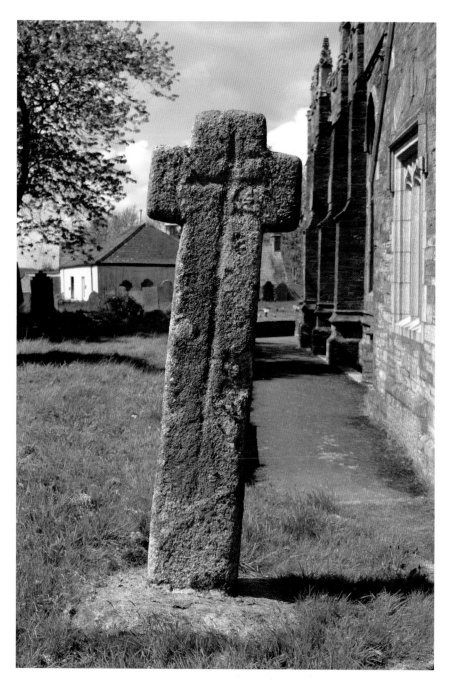

# 67. Michaelstow

SX 0807 7885; PL30 3PD

The cross stands at the west entrance to Michaelstow churchyard. There is full public access.

In 1870, Polsue noted that 'at the foot of the steps leading to the churchyard lies the shaft of an ancient granite cross, about 12 feet in length'.[305] Maclean later added that it formed the lowest step of a flight leading from the village green into the churchyard.[306] Langdon recorded that the cross-shaft was removed from the steps in the autumn of 1883. At that time, the remainder of the cross-head was discovered nearby, and the cross was restored and set up in its present, dramatic position.[307]

This tall cross stands 3.4m (11ft 2in) high. Its elegant cross-head

The Michaelstow cross stands at the top of the churchyard steps, to the right of the church.

has an equal-armed cross with narrow parallel-sided arms within a bead or roll-moulding. The triangular areas between the arms have been completely cut away to form a four-holed cross. Below the head at the neck is an abacus or collar, which forms a raised band around the monument. The shaft is plain, except for a narrow bead or roll-moulding running down the edge. The monument is set in a modern square granite base-stone.

This cross is similar in style to the four-holed crosses at Laneast (no. 48 Laneast 1) and at Lawhitton, all of them having the triangular areas between the cross-arms cut away to create four holes and having a raised collar or abacus at the neck. Except for the fact that the areas between the cross-arms are cut away, the style of the cross resembles those of the wheel-headed crosses no. 1 Advent and no. 72 Mylor, whose simple geometric forms suggest a post-Norman Conquest date. All these large, undecorated, four-holed churchyard crosses are therefore likely to be of a similar date, probably in the twelfth century.

## References

Langdon, Arthur G. (1896), 186–87 and fig.;
Langdon, Andrew G. (1996b), 55, no. 80 and fig.

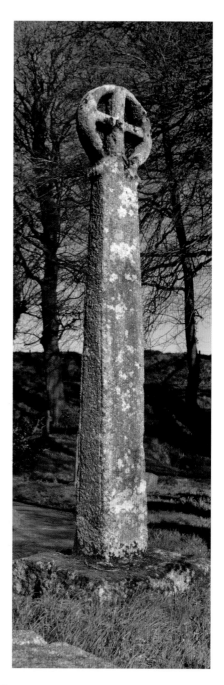

# 68. St Michael's Mount

SW 5144 2981; TR17 0HT

The cross stands on a cliff-edge on the south side of St Michael's Mount. The cross can only be viewed from a distance and National Trust admission charges apply.

Blight first illustrated this stone in 1856.[308] In 1896, Langdon illustrated and recorded the cross in its base on the west side of the island, although this was probably an error since the first edition Ordnance Survey map of circa 1880 shows the cross where it is now, on the south side.[309]

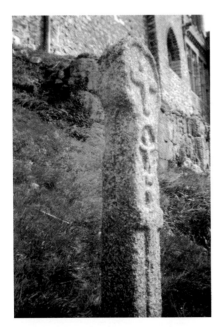

Image from the 1950s by Mary Henderson shows the decoration on the south face of the cross (Andrew Langdon collection).

The cross stands 1.83m (6ft) high. On one side, the head contains an equal-armed cross with parallel arms carved in relief, enclosed by a bead or roll-moulding. Below this, on the upper part of the shaft, is carved a small crucifix figure in relief, within an oval recess. Beneath this, running the remaining length of the shaft, is a broad parallel-armed Latin cross in relief. On the back, another broad parallel-armed cross is carved in relief, the upper and horizontal arms within the wheel-head and the lower arm running the full length of the shaft. The cross stands in a circular base-stone. This wheel-headed cross is unique in having two crosses and a crucifixion carved on its face. The crucifixion is very small and simple, but the raised arms and overall form of the cross confirm a post-Norman Conquest date, probably in the twelfth century.

The cross stands in a dramatic cliff top position on the south side of the island. Here it is overlooked from the castle's curtain wall and is an eye-catching view from the formal gardens below: it may well have been moved to its present position as a landscape feature. This deliberate positioning is certainly characteristic of other crosses on the Mount. The Trevean Cross, originally from St Erth,[310] has also been set up on a cliff top in the private gardens and a tall slender lantern cross from Redruth, standing in a dramatic cliff-top location, can be identified in historical views of the Mount.[311]

See also the remains of four more crosses on the Mount and the causeway,

two of which are not accessible but can be viewed from the public areas; the others survive as a base and shaft only. There is also a fine lantern cross-head in the chapel.

## References

Langdon, Arthur G. (1896), 150–51 and fig.; Langdon, Andrew G. (1999), 40, no. 56 and fig.

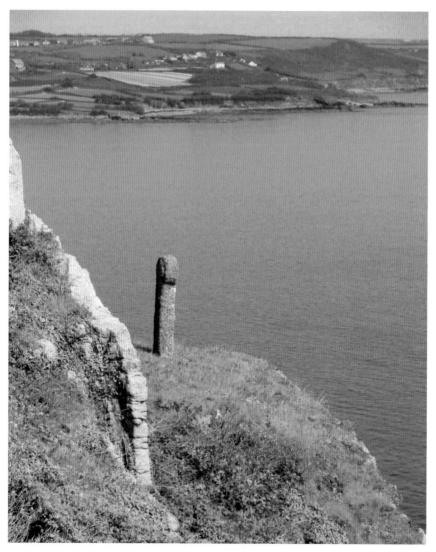

The St Michael's Mount Cross looks out over the ocean from its cliff-edge perch.

# 69. Minster, Waterpit Down

SX 1119 8807; PL32 9SE

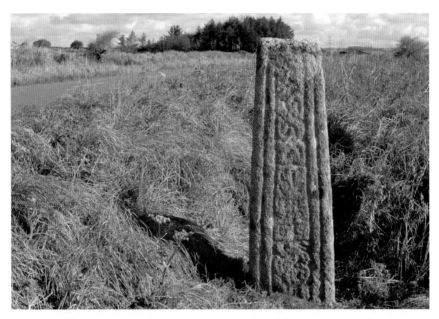

Interlacing patterns and inscription on the main face of the Waterpit Down Cross.

This cross-shaft stands in a base on the roadside, on the left of the unclassified road from Tintagel to Davidstow, 0.5km (approx. 0.3 miles) beyond the junction with the B3266. There is full public access.

The cross-shaft was first recorded in 1838 in its present location.[312] In around 1856, the shaft was moved to a nearby farm, Trekeek, where it was used to work the pivot of a horse-powered threshing machine.[313] However, the base remained in situ, and the shaft was returned to it in June 1889.[314]

This is the shaft of a large decorated cross standing 2.08m (6ft 10in) high. In

the top are the remains of a rectangular socket, into which the cross-head would have been morticed. The shaft is slightly broken at the top, the damage perhaps caused when the cross-head was knocked off. Flat band mouldings frame the worn and very low relief decoration, which includes plant trails, knotwork and interlace as well as the inscription. The eroded inscription is set in five horizontal lines in a panel at the bottom of the main face of the cross. So worn is it that it is now uncertain whether or not it is complete, nor what script is used. Early readings differ from each other, but most

agree on the reading of the first two lines as CR VX for *crux*, 'cross', a reading that fits the remaining traces.[315] In this case, we would expect a personal name to follow.

The various features of this cross shaft, notably the low-relief carving, and decoration which includes plant scrolls and trails, show it to be a member of the Mid- and East Cornwall group of pre-Norman Cornish sculpture, dating from the mid-tenth to the eleventh century.

Although it is in a lonely and remote place, this cross was strategically placed. The modern road beside which it stands was a historical trackway linking the Tintagel area to Liskeard, over Bodmin Moor.[316] Tucked into a valley head 2.4km (1.5 miles) due north of the monument is Minster church, possibly the site of a pre-Norman monastery,[317] while 2.9km (1.8 miles) to the north-east is Lesnewth, whose name, containing the Cornish place-name elements *lys* and *nowydh*, means 'new court' and implies the court of a native Cornish ruler.[318] The cross might originally have been associated with either of these.

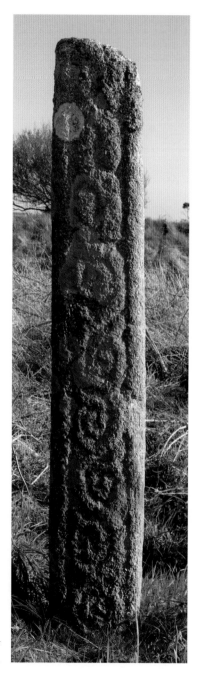

## References

Langdon, Arthur G. (1896), 374–77 and figs; Okasha (1993), no. 74, pp. 318–21 and fig.; Langdon, Andrew G. (1996b), 56, no. 83 and fig.; Preston-Jones and Okasha (2013), 168–69 and figs.

Spiral plant scrolls on the side of the Waterpit Down Cross.

# 70. St Minver, St Michael Porthilly

SW 9368 7535; PL27 6JX

The cross stands in the churchyard, outside the south door of St Michael's church; it is set in a modern granite base which is buried in grass. There is full public access.

At some time before 1870, the cross was moved to its present location 'from the western end of the Church'.[319]

The cross now stands 1.08m (3ft 9in) high, but only the head and the top part of the shaft survive of what must originally have been a massive ring-headed cross. Unusually, the cross-arms are straight with large wedge-shaped ends. On the front

only, there is a large central boss. The four segments between the cross-arms and the ring are deeply hollowed out, but in each only a small hole has been completely cut through. A little worn decoration survives on the shaft, but insufficient to determine the pattern. The cross probably dates from the tenth or the eleventh century.

St Michael Porthilly is, with the similar site at St Enodoc, a chapel of ease to St Minver, in the lowland part of St Minver parish. Both St Michael and St Enodoc are set on the edge of the wide estuary of the River Camel, opposite

The church of St Michael Porthilly is perched on the low cliff edge, overlooking the Camel Estuary, close to the popular resort of Rock.

Padstow, with tidal waters lapping the churchyard wall at St Michael. An early medieval origin seems probable for both. The style of the cross is unique in Cornwall, with the best parallels being found in the early sculpture of places as far away as the Isle of Man and Wales. This may hint at past maritime contacts between the Camel Estuary and places around the Irish Sea.

## References

Langdon, Arthur G. (1896), 385–86 and figs; Langdon, Andrew G. (1996b), 58, no. 86 and fig.; Preston-Jones and Okasha (2013), 170–71 and figs.

# 71. Mullion, Predannack

SW 6705 1703; TR12 7HA

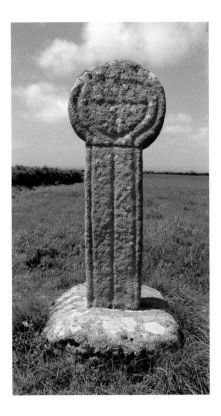

The cross stands beside an old church path between Predannack Manor and Mullion churchtown. There is full public access.

Penaluna first recorded this cross in 1838, as a large 'moorstone cross' about 5ft (1.5m) in height.[320] In 1856, Blight illustrated the cross, stating that it stood near the site of an ancient chapel.[321] In 1852, Harvey recorded the cross lying in a ditch, although he was unsure whether this was through an accident or was

deliberate; the cross was then set up again in its original base-stone.[322] In 1896, Langdon illustrated both sides of the monument, confirming that the cross was in good condition despite the events of 1852.[323]

This wheel-headed cross stands 1.66m (5ft 6in) high. It has on one face a broad Latin cross in relief, with expanded upper and horizontal arms, enclosed around the head and shaft by a bead or roll-moulding. The other face contains a single-line incised Latin cross, within an incised ring, with the lower arm extending the full length of the shaft. There is a similar bead or roll-moulding around the head and running down each edge of the shaft. The shaft is mortised and tenoned into a weathered base-stone. The simple incised cross within an incised ring is similar to that on the grave-cover at Wendron church, a monument that is dated to the twelfth or thirteenth century,[324] and this is the likely date of this cross. The cross is very similar to others not far away, at Trewardreva in Constantine (no. 25) and at Helland in Mabe (no. 63).

There is a joint at the neck of the cross, and this fracture may have occurred during the events of 1852. Despite this incident, the cross is apparently in situ, and stands in a field known as Gwell Grouse, 'cross meadow'.

## References

Langdon, Arthur G. (1896), 283–84 and figs;
Langdon, Andrew G. (1999), 49, no. 73 and fig.

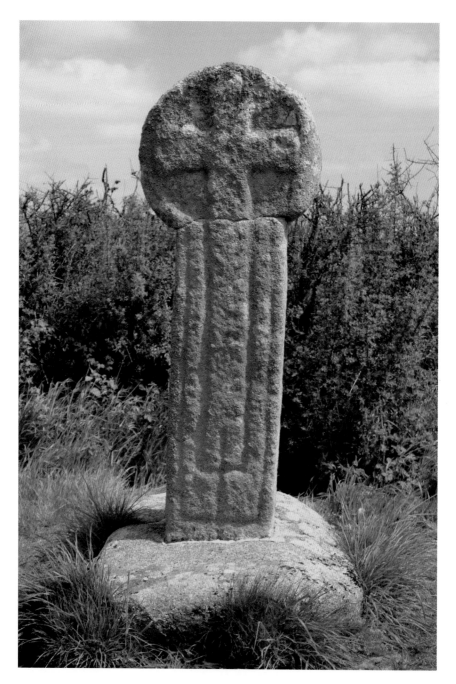

# 72. Mylor

SW 8202 3524; TR11 5UF

The cross stands on the east side of the south porch of Mylor parish church. There is full public access.

Polsue was the first to record this cross and to give a brief account of its discovery: 'At the commencement of the church restoration a granite post which had long done duty as a flying buttress

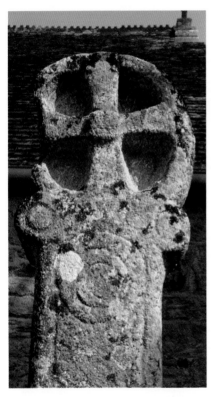

The head of the Mylor cross, showing the decoration of concentric circles.

against the south wall of the church had to be removed; on clearing away the earth in which it was deeply imbedded it was discovered to be a ponderous monolith granite cross, of the "round headed" type, 17 feet 6 inches in length.'[325] Iago, noting the tradition that it originally stood above St Mylor's grave, recorded that the cross was later re-erected close to where it had been discovered, by members of the crew of HMS *Ganges*.[326]

The cross now stands 3.13m (10ft 3in) above the ground. For some reason, when the cross was re-erected, a large portion of the shaft (some 2.21m or 7ft 3in) was buried below ground. If the below-ground length is taken into account, then this is by far the tallest cross in Cornwall, at 5.33m (17ft 6in). The tallest cross above ground level is no. 85 Quethiock at 4.06m (13ft 4in).

The cross is wheel-headed with an equal-armed cross carved on each face, formed by cutting deep triangular areas between the cross-arms. A central boss is carved on the west face only. At the neck of the monument are decorative projections, and directly below these on the west side of the shaft are three concentric incised circles. Running down either side of the shaft from these circles are parallel incised lines that form a plain panel, while the remainder of the shaft is undecorated. On the east side, a further set of three incised concentric circles can be seen. The simple geometric cross on each face, with only a little embellishment of the shaft, suggests a post-Norman Conquest date, probably of the twelfth

century. Similar concentric circles can be found on the Norman font at St Cuby in Tregony.[327]

The triangular areas are so deep that Langdon on visiting the cross in 1891 found a bird nesting in one of them.[328] The sculptor of the cross may have originally intended to cut the triangular areas straight through to form a four-holed cross, similar to no. 67 Michaelstow or the cross at Lawhitton.

## References

Langdon, Arthur G. (1896), 342–43 and fig.; Langdon, Andrew G. (1999), 50, no. 75 and fig.

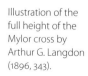

Illustration of the full height of the Mylor cross by Arthur G. Langdon (1896, 343).

# 73. St Neot 1, 2

SX 1859 6783; PL14 6NA

Collection of crosses in St Neot churchyard. St Neot 1 is on the left of the picture, with St Neot 2 balanced on top. On the right is a fifteenth-century lantern cross.

The cross-shaft (St Neot 1) stands in a base in the churchyard of St Neot's church, opposite the south door, amid a group of later medieval crosses. St Neot 2 is a small fragment of a cross-head now placed on top of St Neot 1. There is full public access.

The cross-shaft was first recorded in 1870 in the churchyard, lying against the south wall of the church.[329] In 1889 it was erected in an old base, which is apparently in situ, in its present location.[330] The piece of cross-head was found in around 1925;[331]

it was found 'in an old wall near the Church-yard' and kept near St Neot 1.[332]

The cross-shaft, St Neot 1, is 1.98m (6ft 6in) high. It is a large cross-shaft, of almost square section, with a marked entasis. Each face is divided into three panels, which are filled with interlace, plaitwork and knots. These are all neatly constructed in rounded strands, although in detail the patterning is irregular and asymmetrical. Langdon noted that the shaft 'is the best example of interlaced

work on a granite cross ... in Cornwall' and described it as 'proof of the superiority in workmanship of this stone compared with others [in Cornwall] ... all the interlaced cords lap regularly over and under each other.'[333]

This monument, the oldest of the group of crosses at St Neot, is a member of the panelled interlace group of crosses, and dates from the late ninth or early tenth century.

The fragmentary cross-head, St Neot 2, is 0.38m (1ft 3in) high. It is a section of a ring-headed cross-head consisting of the central area of the head with a boss, and with the stumps of three arms attached. On the longest arm are roll-mouldings representing the cusps of a trefoil-holed cross. On each of the stumps of the arms are the worn remains of a triquetra knot, carved in low relief. It is one of the small but dispersed group of crosses with trefoil openings in the head found in Mid- and East Cornwall and dating from the late tenth to the eleventh century. It can be compared, for example, with the cross at Prideaux Place, Padstow (no. 77 Padstow 3).

When the fragmentary St Neot 2 was found, it was thought to be part of the missing cross-head of St Neot 1.[334] However, the very different cross-sections of the two stones indicate that St Neot 2 is part of a separate monument: St Neot 1 is thick with a square cross-section while St Neot 2 is thinner and has a rectangular section. Moreover, the decoration on St Neot 2 is carved in much shallower relief than that on St Neot 1 and is clearly in a later style.

There was an early monastery at St Neot.[335] It possessed relics of two saints, Gueriir and Niot, and it was here, while hunting in Cornwall as a young man, that King Alfred is said to have been cured

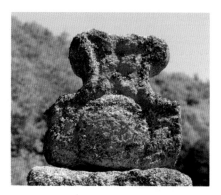

St Neot 2 cross-head fragment.

after praying at St Gueriir's shrine.[336] The date of this event (before 870) is probably too early for the cross-shaft to be directly associated with Alfred's visit, but the cross may perhaps be seen as the result of some continued association with the king. Although only a small fragment of St Neot 2 remains, it is of exceptional interest in representing continued activity at a site that had been of significance in the time of King Alfred, but was on the brink of extinction in 1086. In 1086, the *clerici Sancti Neoti* are recorded as holding the manor of Neotestou, although 'The Count has taken all this land away from the Church, except for 1 acre of land, which the priests have.'[337] The community is not recorded again.

See also the parish page.

## References

Langdon, Arthur G. (1896), 405–07 and figs; Preston-Jones and Rose (1986), 159; Langdon, Andrew G. (2005), 50–51, no. 67 and no. 67a and figs; Preston-Jones and Okasha (2013), 171–73 and figs.

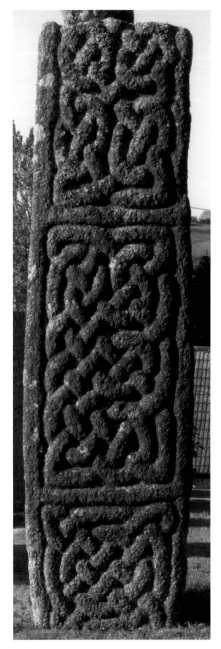

St Neot 1, north face.

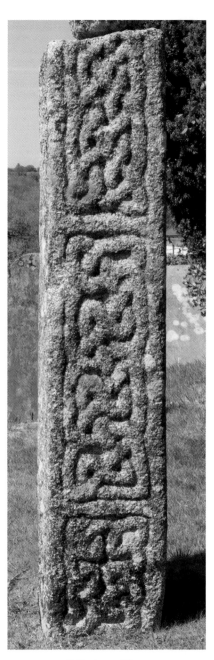

St Neot 1, east face.

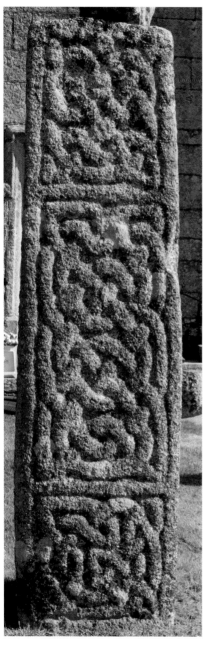

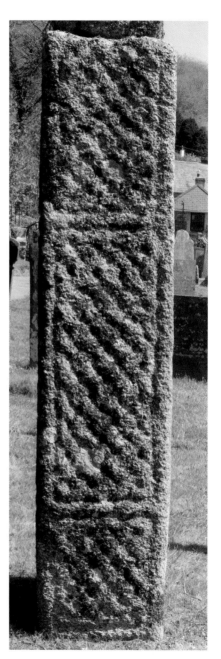

St Neot 1, south face.

St Neot 1, west face.

# 74. St Neot 3, Four Hole Cross

SX 1715 7496; PL15 7TX

The cross stands on an embankment beside the A30, west of Jamaica Inn, set in a modern base. Although there is full public access, great care is needed.

The cross was first recorded in 1748;[338] according to Thomas, it was probably then on the north side of the road.[339] In 1780, the cross was recorded with the top of the cross-head (now lost) lying on the ground beside it.[340] By 1880 the monument was near its present location, on the south side of the road.[341] In October 1995, the monument was moved prior to road-widening; excavation then undertaken suggested that it had been set in concrete in the late nineteenth century. It was erected in its present location in June 1996, in a modern base.[342]

This near-complete ring-headed cross stands 2.7m (9ft) high and is one of the most impressive crosses in Cornwall. Because the top of the head is missing, it has a distinctive outline. The tapering shaft has a slight entasis and is very narrow in relation to its width. The large cross-head has widely splayed arms and a small central boss, with a neat triquetra knot in each arm. A broad incised edge-moulding frames the decoration on the shaft. On the front is a plant trail of lush, curling acanthus-type leaves, the stems clipped to the sides of the shaft. On the back is a bushy plant scroll, in which two separate central stalks are bound by a band at the point from which the fleshy curling leaves fall outwards (see Introduction, Fig. 10). A further running plant trail climbs up one narrow face of the shaft, while a series of knots (Carrick bends) decorate the final side.

The fleshy acanthus leaves used for the plant trails and scrolls on three faces of this cross can be related to English art of the early Winchester school, as seen in an illustration at the beginning of Bede's *Life of St Cuthbert*.[343] The figure-of-eight knots seen on the narrow side are also a characteristic feature of Wessex sculpture of the period.[344] The decoration on the cross may suggest a date from the mid-tenth century. The patterns and form of this cross had a far-reaching influence on the design of further crosses in the area: acanthus-like plant trails feature prominently on crosses of the Mid- and East Cornwall group of the mid-tenth century to the eleventh century, from Padstow to Quethiock in south-east Cornwall.

The modern letters G, L and W, deeply incised halfway down the front of the shaft, make interpretation of the design in this area difficult. They indicate reuse of the cross as a boundary marker for Great Lord's Waste, a post-medieval tenement. Another Great Lord's Waste boundary stone can be seen on the side of Colliford Lake (SX 1639 7324).

The cross stands beside the A30 on formerly open downland at the heart of Bodmin Moor. Here it is also close to the boundary between the parishes of St Neot and Blisland and the hundreds of Trigg and West Wivelshire. It is therefore in a significant and prominent location on what is nowadays the main land route into

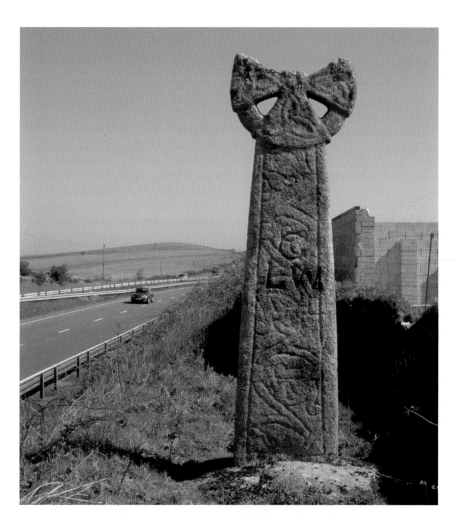

Cornwall. Use of this route may have been increasing in the tenth century as English dominance in Cornwall increased, and as St Petroc's monastery at Padstow, and later at Bodmin, rose to prominence in the later tenth and eleventh centuries. The position of the cross here might also be associated with an extension of settlement on to the moor towards the end of the early medieval period.[345]

## References

Langdon, Arthur G. (1896), 386–89 and figs; Langdon, Andrew G. (1996a), 26; Langdon, Andrew G. (2005), 55, no. 72 and fig.; Preston-Jones and Okasha (2013), 174–75 and figs.

# 75. Padstow 1

SW 9158 7539; PL28 8BG

This cross-head is in the churchyard of St Petrock's church, outside the south porch. There is full public access.

The cross-head was first recorded in around 1837, built into the south side of a garden wall of the old vicarage, immediately to the east of the churchyard.[346] In 1897, it was erected in its present location on a modern shaft.[347]

The cross-head is 0.5m (1ft 6in) high and consists of the head, and a small portion of the shaft, of a rectangular-section cross, set on a modern shaft. The complete monument is 1.92m (6ft 3in) tall. In the space between each of the arms and the ring are three cusps, forming trefoil-shaped openings. All the carving is in low relief and is now very worn. The edge-mouldings and central boss are clear, but only traces remain

of other carving. The cross is cut from greisen (an altered granite).

This is one of the small and dispersed group of late tenth-century to eleventh-century crosses in Mid- and East Cornwall that contain trefoil openings in the head. Other characteristic features of the group include the continuous double moulding encircling the head and triquetra knots in the cross-arms. This latter feature is not clearly displayed here but probably existed. This is one of two crosses at Padstow with trefoil openings in the head, the other being at Prideaux Place (no. 77 Padstow 3). Padstow was the pre-eleventh-century centre of St Petrock's monastery, and it may be that this feature was an innovation developed by stonemasons working in the monastic workshop. Two other crosses with trefoil-heads, no. 29 Egloshayle 1 and no. 24 St Columb Major, are also cut from greisen.

## References

Langdon, Arthur G. (1896), 196–97 and fig.; Langdon, Andrew G. (1996c), 17; Langdon, Andrew G. (1996b), 59, no. 89 and fig.; Preston-Jones and Okasha (2013), 176 and figs.

Padstow 1, showing the trefoil-shaped holes in the head.

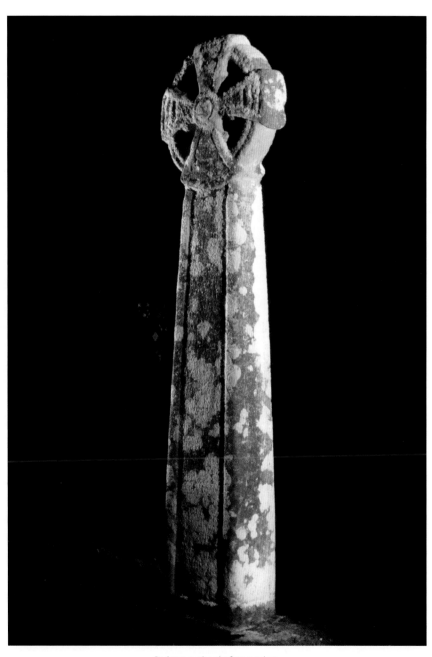

Padstow 1: the shaft is modern.

# 76. Padstow 2

SW 9158 7537; PL28 8BG

Remains of Padstow 2, which may originally have been one of the tallest crosses in Cornwall.

The cross-shaft stands in the churchyard of St Petrock's church, beside the south-east gate. There is full public access.

The cross-shaft was found 'firmly socketed in the basement' in March 1869 by the sexton, while digging the grave of a William Sowden on the south side of the church. In 1869, it was erected in its present location.[348]

This monument, standing 1.46m (4ft 9in) high, consists of part of the shaft and the base of a massive rectangular-section cross. It may have been deliberately broken up: Langdon records that there are the marks of three distinct wedges near the fracture. The wedge-splitting marks on the shaft suggest that the cross may have been broken up at some time between the sixteenth and eighteenth centuries.[349]

The decoration on the shaft, which comprises interlacing patterns and foliage work, is all in very low relief within wide, flat, prominent edge-mouldings. On one broad face is a panel of eight-strand interlace that Langdon identified as a complicated and unusual design with only limited parallels.[350] The other broad face contains a plant with three large fleshy leaves arising from a three-lobed base, probably an acanthus plant. One narrow face contains a simple ring-twist, while the other has a panel of plaitwork. As it displays both interlace and foliage decoration, this cross is a member of the Mid- and East Cornwall group; however, with decoration that is more ambitious and well executed than that of others in the group, it appears innovative and may

be an early example, perhaps dating from the mid-tenth or early eleventh century.

The size of the surviving section of shaft suggests that this cross might have been up to 4m (approx. 12ft) high, and therefore comparable with other tall crosses, such as no. 85 Quethiock and no. 93 St Teath. Its overall proportions and layout bear a close similarity to the cross at nearby Prideaux Place (no. 77 Padstow 3), which has a trefoil-holed cross-head. It is therefore a possibility (but by no means certain) that Padstow 2 also once supported a cusped head. The complex patterns employed suggest that the sculptor may have had access to manuscript models for his designs. Taking into account the other monuments at Padstow, it seems likely that there was a sculpture workshop active here, at the site of one of Cornwall's foremost early medieval monasteries. Such a workshop would have been influential and might possibly be the source of the Mid- and East Cornwall group and in particular the distinctive and uniquely Cornish trefoil cross-head.

## References

Langdon, Arthur G. (1896), 407–10 and figs; Langdon, Andrew G. (1996b), 59, no. 88 and fig.; Preston-Jones and Okasha (2013), 177–78 and figs.

Details of the decoration on Padstow 2: an acanthus plant on the front and a plait on one side.

# 77. Padstow 3, Prideaux Place

SW 9134 7551; PL28 8RP

This cross stands in the grounds of Prideaux Place, south of the house, on a lawn at the edge of woodland. There is limited public access with an entrance fee.

The cross-head has been known since at least about 1832; the shaft was found 'Some years since … in the grounds' by Mr Prideaux-Brune and erected by him in a modern base in its present location.[351] On the grass at the foot of the monument is a piece of cross-shaft, which was first noted in 1974 among the roots of a large tree. In 1987, when the tree was felled, the monument was removed and placed in its present position.[352]

The cross stands 1.85m (6ft) high and comprises the head and a part of

the shaft of a rectangular-section cross cut in Bodmin Moor granite. It is set in a modern base. The cross-head has wide-splayed arms with flat ends and curved arm-pits. In the space between the arms and the ring are three cusps, forming trefoil-shaped openings. The shaft has a wide, flat, edge-moulding within which are well-executed interlace, an acanthine plant trail and a spiral scroll, all in very low relief. As the decoration is truncated at both top and bottom, this must be a section from the middle of the shaft.

The fragment at the base of the cross appears to be a section from the shaft of a granite cross, which has been cut to a square block for reuse as building stone.

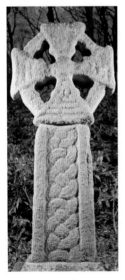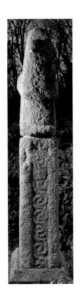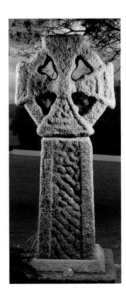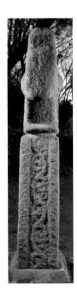

Images taken at night with lights help to highlight the decoration on Padstow 3.

The small piece of stone lying at the base of the cross may be part of the cross-shaft.

One wide and one narrow face have been cut away, but the other two faces contain wide flat edge-mouldings and possibly the remains of plaitwork.

In its original state, Padstow 3 must have been a substantial, distinctive and impressive monument: an original height of perhaps 3m (approx. 10ft) is likely. It is one of the small but dispersed group of late tenth-century or eleventh-century crosses in Mid- and East Cornwall, characterized primarily by the trefoil-shaped holes between the cross-arms in the head. Other characteristic features of the group include the widely splayed arms with triquetra knots, continuous double moulding surrounding the head and the low-relief carving with both plant scrolls and interlace or plaitwork on the shaft.

It has always been assumed that the cross-shaft and cross-head, which were found on separate occasions within the grounds at Prideaux Place, are parts of the same monument, and they certainly fit together well and stylistically they could all have belonged together; there is also the possibility that the separate fragment of stone was part of the shaft of this cross. Geologically, however, the stone from which the head is carved is slightly different from that of the shaft, even though both are Bodmin Moor granite. This therefore means either that the head was part of a separate monument, or that it was part of the same monument but carved of stone from a different source and socketed on to the shaft. Either is possible but, given the importance of Padstow, there could well have been a fourth cross here. The geology and type of decoration make it reasonably likely that the fragment lying on the grass is part of the cross-shaft.[353]

It is unfortunate that the original context of this cross is uncertain. At present, the cross forms a feature in the grounds of Prideaux Place, an Elizabethan mansion on the site of the medieval grange that farmed the Padstow estates of Bodmin Priory, the medieval successor of St Petroc's monastery. However, the status of this site before the Norman Conquest is uncertain. An original association with Prideaux Place is possible, but the cross (shaft, head or both) might easily have been brought here after the Reformation to act as an ornamental feature in the gardens. Alternatively, the cross may perhaps have been associated with Padstow's extended sanctuary.[354]

See also another cross at the Deer Park entrance.

## References

Langdon, Arthur G. (1896), 396–98 and figs; Langdon, Andrew G. (1992b), 164 and fig.; Langdon, Andrew G. (1996c), 26; Langdon, Andrew G. (1996b), 60, no. 91 and fig.; Preston-Jones and Okasha (2013), 178–80 and figs.

# 78. Paul 1

SW 4643 2707; TR19 6UA

The cross-head is mortared on to the top of a large boulder in the churchyard wall of St Paul's church. There is full public access.

The cross-head was first recorded in 1851 when it was 'on the wall of the church-yard';[355] Blight's 1856 illustration shows it at or near its present location.[356] In 1887, it was recorded as built into the churchyard wall, presumably in its present location, with the information that it 'was, at one time, stolen and hidden, but eventually was returned'.[357]

The monument stands 0.6m (2ft) high. Only the cross-head remains, with a tiny stub of shaft attached. On one side is a figure of Christ and on the other are five large bosses. Christ has a disproportionately large head with a halo and a rather pointed chin or beard.

Irregularities in the stone may represent the eroded remains of facial features such as eyes, nose and mouth.

With a crucifixion on one side of the cross-head and five bosses on the other, this cross-head is a member of the Penwith group of pre-Norman sculpture of the mid-tenth to the eleventh century. Its shaft may be built into the north wall of the church (see no. 79 Paul 2). If united, the head and shaft combined would result in a monument with a total height of nearly 2.5m (over 8ft). The Life of the patron saint suggests that Paul church may be the site of an early medieval monastery,[358] although it is not recorded as such in Domesday Book or in any other source.

See also a wayside cross at the entrance to the old vicarage, within walking distance of the church.

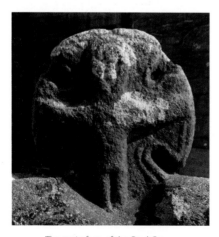

The main face of the Paul Cross, showing the crucifixion.

## References

Langdon, Arthur G. (1896), 192–93 and figs; Thomas, A.C. (1978), 78–79; Langdon, Andrew G. (1997), 50, no. 74 and figs; Preston-Jones and Okasha (2013), 182–83 and figs.

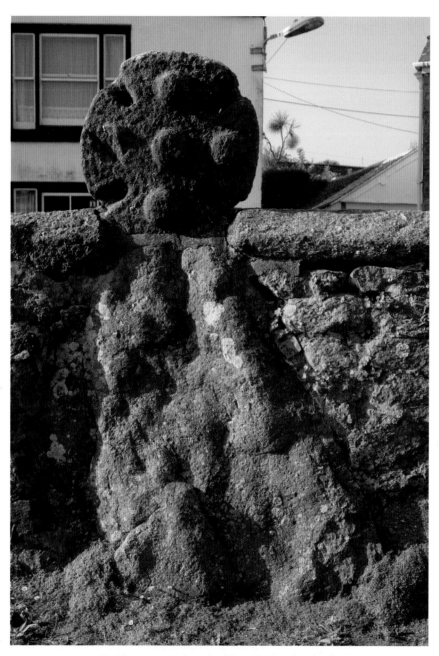
Paul Cross, mounted on a boulder in the churchyard wall.

# 79. Paul 2

SW 4646 2709; TR19 6UA

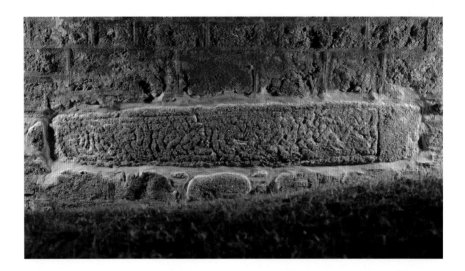

The shaft is built horizontally into the outer face of the north wall of St Paul's church, low down and near the east end of the wall. There is full public access.

The cross-shaft was first noted, in its present location, in February 2006 by Jill Hogben and Aidan Hicks.[359]

Only the shaft of the cross survives; if erect it would stand 1.86m (6ft 1in) high. What remains may be almost the complete original length apart from a small piece missing at the top, since the break is oblique and the pattern at this end is incomplete. The very top of the shaft tapers noticeably inward towards the broken end. At the opposite end, the bottom of the shaft is undecorated and represents the tenon that would have been morticed into a base. It is not certain whether the one visible face is the front,

back or side of the monument. However, investigation has indicated that decoration survives on all the hidden sides of the shaft, and that all angles have an incised edge-moulding.[360]

Although only one face is visible, and so identification cannot be wholly confirmed, it is almost certain that this shaft is from a cross in the Penwith group of sculpture, dating from the mid-tenth to the eleventh century. This shaft and the cross-head no. 78 Paul 1 may be parts of the same monument, but with a section of shaft missing from between the two.[361]

## References

Langdon, Andrew G. (2006a), 38; Preston-Jones (2009); Preston-Jones and Okasha (2013), 184 and figs.

# 80. Paul 3, Kerris, Carlankan

SW 4435 2716; TR19 6UY

The cross stands outside the manor house in the hamlet of Kerris. There is full public access by a public road.

The cross was first recorded by Langdon lying on a piece of waste ground at Carlankan, 700m (0.4 miles) east of Kerris, at approximately SW 4465 2705;[362] at this date it was already fractured at the neck. Langdon recorded that the cross had subsequently been removed and set up in Kerris village, where it remains today.[363] The cross-head was held in place with a central iron dowel and three external iron staples, but these staples became corroded and were removed. In 2011, owing to concerns about the stability of the joint between the head and the shaft, repairs were undertaken, the internal iron pin was replaced with one of stainless steel and the cross was straightened to stand erect.[364]

When seen by Langdon, the full 2m (approx. 6ft) length of the cross was visible. Now much of the shaft is buried in the ground, giving the monument a rather stumpy appearance, standing only 1.35m (4ft 5in) high. It is a complete, plain, Latin-style cross. Its upper and horizontal arms are of similar size, while the shaft tapers from the ground up to the neck. A large piece of the upper arm on the back of the cross has been chipped away. The shaft is also plain except for the scars of the iron staples and the later initials *LA*, carved on one face of the shaft.

This is one of three tall Latin crosses that once marked a church path from the village of Kerris in Paul parish to the parish church. A second cross, which originally stood on Paul Down to the east of Carlankan, was taken to Trereife in the neighbouring parish of Madron where it was set up as a garden ornament; while a third from Rose-an-beagle was removed to Tremethick, also in Madron.[365] The letters *LA* carved on the shaft are deeply cut and are likely to represent the adoption of the cross as a private boundary stone by cutting the initials of the landowner. This style of Latin cross is difficult to date owing to its simplicity; it could have been carved at any time in the twelfth and thirteenth centuries.

See also another cross set on a garden wall, on the opposite side of the road, to the south.

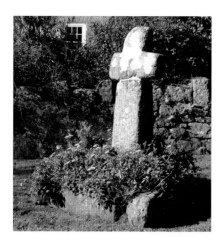

## References

Langdon, Arthur G. (1896), 202–03 and fig.;
Langdon, Andrew G. (1997), 52, no. 78 and fig.;
Preston-Jones (2011b), *passim* and figs.

# 81. Pelynt, Trelay

SX 2031 5505; PL13 2LQ

The pieces of the cross after removal from the garden wall at Trelay.

The cross-head is mounted on the north wall of the north aisle of St Nonna's church, Pelynt. There is full public access.

Four cross-head fragments were discovered on 15 May 2004 by members of the Cornwall Association of Local Historians at Trelay Farm, Pelynt, built into a garden wall (SX 2101 5436).[366] In 2005, they were fixed together to form about three-quarters of a cross-head and moved to Pelynt church.[367]

This large but fragmentary cross-head measures 0.82m (2ft 8in) high. It is not cut from granite, like most Cornish crosses, but from a pale, yellowish-brown, quartz sandstone. The cross-head has arms that splay out widely from a relatively small central boss. The arms are linked by a narrow ring and separated by trefoil-shaped openings formed by three cusps, one on the side of each arm and one on the outer ring. A double moulding surrounds the head, and the arms each contain a low-relief triquetra knot. At the bottom,

Shallow mortice on the bottom of the cross-head.

on the underside of the head, is a shallow mortice for fixing the head to the shaft.

This monument is a member of the small but dispersed group of mid-tenth-century or eleventh-century crosses in Mid and East Cornwall, which are characterized by the trefoil-shaped holes between the cross-arms in the head. Other characteristic features of the group include the widely splayed arms with triquetra knots, continuous double moulding surrounding the head and low-relief carving. As no decorated shaft survives, the Pelynt cross-head is dated by analogy with other members of the group.

## References

Langdon, Andrew G. (2004), 13–18.; Langdon, Andrew G. (2005), 61, no. 82a and fig.; Langdon, Andrew G. (2006a), 11–16; Langdon, Andrew G. (2006b), 36–37; Langdon, Andrew G. (2011), 302; Preston-Jones and Okasha (2013), 185 and figs.

Sue Kelland, of Kelland Conservation, and Andrew Langdon in 2006, winching the cross-head up towards its new position on the wall of Pelynt Church.

# 82. Penzance, Market Cross

SW 4703 3003; TR18 4HE

The cross stands in the grounds of Penlee House Museum, Penzance, on the terrace beside the main entrance to the museum. There is full public access.

The cross was first recorded in 1824 in 'Penzance'.[368] In 1829, it was moved from the 'north-east corner of the Green Market' to the junction of Greenmarket and Causewayhead;[369] however, Courtney recorded that before 1845 it had been moved to 'a recess at the west end of the Market House'.[370] In this position Langdon recorded that 'the back and lower portion of the sides are concealed',[371] which may explain why his drawing does not show the back of the cross. In July 1899, it was

moved to Morrab Gardens, and in the summer of 1953 it was moved again to the gardens of Penlee House. During renovation of the museum in 1996, the cross was placed in storage but was re-erected in 1997 in its present location.[372]

The cross stands 2.12m (7ft) high. It has a solid round disc- or wheel-head and a shaft of rectangular section with a projecting roll-moulding at the junction between head and shaft. The head is over-large in proportion to the shaft and slightly flattened on the top. An incised edge-moulding runs around the edge of the shaft on all four faces. All sides of the shaft are divided into rectangular

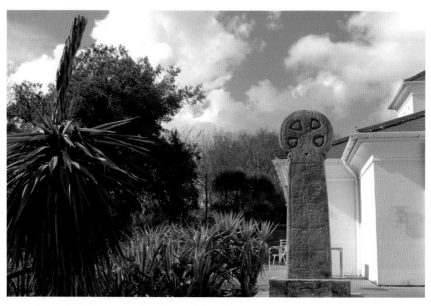

Nowadays Penzance Market Cross stands in the tropical splendour of Penlee Gardens.

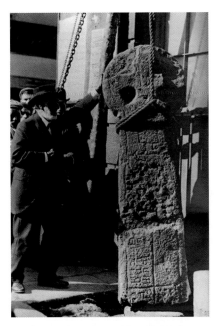

The cross being moved from the Market House to the Morrab Gardens in 1899. The small incised figure and inscription can be clearly seen. Image copyright Morrab Library Photographic Archive.

clear whether these texts are to be read separately or together. The ':' after the letter Q suggests that this text might be in Latin, with Q: indicating -*que*, 'and', but it has to be concluded that these texts are now uninterpretable. One of the narrow sides of the cross also contains two inscribed panels at the bottom of the shaft. These texts are probably complete but are highly deteriorated and the script used is not certain. The texts are set vertically in four lines, two in each panel, and read [RE..+.] [CR-] AND D+[.] [..]. The first text is virtually illegible and the second is too fragmentary to be interpreted.

The overall form of this monument, with its disc- or wheel-head and incised

panels by incised lines, and within these the incised decoration consists of lines of dots, simple figures and inscriptions. The little figures can be seen on the back (the side facing Penlee House reception), just below the head, and on the right side. That on the back may represent a crucifixion or the risen Christ.[373]

The face of the cross has two panels towards the lower part of the shaft that contain inscriptions. The texts are in a predominantly insular script and read vertically, each in three lines. The upper text is almost complete, but the lower text is fragmentary. The upper text reads [.]MBUIN [-]UMQ: [-.]TNI; the lower text reads FO[-] P[-] C[-]. It is not

The side of the cross with panels containing dots and inscriptions.

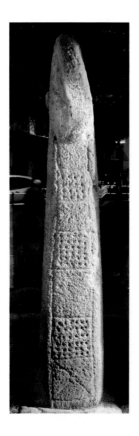
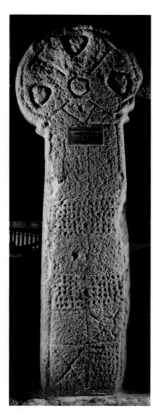

A cross at Eastbourne, originally from near Truro, is very similar in style to the Penzance Market Cross (Langdon, Arthur G., 1896, 364).

decoration, makes it comparable with other crosses in Cornwall of the eleventh century or even early twelfth century, which are transitional between early and later medieval styles of decoration. The Penzance cross, with its inscriptions and unusual decoration, may be earlier in this date range.

In its form, proportions and decorative features the Penzance cross is remarkably similar to a cross from the Truro area, now in Eastbourne.[374] Although there are some obvious differences, the two crosses nonetheless appear to be closely related, despite the fact that they were originally located some distance apart.

## References

Langdon, Arthur G. (1896), 308–10 and figs; Thomas, A.C. (1967), 97, 105; Preston-Jones and Rose (1986), 159; Okasha (1993), no. 37, pp. 195–99 and figs; Thomas, A.C. (1994), 298–300, 330 and figs; Langdon, Andrew G. (1996c), 24; Langdon, Andrew G. (1997), 48, no. 71, and fig.; Thomas, A.C. (1997), 55–63, 65 and figs; Okasha (1998–99), 148–50 and figs; Thomas, A.C. (1999) and figs; Preston-Jones and Okasha (2013), 186–88 and figs.

# 83. Perranzabuloe, St Piran's Cross

SW 7722 5644; TR4 9PN

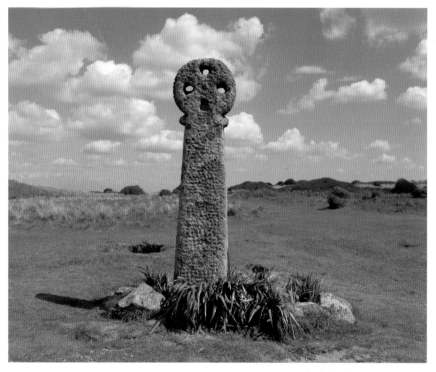

St Piran's Cross, once within the churchyard of Perranzabuloe's old parish church, now stands in an open dune landscape.

The cross stands within the abandoned graveyard of the former St Piran's church, Penhale Sands, 2km (1.2 mile) north-north-east of Perranporth. There is full public access.

The cross was first recorded in 1851 in its present location,[375] possibly in situ.

This complete wheel-headed cross stands 2.44m (8ft) high. Its head is pierced by three holes, to create a St Andrew's-type of cross; a fourth hole is only partially recessed. There is a small central boss and projecting roll-mouldings at the neck. Although almost square in section at the bottom of the shaft, the cross tapers to become rectangular in section at the top. Because of the exposed location, the head in particular is highly eroded. A cross-base referred to by Langdon,[376] and seen on early images, is

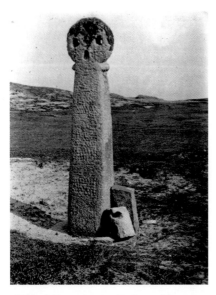

St Piran's Cross, showing the base of the cross and the monument's full height, c.1898. Image by W.J. Stephens (Andrew Langdon collection).

However, if this charter did not exist, then neither would this assumption of date, because the style and decoration of the cross both indicate a later origin. Crosses in Cornwall of mid-tenth-century date are generally decorated with interlace, plant scrolls or key patterns, rather than with rows of incised dots. The simpler incised decoration on this cross is more like that found on monuments of the eleventh and twelfth centuries, which are transitional between pre- and post-Norman Conquest decorative styles; examples are no. 53 Lanivet 2 and no. 82 Penzance. Moreover, pre-Norman monuments generally feature a splay-armed cross-head supported by a ring, examples being seen on no. 11 St Buryan 1 or 24 St Columb Major, not the simpler disc- or wheel-head of this, which is more like the heads of simpler wayside crosses. Thus, the style and decoration of the cross best fits an eleventh- or even an early twelfth-century date.

Nonetheless, the present cross definitely does appear to stand in much the same location as the feature called the *cristelmæl* in the charter.[379] Sadly, there is no evidence for the form of the earlier monument. It could have been a rock carved with a simple cross, or another stone cross but of typically tenth-century style, or perhaps a wooden cross, which was replaced by the present stone cross.

The actual nature of the connection between the cross and the religious community of St Piran, recorded at Perranzabuloe in Domesday Book of 1086 and likely to have been located at or close to the site of St Piran's Oratory, is an interesting problem. At the time of Domesday Book, St Piran's was entirely surrounded by land owned by St Petroc's monastery at Bodmin, which at the time was the wealthiest religious house in

not currently visible, being buried beneath about 25cm (10in) of sand. All sides of the shaft are decorated with rows of tiny incised dots, some in panels, within the possible traces of incised mouldings down the edge.

A grant of land at Tywarnhayle in Perranzabuloe, made by King Edgar in 960 and known from an original charter of that date, has a feature described as a *cristelmæl* in its boundary clauses, at a point near the location of this cross.[377] The Old English word *cristelmæl*, a variant of *cristesmæl*, means 'Christ's cross; sign of Christ's cross'. The location of the point in the bounds agrees with the location of the present cross, so from this it has been reasonably assumed that the *cristelmæl* is identical with the cross.[378] This appears to suggest a date for the cross in the middle of the tenth century or earlier.

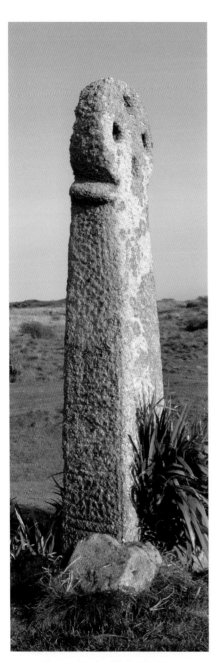

Cornwall. It has been suggested that the cross was originally set up by the more powerful house.[380]

By the late twelfth century the parish church had been built close to the cross following, it is believed, sand inundation and abandonment of the nearby Oratory site.[381] The resultant change in the local landscape meant that when bounds were recorded again in the seventeenth century, the chancel of the church was used as a boundary point, not the cross.[382] When in turn the church became overwhelmed by sand, it too was moved, this time to a location several miles inland. Partial demolition of the church in the early nineteenth century restored the cross to its original status as a prominent and familiar feature in the dunescape.

## References

Langdon, Arthur G. (1896), 180–82 and fig.; Langdon, Andrew G. (1996c), 17; Langdon, Andrew G. (2002), 61, no. 76 and fig.; Preston-Jones and Okasha (2013), 189–93 and figs.

The north side of St Piran's Cross.

# 84. Phillack

SW 5654 3840; TR27 5AD

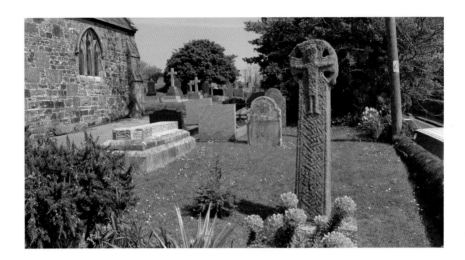

The cross stands in the churchyard of St Phillack's church, to the south of the church. There is full public access.

The cross was moved to its present location in 1856–57 from a position 'about ten feet to the northward'.[383] Only the cross-head was illustrated in 1856 on top of a wall in 'Phillack Churchyard', presumably because the shaft was buried in the ground.[384]

The monument is a complete cross that stands 1.76m (5ft 9in) high and is set in a modern base. The shaft has an almost square section and is unusual in that the main faces (those with figure and bosses) are slightly narrower than the sides. On the cross-head, only the top two holes between the arms and ring are completely drilled through. A double incised line frames all sides of the head and a single incised line runs down all sides of the

shaft and across the bottom. On the shaft, the decoration is incised, not relief-carved.

Illustration by J.T. Blight (1856, 22) when only the cross-head was visible.

206

On the head of one face, and extending down on to the shaft, is a rather long thin figure of Christ; the head is without features or halo, but the figure is clad in a knee-length tunic. On the shaft beneath is a rather angular and irregularly executed plait. On the back are five bosses, one on each of the cross-arms and one in the centre, with plaitwork on the shaft. The other two sides also contain plaits and have a boss on the lower part of the ring.

Although this cross is clearly related to the Penwith group of pre-Norman crosses, with a crucifixion on one side of the head and five bosses on the other, it is a devolved copy, probably dating from the late eleventh century. Features derived but ill-copied from the Penwith crosses include the untidy plaitwork, the merging of the cross-arms and ring, and the bosses added to the lower part of the ring. Similarly placed bosses are found on the eccentric cross no. 99 Wendron 3, Merther Uny. The

An altar frontal in Phillack church, possibly eleventh-century, with a crucifixion very similar to that on the cross.

crucifixion is similar to that on the altar slab in Phillack church, suggesting they could be contemporary or close copies.

There is no record of a pre-Norman religious house at Phillack, but the collection of early stone monuments here indicates an early and important ecclesiastical foundation. Discoveries in sand dunes to the north of the church suggest that the church is on the site of a large cist cemetery with possible prehistoric origins.[385]

See also two more crosses and an early inscribed stone in the churchyard, as well as a tiny chi-rho stone in the wall above the porch.

## References

Langdon, Arthur G. (1896), 10, 389–91 and figs; Thomas, A.C. (1986), 183 and fig.; Thomas, A.C. (1990), 17, 25 and fig.; Langdon, Andrew G. (1999), 52, no. 78 and fig.; Preston-Jones and Okasha (2013), 193–94 and figs.

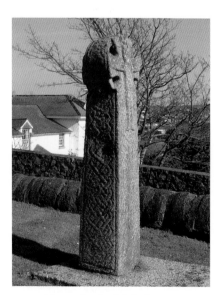

The north side of Phillack cross.

# 85. Quethiock

SX 3129 6471; PL14 3SQ

The cross stands in the churchyard of St Hugh's church, to the south of the church, near the boundary wall. There is full public access.

In 1881, the cross was found in four pieces in the churchyard. The base and head were beneath ground level near the southern boundary of the churchyard, while the two pieces of shaft were in use as gateposts to an entrance to the churchyard. The four pieces were fixed together and the monument erected in its present location.[386]

This imposing monument stands 4.06m (13ft 4in) high and consists of the head and shaft of a rectangular-section cross. On the cross-head the arms are linked by a ring, and in the space between each of the arms and the ring are three cusps, forming trefoil-shaped openings. The decoration on the head and shaft,

framed by a shallow flat-band moulding, is in very low relief and, on the shaft in particular, is now extremely worn and indistinct. Traces remain of interlace, plaitwork and plant scrolls.

The decoration is generally too worn to interpret, although the overall form of the head, the plant scrolls, the very low-relief carving and the flat band interlace compare with monuments such as no. 50 Lanhydrock, no. 1 and no. 52 Lanivet 1, showing it to be part of the mid-tenth-century or eleventh-century Mid- and East Cornwall group, despite its outlying location. The trefoil-holed head links it to the slightly later members of the group. In terms of overall design and great height, its closest parallel is the cross at St Teath, even though the latter does not have trefoil holes.

Quethiock church is not recorded until the thirteenth century and there are no remains in the church fabric earlier than the late twelfth or thirteenth century, making the cross the earliest datable feature on the church site. There is no Celtic dedication known, but the name Quethiock is Cornish, probably meaning 'wooded place'.[387] The church, which is located in a valley head, has a small curvilinear churchyard, which may suggest an early medieval origin.

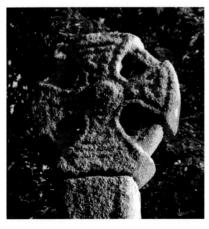

The head of the Quethiock Cross, showing triquetra knots in the cross-arms.

## References

Langdon, Arthur G. (1896), 398–401 and figs; Langdon, Andrew G. (2005), 62, no. 84 and fig.; Preston-Jones and Okasha (2013), 196–97 and figs.

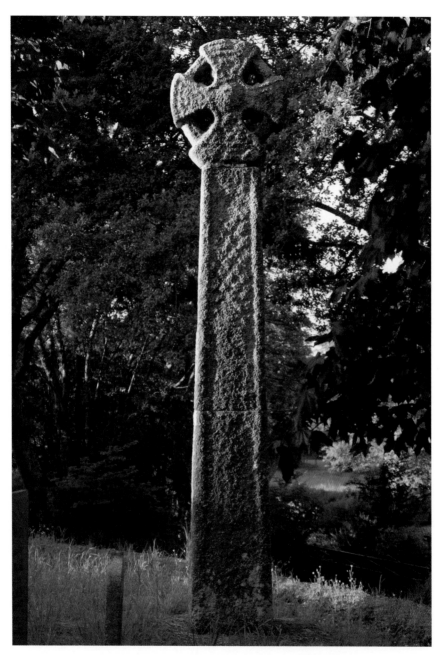

The north face of the Quethiock Cross, with very angular plaitwork.

# 86. Roche

SW 9879 5977; PL26 8HA

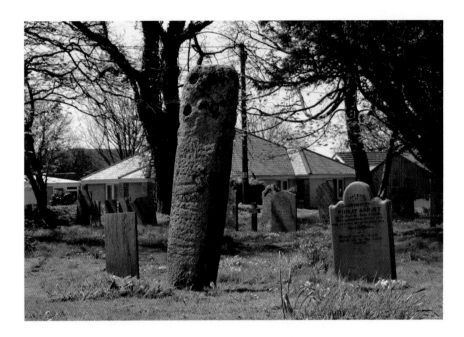

The cross stands in the churchyard of St Gonand's church, beside the south door. There is full public access.

The cross was first recorded in 1814 'in the church-yard at St. Roche' [*sic*],[388] presumably in its present location.

The cross has a slab-like form and stands 2.47m (8ft 1in) high. On the front, the head of the cross is indicated by a central boss and four deep circular sinkings, each with a distinct raised boss at the centre. On the back of the head are two concentric incised circles instead of a boss, radiating from which are pairs of faint incised lines defining a cross. The front of the shaft contains irregular rows of incised dots, followed by four roughly horizontal incised lines. Beneath is a smaller set of irregular incised dots followed by an incised line resembling a U-shape on its side. The back of the shaft contains similar rows of dots and irregular horizontal lines. One narrow side is largely undecorated, while the other has irregular rows of incised dots with three small raised bosses, one above the other. Below these is a vertically set sword, the hilt carved in relief and the blade represented by three incised lines with herringbone-like cross-hatching between. The tip of the blade is not shown, being truncated by three to four horizontal incised lines at the bottom

of the shaft, suggesting that the sword may be in a scabbard.

This monument is one of the most curious of the Cornish crosses with incised decoration. It may date from the twelfth century. The sword on the shaft suggests a parallel with medieval cross-slab grave-covers that occasionally depicted swords, although there are none like this in Cornwall. The sword (as far as can be told) does appear to be of medieval type.[389] The incised dots are a feature of crosses carved in Cornwall before or shortly after the time of the Norman Conquest. The closest parallel to this cross is the Merther Uny cross, no. 99 Wendron 3, but as this is situated some 80km (50 miles) away it is uncertain whether there is any connection between the two.

In contrast with the cross is the exceptionally fine Norman font in Roche church, possibly of broadly similar date. The difference between the two in style and execution is so striking that it is difficult to see them as belonging to the same site, let alone the same period. Perhaps the cross marked the site until the new Norman church was built, or different craftsmen may have been responsible for the different types of monument. There is no evidence that Roche church is on a site of early medieval origin but it has a close relationship with nearby Roche Rock, a natural pinnacle of tourmaline-rich granite on which is a medieval chapel, and which is now known to have been a ritual focus from at least Neolithic times.[390]

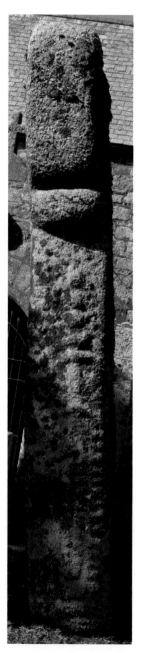

The south side of Roche cross, with sword.

### References

Langdon, Arthur G. (1896), 344–45 and figs; Langdon, Andrew G. (1996c), 30 and fig.; Langdon, Andrew G. (2002), 63, no. 80 and fig.; Preston-Jones and Okasha (2013), 241–42 and figs.

# 87. Sancreed 1

SW 4202 2934; TR20 8QS

Sancreed 1 cross-head on the churchyard wall in the mid-nineteenth century (Blight 1856, 21).

The cross stands in the churchyard of St Sancred's church, near the porch. There is full public access.

The cross-head was recorded in 1856 on the churchyard wall.[391] The shaft was found in 1881 built into the east wall of the aisle. The head and shaft were then fixed together and placed beside the gate leading from the churchyard to the vicarage; in June 1894, the cross was placed in a base in its present location.[392]

The monument stands 1.92m (6ft 3in) high. It consists of the head and shaft of a ring-headed cross, in which the holes have not been fully cut out. On the front of the cross-head are small hollows in the arm-pits, suggesting that the sculptor may have begun drilling the holes to make a ring-head but changed his mind. The reconstructed cross is not quite complete since the cross-shaft and head do not match exactly: a portion near the top of the shaft is missing, which is especially obvious from

the side. Decoration on both head and shaft of all faces is bordered by an incised edge-moulding. Except for the figure on the front, the carving is all very shallow.

On the front of the cross-head is a crucifixion carved in relief, the figure rather poorly proportioned, with over-long arms and a very large head. A belt is clearly depicted as is the lower edge of a garment, probably a tunic. The legs are short and the out-turned feet rest on the incised moulding that separates the cross-head from the shaft. On the shaft is a

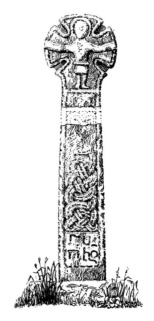

The main face of Sancreed 1, with crucifixion, very worn inscription and interlace (Langdon, Arthur G., 1896, 364).

defaced panel and below it a longer panel containing interlaced work. The back of the shaft contains further interlace. On one side is an interlaced serpentine creature with a ribbon body, biting its tail, and on the other a key pattern.

At the bottom of the front of the shaft is an inscription set in two lines within a panel. It is highly deteriorated but appears to be complete. It is incised in a predominantly insular script and the letters read horizontally. The text on the cross now reads R[.HO.] and early drawings demonstrate that it has always been hard to read. Since the text is similar to that on the Lanherne Cross (no. 43 Gwinear 2), which probably reads RUNHOL, it has been suggested that this was the name of the person who carved both crosses. Alternatively it could be a word in Old Cornish, meaning 'inherited' or 'inheritance'.[393]

This cross is a member of the Penwith group of pre-Norman sculpture, dating from the mid-tenth to the eleventh century, which is characterized by a crucifixion on one side of the head and (usually) five bosses on the other. This cross does not have the five bosses but does have other features in common with other members of the group, namely simple interlace patterns executed with double or triple strands, a key pattern and a serpentine beast. The beast and the inscription link it particularly closely with the Lanherne Cross (no. 43 Gwinear 2). It is possible that the rather ill-proportioned figure of Christ, the very shallow carving and the fact that the holes in the head are undrilled indicate that this is a later member of the group, perhaps dating from the late tenth to the eleventh century.

The early medieval origin of the Sancreed church site is indicated by its small circular graveyard enclosure in a

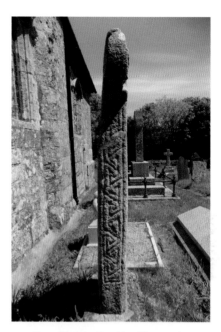

Key pattern on the side of Sancreed 1.

valley-head location and confirmed by the existence here of no. 88 Sancreed 2, an early inscribed stone later made into a cross. The church is named from its Celtic patron saint; a name in *eglos* is also recorded.[394] Although there is no record of an early religious house at this parish church, the evidence seems to point to a significant early Christian site.

See also a further three crosses in the churchyard.

---

### References

Langdon, Arthur G. (1896), 359–60, 362–65 and figs; Thomas, A.C. (1967), 90, 104–05; Thomas, A.C. (1978), 78–79 and fig.; Okasha (1993), no. 53, pp. 251–54 and fig.; Thomas, A.C. (1994), 299, 330; Langdon, Andrew G. (1997), 54, no. 81 and fig.; Preston-Jones (2005); Preston-Jones and Okasha (2013), 198–99 and figs.

# 88. Sancreed 2

SW 4202 2933; TR20 8QS

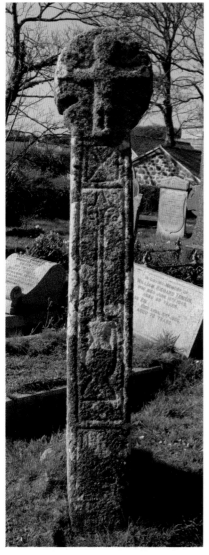

Sancreed 2, main face.

The cross stands in the churchyard of St Sancred's church, to the south of the porch. There is full public access.

The cross was first recorded in 1814 in the churchyard.[395] In 1895, the lower part of the shaft was unearthed and the cross was reset in its present location in an old base brought from Treganhoe in Sancreed parish.[396]

From the 1980s, the settlement of a nearby grave caused the cross to move gradually out of vertical. The problem was exacerbated by the fact that the base-stone from Treganhoe was too small to provide sufficient support for this tall cross. By 2016 it was leaning at such an acute angle that there were real concerns about its stability. The threat was rectified in 2018 by carefully straightening the cross using a winch suspended from the cross bar of a small scaffold.

Complete apart from its original base, Sancreed 2 stands 2.36m (7ft 9in) high. It is an impressive monument dominating the approach to Sancreed church from the churchyard's south entrance. The nearly square cross has decoration on all four sides, a crucifixion on one side of the head and a simpler incised cross with central boss on the back. The decoration on the cross-head and the shaft are framed by an incised edge-moulding; all the decoration, with the exception of the relief-carved crucifixion, is boldly incised and very clear.

The front of the cross-head contains a crucifixion. The head is haloed and the face has eyes, nose, mouth and a pointed chin or beard. The over-long

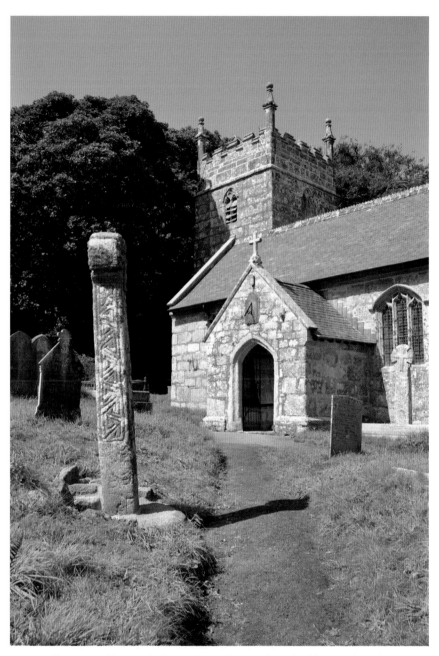

The setting of Sancreed 2; Sancreed 1 stands just to the right of the church porch.

arms are slightly bent at the elbow, unless the figure is wearing a tunic with long drooping sleeves, but he is more likely wearing a loincloth. The short legs extend on to the shaft and the feet are crossed. The incised decoration on the front of the shaft consists of an incised diagonal cross within a square with, below this, a long-stemmed fleur-de-lys in a jug. Beneath it is a panel that might contain traces of a now illegible inscription.

The back of the cross-shaft contains a diagonal cross within a square with a triangle beneath. One side contains a similar diagonal cross with an incised zig-zag beneath. The other side has a cross within a square, with a fine key pattern beneath. Below that are the remains of an inscription reading vertically downwards in one line. The letters appear to be in a capital script but are badly deteriorated. The last few letters might read [. . . SAT].

In conclusion, this is a complex monument. While it has the form and some of the attributes of a pre-Norman monument, features of the decoration also point to a later date. Meanwhile, it also has parts of worn inscriptions comparable to those on early Christian memorial stones. Unfortunately the remnants of text are too fragmentary and illegible to be interpreted. Langdon suggested that the cross was carved from an earlier inscribed stone, and this is a possibility.[397]

The cross has a clear relationship with Sancreed 1, an undoubtedly early medieval monument of the Penwith group. Features in common include the shape of the cross-head, the presence of a crucifixion (although there are differences in detail) and the well-cut key pattern. In contrast, the features that indicate a later date are the incised patterns, including the fleur-de-lys in a vase. The chevron or zig-zag pattern is strongly reminiscent of Romanesque work and is found on a number of other late crosses, including that from Rame, now at Scorrier House,[398] while the vase and fleur-de-lys are characteristically Gothic images (see no. 31 Egloshayle).

The most logical way of explaining this variety of ornament is that the cross is a multi-phase monument. It may have

Traces of an inscription on the side of the cross.

begun life as a prehistoric menhir or standing stone, which was 'Christianized' with the addition of an inscription in the sixth to the eighth century. In the tenth or eleventh century, it appears to have been inverted, the stone recut, partly obliterating the inscription in the process, and the outline of the head with boss and crucifixion carved. Only one side was fully sculpted, that with the key pattern, and for some reason the monument was not completed. Then, perhaps in the late twelfth or thirteenth century, in order to complete the monument, patterns more in keeping with decoration of that era were added, including the lovely fleur-de-lys on the main face.

## References

Langdon, Arthur G. (1896), 359–62 and figs; Okasha (1993), no. 54, pp. 255–59 and figs; Thomas, A.C. (1994), 286–87, 330 and figs; Langdon, Andrew G. (1997), 55, no. 82 and fig.; Preston-Jones and Okasha (2013), 243–45 and figs.

Sancreed 2, back.

# 89. Sancreed 3, Brane

SW 4089 2876; TR20 8RE

The cross forms an upright support of a stile on the church path from Brane leading via Boswarthen and Newham Farms to Sancreed parish church; the stile is where the path is crossed by a farm track leading up to Caer Bran hill fort. There is full public access.

The cross was first recorded and illustrated by Blight in 1856.[399] In 1896, Langdon noted that the cross marked the boundary between the two estates of Brane and Boswarthen, but was not explicit about the monument's relationship to the stile.[400]

This wheel-headed cross stands 1.73m (5ft 8in) high. It contains on both faces an expanded-arm Latin cross carved in relief. The upper and horizontal arms extend to the edge of the stone, with the lower arm extending halfway down the shaft.

The carved cross on the back of the Brane Cross.

The wheel-head has been badly chipped on both faces. The simple geometric style suggests a twelfth-century date.

Although the cross does not appear to be supported by a base-stone, it is likely to be near its original position, marking both a boundary between farms and the crossing of two ancient routes. It is possible that the cross is in situ, and that the hedge was built up to and around it when the land was enclosed. The stile was built into the hedge to take the church path through. Several stone crosses have, in the past, been built into stiles including the Crewel Cross (no. 61 Lostwithiel).

## References

Langdon, Arthur G. (1896), 269–70 and figs;
Langdon, Andrew G. (1997), 57, no. 86 and fig.

# 90. Sennen, Trevear

SW 3569 2552; TR19 7AD

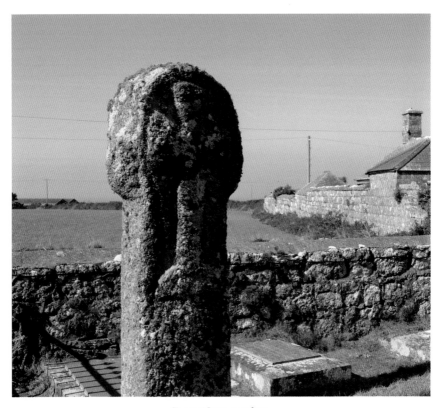

Trevear Cross, east face.

The cross is situated on the north-west side of St Senana parish churchyard, close to the roadside boundary. There is full public access.

The cross was first illustrated by Blight on 5 May 1864, in use as a footbridge across a stream at Trevear Bottom, on the old road leading to Penzance.[401] He noted that the base of the cross was on the road between Trevear Farm and Sennen church. According to Langdon, it was through the efforts of Rev. R.J. Roe, with the co-operation of the landowner, a Mr Harvey, that the cross was lifted from the footbridge in 1878.[402] The base-stone was also rescued, and the cross and base were restored and placed on the roadside almost opposite the west side of the

church. Here it stood until a new cemetery was created in 1890, when the cross was again moved to be set up there.[403] It was finally put in its present position in 1955.[404]

This massive wheel-headed monument stands 2.36m (7ft 9in) high. It contains a Latin cross carved in relief on both faces. On the main face, the lower arm of the cross terminates a third of the way down the shaft in a wide triangular step. The upper and horizontal arms are splayed at their ends, but do not extend to the edge of the stone. On the reverse face is a similar Latin cross, although here the upper and horizontal arms extend to the edge of the stone. The lower arm of this cross extends two-thirds of the way down the shaft. The cross-head is slightly chipped on the north face. The simple geometric cross on each face suggests a post-Norman Conquest date, probably in the twelfth century.

This is not the only tall cross to have been reused as a footbridge. The crosses no. 93 St Teath and no. 47 St Kew 2 both suffered the same fate in the nineteenth century. It is interesting to note that Rev. R.J. Roe is probably the same clergyman who in 1900, as rector of Lanteglos by Camelford from 1886 to 1921, removed two crosses as well as no. 56 Lanteglos by Camelford 1 and no. 57 Lanteglos by Camelford 2 from the rectory and set them up in the churchyard.

See also a large cross-head at the south entrance to the churchyard, as well as one on a footpath to the north-east within walking distance.

## References

Langdon, Arthur G. (1896), 107–08 and figs;
Langdon, Andrew G. (1997), 58, no. 89 and fig.

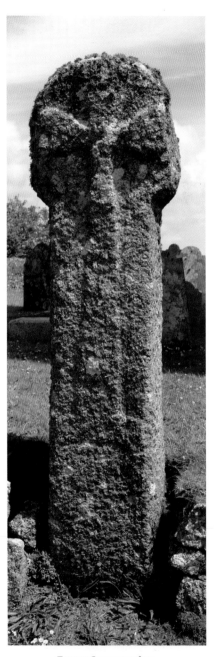

Trevear Cross, west face.

# 91. South Petherwin, Holyway Cross

SX 2727 8232; PL15 7SZ

The cross stands beside the A30, 7.5km (4 miles) south-west of Launceston. There is full public access.

The cross was first noted by Blight in 1858, who said it was at Holloway in Lewannick parish.[405] Langdon also named the monument Holloway Cross, Lewannick; at that time it stood in the garden of a cottage at the fork in the roads.[406] He recorded that it was said to have been discovered in a hedge opposite its present site and was removed to the

garden for safety.[407] While in the garden, the cross was partially buried in the ground, and Langdon recorded its height as 3ft 7in (1.09m). In 1945, following a road accident, the cottage was demolished and the cross dug up and left lying on the ground.[408] In 1950, the stonemasons at St Breward provided a new base-stone and the monument was restored to its former site.[409]

The cross stands 1.6m (5ft 3in) high. On both faces of the head, equal-armed crosses are carved in relief; they have expanded ends, the lower arms extending down the shaft as a narrow tapering bead or moulding. The cross-arms are slightly concave, and extend almost to the edge of the head. The shaft has small rounded projections at the neck and a bead or roll-moulding running down each side of the shaft. The simple geometric cross suggests a twelfth-century date.

Although previously recorded by both Blight and Langdon under Lewannick parish, the cross actually stands just inside the parish of South Petherwin. Either way, this cross evidently marks the parish boundary as well as a major road, now the A30. Quiller-Couch recorded that there was formerly a small deep well near the cross, believed by some to be a holy well,[410] implying that the name of the cross is derived from the site of the well; however, there is no sign of the well today.

In the late nineteenth and early twentieth centuries half of the length of the Holyway cross-shaft was buried. This is the portion that nowadays has more lichen growing on it. (Langdon, Arthur G., 1896, 166).

## References

Langdon, Arthur G. (1896), 166 and fig.;
Langdon, Andrew G. (1996b), 61, no. 93 and fig.

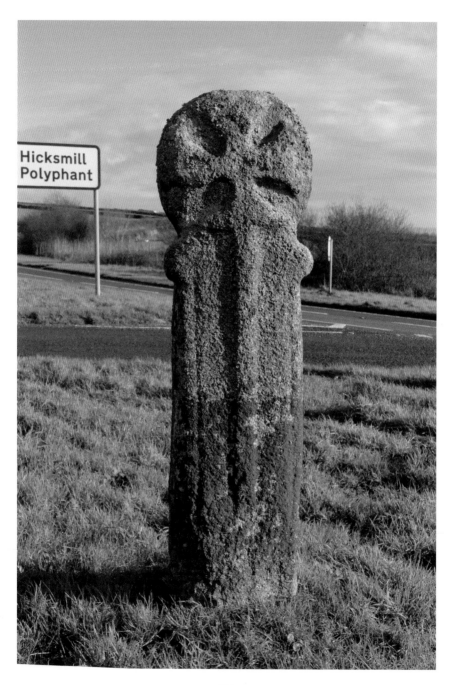

# 92. Stithians, Tretheague

SW 7296 3613; TR3 7AF

The cross stands in a field below Tretheague Barton, overlooking the road near Tretheague Bridge. There is no public access. but the cross is visible from the public road.

This cross was found in 1921 in the bed of the river, under the northern arch of Tretheague Bridge. It was then erected on the roadside, immediately to the north of the bridge.[411] In 1968, it was moved to its present location, about 42m (138ft) north-west of the bridge.[412]

This round-headed cross, mounted in a modern base, stands 1.38m (4ft 7in) high. The cross-head contains bosses at the neck and an equal-armed cross on both sides; the cross-arms are slightly splayed. The decoration on the front of the cross-shaft is in two parts separated by an incised line down the centre. That on the left consists of six raised diamonds and half of a seventh. That on the right is badly worn, but the remaining traces suggest a diamond or a zig-zag pattern. On the back the decoration is similar with eight diamonds and half of a ninth on the left side and possibly incised diamonds on the right. The narrow faces each have a boss between the head and the shaft and the decoration on the shaft consists of incised diamonds, horseshoe shapes and triangles.

This cross is one of a small group of twelfth-century Norman crosses in the Carnmenellis granite area bearing a simple geometric cross on the round (wheel-)head and chevrons, diamonds or zig-zags, and other incised patterns on the shaft. In common with others in the group, this cross has incised horse-shoes, here unusually located on the side of the head.

The crosses in this group do duty as boundary stones and wayside crosses or mark chapel sites, but none originally stood at parish church sites. In this case, the cross stood at a river crossing on the road from Stithians parish church to Rame, Wendron, which was once the location of another cross in the same group.[413]

## References

Langdon, Andrew G. (1999), 58, no. 89 and fig.; Preston-Jones and Okasha (2013), 245–46 and figs.

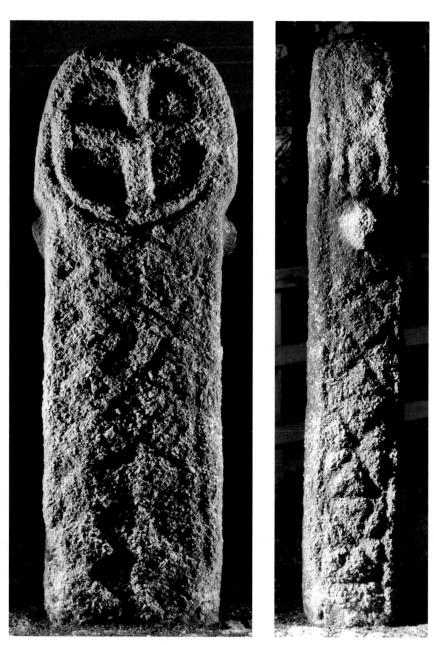

The main face and one side of the Tretheague Cross, showing the
decoration of chevrons, zig-zags and diamonds.

# 93. St Teath

SX 0637 8063; PL30 3JA

Sue and Lawrence Kelland repairing the Victorian additions to St Teath's churchyard cross in 1995.

The cross stands in the modern churchyard at St Teath, beside the gate. There is full public access.

Until around 1835, part of the cross-shaft was used as a bridge 'across the outlet of a pond'; it was then moved into the churchyard,[414] before being cut into pieces. Some parts were used to form the 'coping for a wall at the west entrance of the churchyard'; other parts were sunk into the ground and used 'to carry the pivoting of the churchyard gates'.[415] By 1883, all the pieces had 'quite recently' been recovered. The cross was then reconstructed and erected in its present location.[416] By the

1980s, parts of the Victorian restoration had deteriorated, necessitating repairs by Kelland Conservation in 1995.[417]

This exceptionally tall monument stands 4.01m (13ft 2in) high and is the third tallest cross in Cornwall after no. 72 Mylor and no. 85 Quethiock. It consists of the head and shaft of a worn and highly mutilated cross. All the surviving decoration is in very low relief and is difficult to make out. There are traces of edge-mouldings and, on the side of the cross-head facing the churchyard gate, indistinct remains of triquetra knots and a small low central boss. On the top third

St Teath Cross: spiral plant scroll on east side of cross.

of the shaft on this face are slight remains of a knotwork pattern and, below this, mutilated traces of further decoration. On one of the narrow sides of the shaft is a spiral scroll with small simple leaves in the spaces between the plant stem and the edge-moulding. On the opposite side are remains of an unusual double plant-scroll.

The surviving decoration is too worn to interpret with confidence. However, the spiral plant scrolls and the very low-relief carving link it with the Mid- and East Cornwall sculpture group; it may date from the late tenth or the eleventh century.

---

## References

Langdon, Arthur G. (1896), 391–94 and figs; Langdon, Andrew G. (1996c), 26; Langdon, Andrew G. (1996b), 62, no. 95 and fig.; Preston-Jones and Okasha (2013), 200–01 and figs.

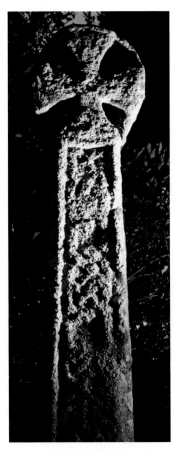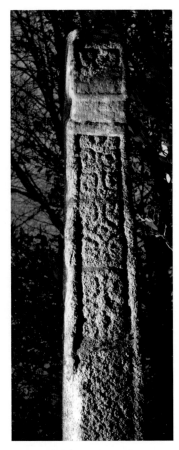

Lights help to illuminate the very worn, low-relief decoration on the St Teath cross: knotwork patterns (left) and a double scroll (right).

# 94. Tintagel 1

SX 0575 8842; PL34 0EF

The cross stands in the front garden of the former Wharncliffe Arms Hotel, now converted into flats. There is no public access, but the cross can be seen from the adjacent pavement.

The cross was probably first recorded in 1858, in use as a gatepost at Trevillet,[418] that is at SX 0797 8826, although the height of the cross given by Blight is different and there is no mention of a text. The cross was moved in about 1875 to its present location.[419]

This small wheel-headed cross stands 1.17m (3ft 10in) high and is set in a modern base. It is cut from a thin slab of elvan. The sides of the head have been trimmed to make the stone roughly rectangular, presumably for reuse as a gatepost, and holes in the head relate to this reuse. All the carving is incised or in very low relief. Despite its small size, this is a surprisingly elaborate monument. On the front of the head is a cross formed by slightly sinking the area between the arms. The arms flare widely from a small central boss; they are bordered by a double incised line, with a cable-moulding along the outer edge of the bottom arm. Centrally placed within the spaces between the cross-arms are four small bosses. A small section of a flat, plain ring joins the outer edge of the bottom arm. The cross on the back of the head is similar, but there is a cross within the central boss, and remains of the ring can be seen more clearly on this face. In the spaces between the ring and cross-arms are four small oval bosses, crudely carved to represent bearded heads. Small hollows represent the eyes and mouths. Down the sides of each main face of the cross-head is an incised edge-moulding, terminated at the bottom with a small cross.

The entire shaft on the front face of the cross is filled with an inscribed text set inside a panel. The text originally took up six lines, but only three are now legible. The letters are predominantly capitals and read horizontally. The remaining text reads [E]L̲N[A]T+ [F]ECIT. Earlier readings suggest that the first word was the personal name Ælnat and the text after *fecit* was an abbreviated form of *hanc crucem pro anima sua*; that is, it read

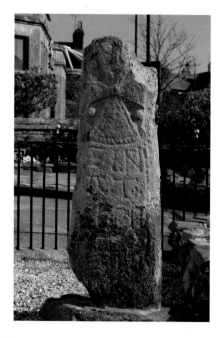

'Ælnat made this cross for the sake of his soul.'[420] The name is likely to be of English origin and may have been that of the carver or commissioner of the cross.

The entire shaft on the back of the cross is also filled with an inscribed text set inside the remains of a panel. Traces of five lines can be made out, three reading horizontally and two vertically.[421] The text is in a predominantly capital script, but the letters are highly deteriorated. The remaining text reads [M.]ᴛ [-s] [M-] ʟᴜᴄ[.] sɪᴏ[-]. Langdon's drawing shows the text in a much more legible state than it is today. He read the text as the names of the Four Evangelists, *matheus marcus lucas ioh*, the last name with an abbreviation mark indicating *iohannes*.[422] The traces remaining today fit well with this reading.

This cross is unique in Cornwall, which makes its dating problematic. The degree of elaboration, and the presence of the inscription commemorating a person with an English name, suggest a pre-Norman date, yet most of its attributes are without parallel among the pre-Norman crosses

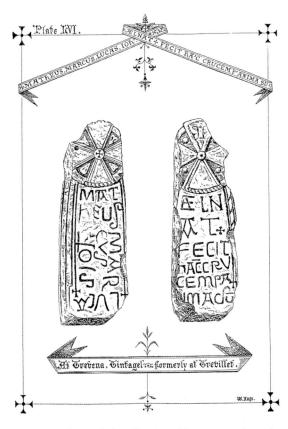

Illustration of Tintagel 1 by William Iago (Maclean 1876, plate 66).

Four tiny heads between the cross-arms may represent the Four Evangelists.

of Cornwall. It lacks the usual features of interlace decoration and of holes between the cross arms and ring that distinguish the pre-Norman crosses from the later and much simpler disc- or wheel-headed wayside crosses. However, the naming and depiction of the Evangelists is paralleled (though in rather different form) on a cross-base no. 41 Gulval 2, which may well be of pre-Norman date. Supporting a pre-Norman date for the Tintagel cross is the fact that monuments of tenth- and eleventh-century date with wheel-heads, wide-splayed arms, inscriptions filling the whole of the shaft and incised decoration are found in South Wales,[423] although none is exactly like the Tintagel stone. The names of the Evangelists also appear on two crosses in South Wales, at St David's,[424] and at Llanhamlach.[425]

On the other hand, in a Cornish context, the wheel-head has more in common with the later wheel-headed wayside crosses, although the Tintagel cross is far more ornate than any of these. In fact, the closest parallel in Cornwall is with the two stones nos 56 and 57 Lanteglos by Camelford 1 and 2, which may once have formed part of the same monument. The Lanteglos cross-head is simpler, but the general form of the cross-head, with arms flaring widely from a small central boss and the bosses within the spaces between the arms, is very similar. The use of inscriptions on two faces of the shaft is also comparable. The names on this stone are, as with those on Tintagel, of English origin, but the Lanteglos text is Middle English and is dated to the late eleventh or twelfth century.

In summary, the fact that this cross is not really like anything else in Cornwall of either pre- or post-Norman Conquest date makes it difficult to date. The English name on it, and the comparisons with 56 and 57 Lanteglos by Camelford 1 and 2, indicate that it should probably be dated to the latter half of the eleventh or the early twelfth century, even though the Welsh parallels might suggest a slightly earlier date.

Since this cross was first noted in use as a gatepost, its original context is not known. Its small size suggests that it was erected as a personal memorial to Ælnat, and one possibility is that it was associated with St Piran's chapel at Trethevy (SX 076 891).[426]

## References

Langdon, Arthur G. (1896), 366–68 and figs; Okasha (1993), no. 64, pp. 291–95 and figs; Langdon, Andrew G. (1996b), 63, no. 97 and figs; Preston-Jones and Okasha (2013), 201–03 and figs.

# 95. Tintagel 2, Bossiney

SX 0716 8831; PL34 0BD

The cross stands beside a crossroads, 1km (0.5 miles) south-east of Bosinney, where the road from Davidstow is intersected by a minor road from Trenale to Halgabron. There is full public access.

The cross is likely to be in or close to its original location, though it has been moved slightly on two recorded occasions. Blight was the first to illustrate this cross, recording that it was near 'Bossinney'.[427] Polsue recorded it under 'Hendra' and noted that it was slightly damaged.[428] In 1896, Langdon recorded and illustrated the cross under 'Bossiney' and stated it was beside the ancient road from Bossiney to Waterpit Down.[429] Maclean also illustrated the cross under the name Pentaly, as did Ellis,[430] while Mary Henderson recorded it under Fenterleigh.[431] She stated that when she visited the site in 1967 the cross had been removed from the hedge, following alterations to the road junction, and it was then standing, as it now is, on a wide grass verge.

An interesting story was related about this cross in 1921. 'When on a walking tour through North Cornwall about forty years ago I stopped to sketch a wayside cross near Tintagel; and was told by the farmer of the adjacent land that it was overthrown some time ago, and on setting it up again, he found several bottles full of water, and with many pins in them, buried around its foot.

'On enquiring the reason for these bottles being buried, I was told at Boscastle that "If you are ill-wished you must take a bottle, fill it with water, and put some pins in it, cork it tight, and then bury it at the foot of a holy cross; and the ill-wish will fall on the person who ill-wished you."'[432]

This wheel-headed cross now stands 1.55m (5ft 1in) high. According to Canner, it is 2.13m (7ft) in height,[433] but today it stands deeply buried in the grass verge. The face of the cross contains an equal-armed cross in relief, which was originally enclosed by a bead or roll-moulding, most of which has been broken off. There is a central boss and the cross has been formed by recessing four triangular areas between the arms. The back of the cross is similar. The shaft has a slight entasis on its west side, along with a narrow edge-moulding. The simple geometric cross suggests a date in the twelfth century.

Low down on the back of the shaft is a hole, which suggests that the cross may at some time have been used as a gatepost, and the front of the shaft has been scarred by an Ordnance Survey bench mark.

## References

Langdon, Arthur G. (1896), 98–99 and fig.;
Langdon, Andrew G. (1996b), 63, no. 96 and fig.

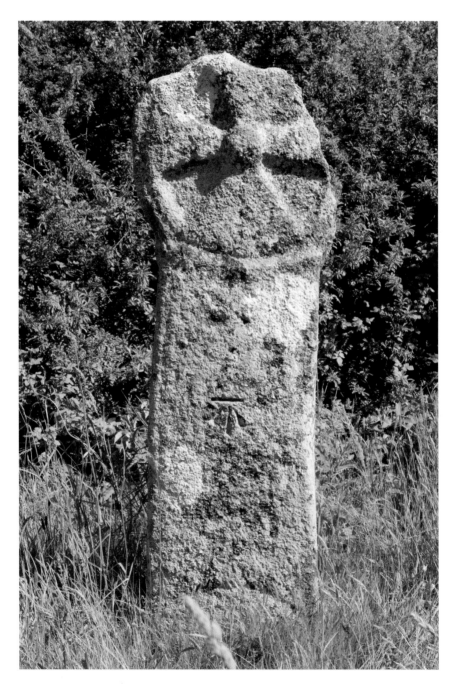

# 96. Truro

SW 8255 4491; TR1 2AJ

The cross stands in an area known as High Cross, immediately to the west of Truro Cathedral. There is full public access.

The upper part of this monument, consisting of the cross-head and around 0.5m (1ft 8in) of shaft, was discovered

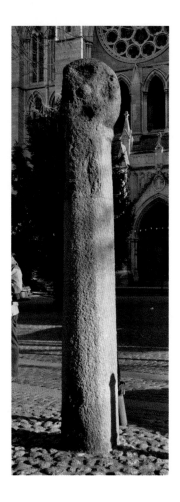

in 1958 in a deep trench that was being excavated in St Nicholas Street.[434] It was spotted by H.L. Douch, curator of the County Museum in Truro, who had it placed outside the museum in River Street. The following year, it was set up on a modern granite base in a flower border on the west side of the cathedral at High Cross, and in 1981 it was moved 40m (130ft) to the west to the cobbled square. During April 1987, through the enthusiasm of the mayor, Councillor John Christie, it was taken to Hantergantick granite quarry at St Breward, where a new shaft was cut to make it into a true high cross. Thus heightened, the cross was returned to its former position in March 1988.[435] In February 2019, the cross was hit by a vehicle and broken into four pieces. It was repaired and restored to High Cross in December 2019.[436]

The restored cross stands 3.05m (10ft) high, but prior to restoration it was 1.2m (3ft 11in) high. The height of the restored cross is probably greater than that of the original cross, but the proportions of the surviving head and section of shaft suggest that the original was nonetheless an impressive monument, perhaps up to 2.5m (approx. 8ft) tall. The wheel-headed cross has on each face a central boss and a saltire or St Andrew's cross carved in relief and formed by cutting triangular depressions. The shaft is plain except for small projections on either side of the neck. The simple geometric cross on each side of the head suggests a post-Norman Conquest date, probably of the twelfth century.

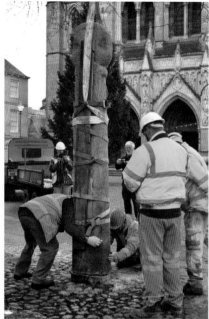

C.F. Piper & Son restoring Truro's
High Cross in December 2019.

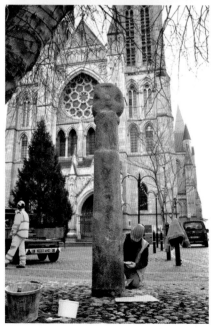

The area on the west side of the
cathedral where the cross now stands
is known as High Cross, and there is a
document dated 1290 referring to a stone
cross at Truro, *crucem lapideam burgi de
Truru*.[437] From 1755 there is a reference
that suggests that bulls may have been
baited at the cross, for which purpose a
ring was fixed to an old base-stone at the
site;[438] however, it is far from certain that
this is the same cross.

## References

Langdon, Andrew G. (1989), 406–09 and figs;
Langdon, Andrew G. (2002), 67, no. 86b and fig.

235

# 97. Wendron 1

SW 6787 3104; TR13 0EA

The cross-head is in the churchyard of St Wendron's church, beside the south porch. There is full public access.

The cross-head was found in around 1865, buried in the churchyard to the east of the church, close to the surface; by 1890 it had been placed at the 'eastern end of Wendron churchyard'.[439] In 1909, the cross-head was recorded in its present location.[440]

The monument stands 0.8m (2ft 8in) high. It consists of a broken and extremely worn cross-head with part of its shaft. The remaining part of the shaft is undecorated. The cross-head has widely splayed arms, linked by a ring that is slightly recessed

from the face of the cross. Between the cross-arms, the three remaining holes are small and circular and are all of different diameters. Both broad faces of the cross-head contain a central boss, with a further boss on each remining cross-arm.

This cross is unusual in featuring bosses on both sides of the head; another possible example is no. 6 Breage, another very worn monument. As Breage is only 6.5km (4 miles) away, this may be an indication of a local group, although no other nearby examples are known at present. The ring head with bosses suggests a pre-Norman date, perhaps of the mid-tenth to eleventh century, but the cross is so worn, with so little surviving decoration, that it is difficult to be sure of the date.

Wendron church is associated with the Domesday royal manor of Helston whose name, containing the place-name element *hen-lys* 'ancient court',[441] indicates an early medieval administrative centre. Wendron church was also the mother church of a number of chapelries, so was evidently a place of some status.[442] This cross is the earliest tangible evidence for the church site.

See also two small cross-heads in the parish church, as well as one in the churchyard opposite.

## References

Langdon, Arthur G. (1896), 188–89 and fig.; Langdon, Andrew G. (1996c), 17; Langdon, Andrew G. (1999), 60, no. 93 and fig.; Preston-Jones and Okasha (2013), 209–10 and figs.

# 98. Wendron 2, Meruny

SW 7018 2912; TR13 0NY

The cross stands on Polglase Hill opposite the entrance to Polglase Farm. There is full public access.

This cross was first illustrated by Barnicoat in 1839 under the name Melluny Mill.[443] In 1896, Langdon illustrated both sides of the cross and stated it was

in situ.[444] He also noted that at one time a road led from the cross north to Merther Uny chapel site, and that by tradition there was a burial beneath the cross.[445]

This wheel-headed cross stands 1.93m (6ft 4in) high, in an oval base, and is probably in situ. All the decoration on this cross is incised. On one face is a Latin cross with parallel arms and a long stem extending down the shaft to terminate on a triangular base. The cross on the head is outlined with further incised lines. On the other face is a simple parallel-armed Latin cross, with the lower arm extending down the shaft of the monument. Both crosses have a small hole or depression at the centre, while the edges of the shaft are chamfered on each side. These chamfered edges suggest a thirteenth-century date.

Although no road or track now survives to Merther Uny chapel and cemetery site, it is likely that one existed in the past. To the south, a footpath runs from the cross via Polglase Farm and Tolvan Cross to Gweek; if the line of the footpath is continued north, the chapel is only two fields away. If a footpath had once existed, the cross would have stood at the crossing.

## References

Langdon, Arthur G. (1896), 264–65 and figs;
Langdon, Andrew G. (1999), 61, no. 96 and fig.

# 99. Wendron 3, Merther Uny

SW 7033 2931; TR13 0NU

The cross is in the old graveyard within the hamlet of Merther Uny, beside the west boundary. There is limited public access by public footpaths and a bridleway.

The cross was first recorded in 1872 on the site of an 'ancient chapel',[446] probably in its present location, possibly in situ.[447] According to Henderson, the base was broken and lay some 0.46m (about 1ft 6in) beneath the ground. Henderson also recorded that in 1886 the cross fell down and was re-erected, revealing 'human bones and oak coffins'.[448] In 1970, during excavation, portions of the base were uncovered.[449]

The monument is complete and stands 1.68m (5ft 6in) high. It has a slab-like form, with the sub-rectangular head of the same width as the shaft and with a projecting roll-moulding at the neck. The cross is indicated by four asymmetrical circular holes and a roughly central boss on each side of the head. All four faces of the shaft are decorated with irregular and asymmetrical decoration consisting of small bosses, incised lines and rows of dots.

The relationship of this cross to the early medieval ring-headed crosses is seen in the appearance of four holes and a boss on the head, but, like no. 84 Phillack, for which a late eleventh-century date has been proposed, further bosses are set in unusual places. Here however the resemblance to the pre-Norman crosses ends, and further parallels are with later monuments such as no. 28 St Dennis and no. 86 Roche. However the decoration is so unusual that there is little to compare

it to and it contains no definite datable features. The cross might possibly be from the twelfth century. Dexter and Dexter were of the opinion that this cross could not be Christian, describing it as 'a monstrosity'.[450] The cross is one of a group of unusual incised crosses associated with the Carnmenellis granite area and especially the parish of Wendron, although the majority have more regular decoration of diamonds and lozenges.

A suggestion that the cross may date from about AD 1000 and mark the foundation of Merther Uny chapel site appears to lack substance.[451] However, excavation here did establish that the small curvilinear enclosure within which the cross is located started life as an Iron Age or Romano-British round, whose earliest use as a chapel yard is indicated by finds of bar-lug pottery.[452] Henderson suggested that the chapel had its own parochial limits but for some reason never attained full parochial status.[453] The name Merther Uny means 'saint's grave' or 'place claiming relics' of St Euny: 'curiously, there were two different places called *Merther-Euny*, yet neither possessed the body of the saint, which was considered to be at Lelant'.[454]

## References

Langdon, Arthur G. (1896), 346–47 and figs;
Langdon, Andrew G. (1999), 64, no. 101 and figs.

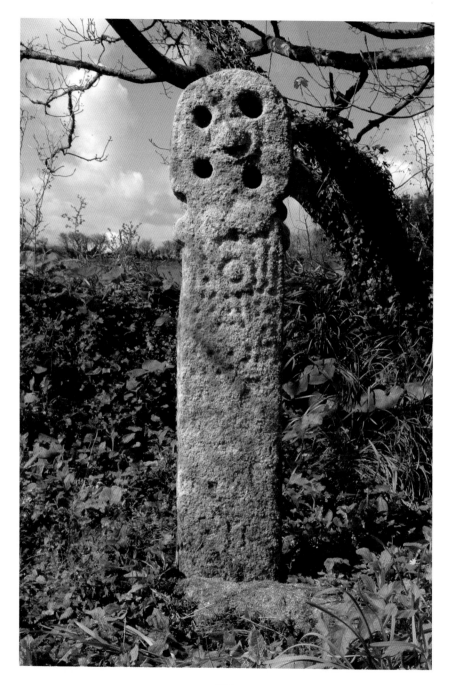

# 100. St Wenn, Crossy Ann

SW 9574 6262; PL30 5PF

The cross stands on Tregonetha Downs 4.6km (2.8 miles) east of St Columb and to the west of Castle an Dinas hill fort. There is full public access.

This cross is recorded in a parish terrier of 1613 for St Columb Major as 'ye Cross of ye hand',[455] and later, in 1819, as 'Cross and Hand', one of the stone posts marking the boundary of the common, under an enclosure called Castle Dennis Common.[456] Langdon illustrated the cross, noting that it marked the boundary of three parishes, St Wenn, St Columb Major and Roche; he also said that it was insecurely fixed to its base, which is supposed to be in situ.[457]

This wheel-headed cross stands 1.8m (5ft 11in) high and is very roughly hewn from coarse-grained granite. On both faces there is an irregular parallel-armed cross in relief formed by cutting away triangular recesses between the arms. The shaft has entasis, which improves the visual effect of the monument. The simple geometric cross suggests a twelfth-century date.

Nearby is another base-stone for a cross of a later date, this one within St Columb Major parish. The origin and meaning of the name Cross and Hand is uncertain. Andrew suggested that the cross missing from the other base-stone may have been one that had the carving of a hand, rather than the cross described here, although there is no actual evidence for this.[458]

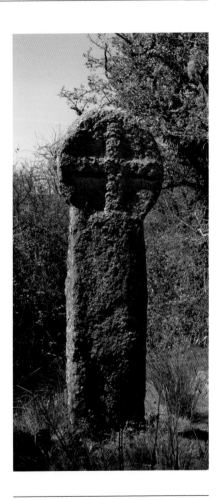

## References

Langdon, Arthur G. (1896), 94–95 and fig.;
Langdon, Andrew G. (2002), 73, no. 97 and fig.

# PARISH PAGES

# St Allen

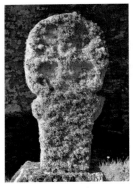

Cross 2, on south-east side of churchyard.

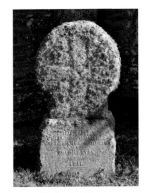

Trefronick Cross.

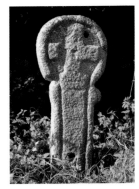

Trevalsa Cross.

Trevalsa Cross, beside a road junction, close to the edge of the parish.

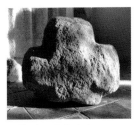

The head of a latin cross on the floor at the east end of St Allen Church.

Although not in one of the granite areas of Cornwall, St Allen parish nonetheless has a good collection of granite wayside crosses. Three are in the parish churchyard (including cross no. 2) and inside the church are remains of two more crosses: the head of a small Latin cross and the base-stone of a gothic lantern cross, now converted into a font. A decorated thirteenth-century grave-slab, mounted against a wall in the church, is also of note. Only one cross remains in the countryside, near Trevalsa Farm. Formerly used as a gatepost, this was restored on a new base-stone in 1996.

# St Buryan

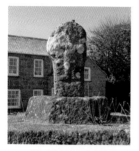

Churchtown Cross.

The parish of St Buryan has more surviving wayside crosses than any other parish in Cornwall. Most are on, or close to, their original locations. Some are said to have marked the boundary of the especially privileged sanctuary that St Buryan possessed throughout the middle ages, though this is difficult to prove; others stood on roads, tracks and paths between farms and over the higher ground of the parish. Two, the Boskenna cross and that in St Buryan churchtown, are carved with a figure of the crucifixion that may have been copied from the churchyard cross (no. 11).

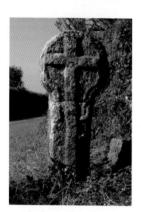

Boskenna Gate Cross.

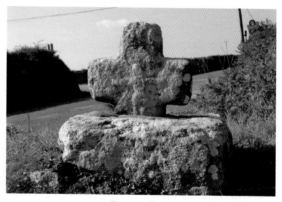

Chyoone Cross.

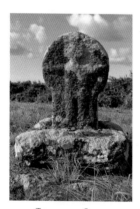

Trevorgans Cross.

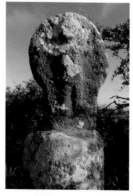

Boskenna Cross.

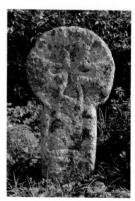

Nûn Careg Cross.

# St Clether

New Park Cross.

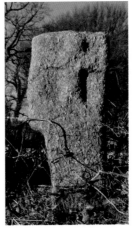

Trefranck Cross.

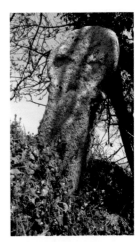

Basil Cross 2.

The wayside crosses of St Clether are of a very distinctive and uniform parochial style. One, the Cross Gates Cross, features in a detailed entry (no. 23). Almost all are exceptionally tall and of narrow cross-section, with projections at the neck and an equal-armed cross carved in relief on the head. One, the Tarret Bridge Cross (not featured here as it is not easily accessible), is unusual in being cut from a greenstone or slate. Others, at Trefranck and Ta Mill, were only discovered quite recently, in 1993 and 2000.

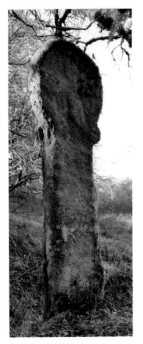

Basil Cross 1.

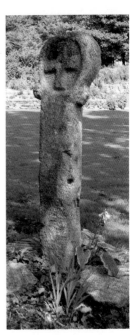

Ta Mill Cross
(no public access).

# Lanivet

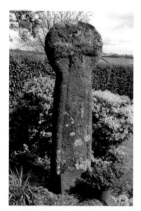

Bodwannick Cross (no public access unless the gardens are open to the public).

Lanivet is notable for the many wayside crosses surviving on the verges of the parish's roads. The majority of these are wheel-headed crosses, carved on the head with an equal-armed cross in relief. The consistency of their style suggests that the majority may have been carved and set up at about the same time. Lanivet parish church also has a number of other ecclesiastical monuments, including two sixth-century inscribed memorial stones and two recumbent grave-covers, one comparable to the Viking 'hogback' gravestones of the north of England.

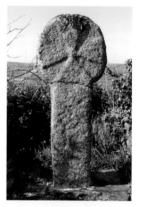

St Ingunger Cross.

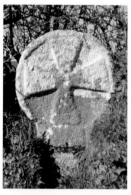

Tremore Cross.

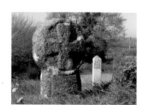

Reperry Cross.

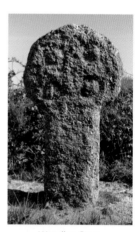

Woodley Cross.

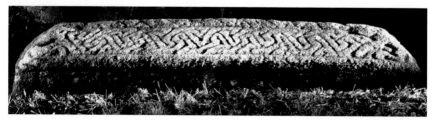

Hogback tombstone in churchyard.

# Lanteglos by Camelford

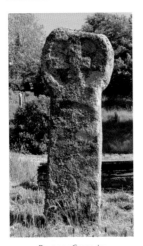

Rectory Cross, in the churchyard.

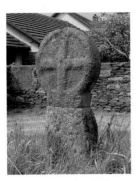

Trevia Cross, beside the road from Camelford to Tintagel and Boscastle.

In addition to the crosses in the churchyard described in more detail (nos 56 and 57), the parish of Lanteglos by Camelford contains an interesting group of wayside crosses. Three others are in the churchyard, while in the surrounding countryside are three further examples. Several of the crosses have the same straight-armed cross whose simple, geometric form suggests a date in the early Norman period. After many years in which it lay neglected in the church tower, the Tregoodwell Cross was restored in 2013 on a new base and shaft close to its site of discovery.

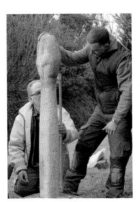

Tregoodwell Cross: left, measuring up the head before restoration; above, restoration by Ernie and Kevin Hillson.

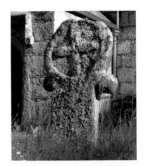

Valley Truckle Cross.

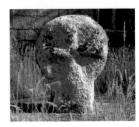

Trewalder Cross, in the churchyard.

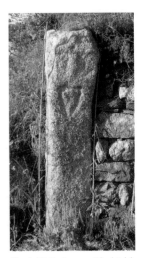

Trevia Walls Cross, with shield.

# Lelant

Sheltered by a dense spreading tree, Lelant churchyard Cross 3 never sees the light of day.

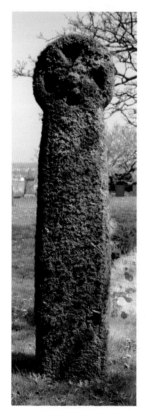

Eight wayside crosses are known in the parish of Lelant, which also has a churchyard cross of probably thirteenth-century date, standing in the traditional place to the south of the parish church. Four of the wayside crosses were gathered into the churchyard in the nineteenth and twentieth centuries; another is in use as part of the parish war memorial. In the modern churchyard to the west of the church are numerous Victorian headstones that copy the form of medieval wayside crosses. Now encrusted in lichen, they can be difficult to distinguish from the original monuments.

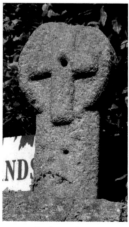

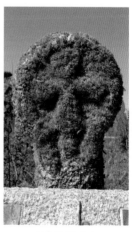

Churchyard Cross.                    Sea Lane Cross.                    Lelant Cross 2.

# Ludgvan

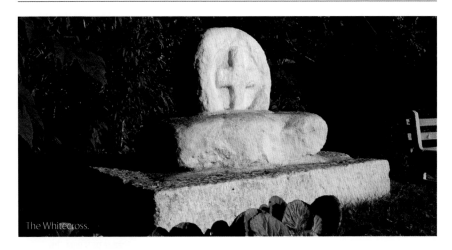

The Whitecross.

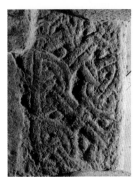

The Whitecross near Crowlas is a distinctive sight for anyone driving along the A30 through Ludgvan parish between Hayle and Penzance. It is one of a number of wayside crosses in the parish, of both Latin and wheel-headed form. The three in the parish churchyard (one featured as no. 62) must have been moved there from the surrounding countryside, but the date is not recorded. Built into a step in the church tower is a section of the shaft of a pre-Norman cross, finely carved with triquetra knots.

Fragment of a pre-Norman cross, used as a step to the ringing chamber in the church tower.

Tregender Cross.

Cross 2 in the churchyard.

Cross 3 in the churchyard.

248

# St Neot

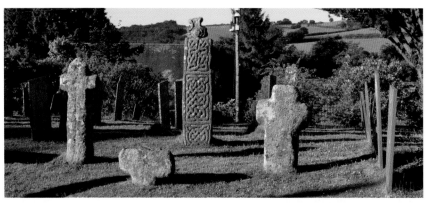

Three wayside crosses and the tenth-century cross-shaft in the churchyard.

St Neot's parish churchyard has a rich collection of medieval monuments. These include the remains of two churchyard crosses (no. 73), one fine late medieval lantern cross and three rugged granite wayside crosses. St Neot 3 (no. 74) stands on the northern boundary of the parish. The wayside crosses exemplify the parochial style, which was for simple Latin crosses enriched only with an incised line cross. Further crosses remain out in the countryside, at Hilltown, Newton, Polmenna, Trenant, Tredinnick and Wenmouth Cross.

Wenmouth Cross.

Latin wayside cross in the churchyard.

Tredinnick Cross.

# Notes

## Introduction

1. Langdon, Andrew G. (2013), 259–77.

## Historical overview

1. For a more comprehensive account of the early archaeology of Cornwall in relation to the sculpture, see the chapter by Ann Preston-Jones in Preston-Jones and Okasha (2013), 37–49. A comprehensive discussion of the historical background by Oliver Padel appears in the same volume, 21–36.
2. Preston-Jones (2011a), 269–76.
3. Okasha (1993).
4. Padel, in Preston-Jones and Okasha (2013), 29–30.
5. Padel, in Preston-Jones and Okasha (2013), 36.
6. Padel, in Preston-Jones and Okasha (2013), 36.
7. Herring (2011).
8. Orme (2007), 25.
9. Orme (2007), 24, 30–31.

## Inscriptions on the crosses

1. Further details on these inscriptions appear in Okasha (1993).
2. Preston-Jones and Okasha 2016, ills. 81–2, 338–41.

## Cornish groups or schools of stone sculpture

1. Preston-Jones and Okasha (2013), 85–99.
2. Padel, in Preston-Jones and Okasha (2013), 25, 135–37.

## Dating the monuments

1. Cumber (1950), 23.
2. Anon. (1952), 9.
3. The evidence is described more fully in Preston-Jones and Okasha (2013), 85–99.
4. Okasha (1993); Thomas, A.C. (1994).
5. See Padel, 'Further Discussion of the Name', in Preston-Jones and Okasha (2013), 135–37.
6. Thomas, A.C. (1978), 75–76, followed by Preston-Jones and Langdon, Andrew G. (1997), 118.
7. Webster (2012), 174–78.
8. Preston-Jones and Okasha (2013), 165.
9. Butler (1964), 115, fig. 1; Ryder (1991), 50–51.
10. Sedding (1909), 459–60.
11. Langdon, Andrew G., in Preston-Jones and Okasha (2013), 106.
12. Langdon, Andrew G. (2006c), 117–21.

## Function of the crosses

1. Padel (1985), 130; Padel (1988), 96.
2. Cornwall Record Office, SF 285/68, 69.

# Antiquarian study and restoration

1. Preston-Jones and Okasha (2013), 167–68.
2. Jones and Quinnell (2018).
3. Quoted in Langdon, Arthur G. (1896), 303.
4. Langdon, Arthur G. (1896), 277, 291.
5. Blight (1858), 28.
6. Hare (1881–83), 139–40.
7. Hare (1881–83), 139–40.
8. Langdon, Arthur G. (1896), 391–94.
9. Anon. (1883), 22.
10. Langdon, Andrew G. (1996d), 570–71.
11. Maclean (1876), 558.
12. Bates and Spurgin (2006), 9–13.
13. Michell (1977), 64.
14. Langdon, Arthur G. (1890); letter from Arthur G. Langdon of 17 Craven Street, Strand, London WC to Rev. Saltren Rogers, vicar of Gwennap.
15. http://www.roll-of-honour.com/Pembrokeshire/HaverfordwestBoer.html.
16. Henderson, C.G. (1935), xvi.
17. Cooke (1993), 31.
18. Rowse (1984), 218–25.
19. Henderson, C.G. (1935), xv.
20. Henderson, C.G. (1930), 6–12.
21. Henderson, M. (1985).

# A note on photography

1. Preston-Jones and Okasha (2013), 5–7.

# Catalogue of crosses

1. Blight (1858), 67.
2. Maclean (1876), 282–83 and fig.
3. Respectively Wendron 3 and Wendron 4 in Preston-Jones and Okasha (2013), 248–50.
4. Henderson, C.G. (1928), 28.
5. Henderson, C.G. (1928), 28.
6. Moyle (1726), 237.
7. Penaluna (1838), I, 57.
8. Polsue (1867), 62.

9. Hammond (1897), 310; Langdon, Arthur G. (1906), 419.
10. Borlase (1754), 363–64.
11. Blight (1858), 24 and fig.
12. Ellis (1950–51), 141–42 and fig.
13. Langdon, Arthur G. (1896), 171–72 and fig.
14. Henderson, M. (1985), 89–90.
15. Blight (1858), 66.
16. Maclean (1873), 118–19.
17. Langdon, Arthur G. (1896), 311n.
18. Munn and Long (1988), no. 22.
19. Langdon, Andrew G. (1996c), 24.
20. Langdon, Andrew G. (1996b), 17.
21. Henderson, C.G. (1930), 8.
22. Blight (1865), 73.
23. Langdon, Arthur G. (1896), 380.
24. Langdon, Arthur G. (1896), 380.
25. Henderson, C.G. (1925a), 63–64, 83, 100, 105; Orme (2010), 128.
26. Henderson, C.G. (1953–56), 170, 192.
27. Padel (2002), 354.
28. Blight (1858), 7.
29. Langdon, Arthur G. (1896), 57–68 and fig.
30. Langdon, Arthur G. (1896), 139–40.
31. Langdon, Andrew G. (1997), 41.
32. Langdon, Andrew G. (2017), 45–52.
33. Blight (1858), 32.
34. Langdon, Arthur G. (1891), 301.
35. Padel (1988), 59.
36. Johnson and Rose (1994), 77–79.
37. Langdon, Arthur G. (1906), 438.
38. Henderson, C.G. (1935), 196.
39. Ellis (1952–53b), 85.
40. Langdon, Andrew G. (1996b), 21.
41. Blight (1858), 66.
42. Maclean (1873), 354 and fig.
43. Ellis (1937–42), 237–39 and fig.; Ellis (1952–53a), 32–33.
44. Langdon, Arthur G. (1896), 240–41.
45. Gough, R. (1789), I, 12.
46. Britton and Brayley (1801), 494 and fig.
47. Gossip et al. (2016), 13–16.
48. Olson (1989), 78–81; Orme (2010), 128.
49. Olson and Padel (1986), 48.
50. Henderson, C.G. (1925a), 34–36.
51. Henderson, C.G. (1925a), 36.
52. Haslam (1845), 26–32, and pl. 2 fig. 5.

53. Hingston (1850), 2 and fig.
54. Blight (n.d.), II, 45.
55. Blight (1856), 4 and fig.
56. Langdon, Arthur G. (1896), 318–19 and fig.
57. Padel (1985), 123.
58. Borlase (1751–58), p. 81; see Henderson, C.G. (1935), 83–84, and Thomas, A.C. (1967), 88–90, 172–73.
59. Peter (1898), 76–77.
60. Thomas, A.C. (1967), 90.
61. For example Calverley 2, Adel 2, Emley 1: Ryder (1991), 8, 17, 22–23.
62. Preston-Jones and Okasha (2013), 128–29.
63. Langdon, Andrew G. (1999), 18.
64. Langdon, Andrew G. (2000), 18–19.
65. Oxford University archives, ref Hyp/A/1 (Reg.Aaa), f 97, r–v; Langdon, Arthur G. (1896), 7–8; Thomas, A.C. (1967), 91.
66. Blight (1858), 26.
67. Iago (1874–78), 363.
68. Langdon, Arthur G. (1896), 356.
69. Bailey (1980), 72.
70. Bailey and Cramp (1988), 36.
71. Okasha (1993), 88–90; Thomas, A.C. (1994), 265, 307, 328.
72. Henderson, C.G. (1925a), 71; Picken (1955), 50.
73. Padel (1985), 204, 217.
74. Picken (1955), 204–05.
75. Blight (1858), 26 and fig.
76. Langdon, Arthur G. (1896), 173 and fig.
77. Langdon, Arthur G. (1902), 51–52.
78. Langdon, Arthur G. (1902), 51–52.
79. See the discussion in Okasha (1993), 88–90.
80. Henderson, C.G. (1925b), 81.
81. Blight (1858), 40 and fig.
82. Langdon, Arthur G. (1896), 174 and fig.
83. Langdon, Andrew G. (1996a), 17.
84. Camden (1600), 155.
85. Hals (1750), 46–47.
86. Spence (1849), 212–13; fuller details about the stone's history can be found in Okasha (1993), 213.
87. Redknap and Lewis (2007), 329–37, 373–76, 382–89.
88. See Padel, 'Further Discussion of the Name', in Preston-Jones and Okasha (2013), 135–37.
89. See Padel, 'Further Discussion of the Name', in Preston-Jones and Okasha (2013), 137.
90. Preston-Jones and Okasha (2013), 135.
91. Camden (1600), 155.
92. See Okasha (1993), 213.
93. Cramp (2006), 82–83, ills 10–14.
94. Cox (1720), 316.
95. Anon. (1803), 121.
96. Blight (1858), 20.
97. Britton (1835), 69, plate A.
98. Stockdale (1824), 151.
99. Prout (1809), illustration.
100. Ellis (1952–53c), 145.
101. Langdon, Arthur G. (1896), 208.
102. Borlase (1754), 356.
103. Haslam (1845), 30.
104. Polsue (1867), 220.
105. Langdon, Arthur G. (1896), 158.
106. Langdon, Andrew G. (2006a), 33–39.
107. Preston-Jones (2007), 13–15.
108. Godwin (1853), 323.
109. Langdon, Arthur G. (1896), 281.
110. Langdon, Arthur G. (1896), 147.
111. Henderson, C.G. (1937), 24.
112. Blight (1856), 35.
113. Langdon, Arthur G. (1896), 267.
114. J.D. Enys was a keen antiquarian, and in later life funded the publication of Langdon's *Old Cornish Crosses* in 1896.
115. Blight (1858), 21.
116. Preston-Jones and Okasha (2013), 250–51, Wendron 5.
117. Preston-Jones and Okasha (2013), 107.
118. Padel (1988), 78.
119. Langdon, Arthur G. (1896), 194–95.
120. Langdon, Arthur G. (1896), 226.
121. Maclean (1873), 405–07.
122. Polsue (1867), 317.
123. Langdon, Arthur G. (1896), 180.
124. Maclean (1873), 407.
125. Andrew (1937–42), 223.
126. Andrew (1937–42), 223.
127. Langdon, Arthur G. (1896), 180.
128. Hals (1750), 109.
129. Gilbert (1838), 368.

130. Blight (1858), 36.
131. Langdon, Arthur G. (1896), 337–38.
132. Langdon, Andrew G. (1996b), 30.
133. Maclean (1873), 120.
134. Quoted in Ellis (1954–55a), 65; see also Trevan (1834), 75.
135. Maclean (1873), 485.
136. Willmot (1933), 17.
137. Langdon, Arthur G. and Allen (1895), 58 and fig.
138. Langdon, Andrew G. (1996b), 22.
139. Langdon, Arthur G. and Allen (1888), 318.
140. Langdon, Arthur G. (1896), 402.
141. Preston-Jones and Langdon, Andrew G. (1998), 9–10.
142. Padel (1988), 82.
143. Padel (1985), 142.
144. Penaluna (1838), I, 162.
145. Blight (1856), 24 and fig.
146. Henderson, M. (1985), entry no. 190, p. 374 and photographic record, note dated 28 September 1953.
147. Polwhele (1803), II, 199n–200n; see Okasha (1993), 129–32 and fig.
148. Iago (1878–81), 398.
149. Langdon, Arthur G. and Allen (1895), 51.
150. BL MS Stowe 1023, p. 47, renumbered as p. 29; for discussion, see Okasha (1993), 129–32.
151. Penaluna (1838), 189.
152. Polsue (1868), 6.
153. Blight (1858), 41 and figs.
154. Ó Floinn (1987), 181.
155. Ryder (2005), 13, 43, 57 and figs.
156. Leland, c.1540, part III, fol. 18, ed. Smith (1907), I, 207.
157. For full details, see Okasha (1993), 91–92.
158. Anon. (1893–95), 142.
159. Rowe (1926–28), 447.
160. See Okasha (1993), 94.
161. Padel (1981), 77.
162. See Padel (1981), 55, 77–79.
163. Padel (1981).
164. Langdon, Arthur G. (1896), 201 and fig.
165. Ellis (1954–55a), 68–69 and fig.
166. Langdon, Andrew G. (2005), 38.
167. Langdon, Andrew G. (2005), 32.
168. Ellis (1954–55a), 68.
169. Blight (1858), 48.
170. Polsue (1868), 77.
171. Langdon, Arthur G. (1896), 263–64.
172. Millett (1884–88), 145.
173. Anon. (1884–88), 314.
174. Langdon, Arthur G. (1896), 372.
175. Langdon, Arthur G. and Allen (1895), 58.
176. Macalister (1945), 440.
177. Thorn and Thorn (1979), 2, 10.
178. Blight (1856), 50.
179. Preston-Jones and Okasha (2013), ills 88–91, 338–41.
180. http://tom.goskar.com/2013/07/23/a-medieval-discovery-at-gulval-church-cornwall/.
181. Aston et al. (2013), 4.
182. Preston-Jones and Okasha (2013), 222–23, ills 269–70.
183. Bodleian Library MS. Auct. D. 2. 16; British Library Addit. MS. 9381.
184. Preston-Jones and Okasha (2013), 151.
185. Preston-Jones (2017), 38–39.
186. Borlase (1751–58), 180; Thomas, A.C. (1967), 96.
187. Blight (1856), 27 and fig.
188. Langdon, Arthur G. (1896), 306–07 and figs.
189. Langdon, Andrew G. (1996c), 24.
190. Thomas, A.C. (1967), 96–97.
191. Note on a watercolour sketch in the Arundel archive in Kresen Kernow, AR/48/6.
192. Lysons and Lysons (1814), ccxlv.
193. Henderson, C.G. (1957–60a), 340; P.C.P.W. (n.d.), 20.
194. See further Okasha (1993), 136.
195. See further Preston-Jones and Okasha (2013), 153–55.
196. Thorn and Thorn (1979), 1, 11.
197. Henderson, C.G. (1953–56), 198–200.
198. Blight (1858), 66.
199. Langdon, Arthur G. (1896), 162–63 and fig.
200. Ellis (1954–55b), 100–01.
201. Langdon, Andrew G. (1996b), 35–36 and figs.

202. Polsue (1868), 290.
203. See Peter (1899–1900), 185.
204. Peter (1899–1900), 188.
205. Langdon, Arthur G. (1896), 404.
206. Okasha (1993), 243–47; Thomas, A.C. (1994), 286–87, 295.
207. Padel (1988), 100–01; Padel (2002), 355.
208. Ellis (1954–55c), 161.
209. Stephens (1915), 90.
210. Ellis (1954–55c), 161.
211. Ellis (1954–55c), 161–62.
212. Maclean (1876), 81.
213. Stephens (1915), 87 and fig.
214. Ellis (1954–55d), 131–32.
215. Anon. (1952).
216. Ellis (1954–55e), 194–96.
217. Ellis (1954–55e), 194–95.
218. Beacham and Pevsner (2014), 268–69; Sedding (1909), 189.
219. Padel (1988), 106.
220. Polsue (1870), 2.
221. Langdon, Arthur G. (1896), 163.
222. Langdon, Andrew G. (2009), 29–30.
223. Preston-Jones (2006b), 12.
224. Forbes (1794), 162.
225. Langdon, Arthur G. (1896), 382.
226. Langdon, Arthur G. (1896), 382.
227. Henderson, C.G. (1925a), 104.
228. Padel (1988), 106.
229. Iago (1876), no page numbering.
230. Langdon, Arthur G. (1896), 183.
231. Britton and Brayley (1801), 518.
232. Regrettably hidden by a large yew tree at the time of writing.
233. Padel (1985), 142–45, 172; Padel (1988), 106.
234. Henderson, C.G. (1925a), 104–05; Henderson, C.G. (1957–60a), 286–91.
235. Britton and Brayley (1801), 518.
236. Redknap and Lewis (2007), 185–90, 200–02, 210–13.
237. Langdon, Arthur G. (1896), 296.
238. Dexter and Dexter (1938), 18, 39–44.
239. Preston-Jones and Okasha (2013), 163.
240. Blight (1858), 3.
241. Polsue (1870), 20.
242. Langdon, Arthur G. (1896), 58–59 and figs.
243. Ellis (1956–58), 5.
244. Langdon, Arthur G. (1896), 273–74.
245. Langdon, Arthur G. (1896), 274–75 and fig.
246. Blight (1858), 126.
247. Polsue (1870), 57.
248. Rhys (1875), 363.
249. Photograph in the collections of the National Museum of Wales, accession number 25.486.
250. Langdon, Arthur G. (1906), 416.
251. Langdon, Andrew G. (1992a), 40, no. 54; Preston-Jones and Okasha (2013), 165.
252. Blight (1858), 126.
253. For a fuller linguistic discussion see Okasha (1993), 144–45.
254. Padel (1976–77), 22–23.
255. Blight (1858), 32.
256. Polsue (1870), 56.
257. Langdon, Arthur G. (1896), 169.
258. Langdon, Arthur G. (1906), 429.
259. Langdon, Arthur G. (1896), 169.
260. Photograph in the collections of the National Museum of Wales, accession number 25.486.
261. Hingston (1850), no. 6 and fig.
262. Blight (1856), 14 and fig.
263. Blight (n.d.), I, 86.
264. Cooke (2003), 22–23 and figs.
265. Henderson, C.G. (1912–17), I, 120–22 and fig.
266. Anon. (1877), 17 April, p. 3, col. 1.
267. Anon. (1878), 12 March, p. 2, col. 7.
268. Polsue (1870), 105.
269. Maclean (1873), 400, 585–86 and fig.
270. Langdon, Arthur G. (1896), 375.
271. Langdon, Arthur G. (1896), 22–23, 42.
272. Redding (1842), 180.
273. Blight (1861), 135 and fig.
274. Langdon, Arthur G. (1896), 298.
275. See for example Ó Floinn (1987), 168–88.
276. Gough, J. and Padel (2009), 72.
277. Polsue (1870), 32.
278. Langdon, Arthur G. (1901–09), no. 40 and fig., drawing dated 2 September 1901.
279. Langdon, Arthur G. (1901), 130–34.
280. Langdon, Andrew G. (1999), 33.
281. Langdon, Andrew G. (1997), 57, no. 89.

282. Langdon, Arthur G. (1896), 273–75, no. 55.
283. Blight (1856), 58.
284. Langdon, Arthur G. (1896), 114–15 and figs.
285. Henderson, C.G. (1957–60a), 312.
286. Preston-Jones and Okasha (2013), 167–68 and figs.
287. Langdon, Arthur G. (1896), 323–24 and figs.
288. Henderson, C.G. (1957–60a), 316–17.
289. Padel (1985), 130; Padel (1988), 96.
290. Preston-Jones and Okasha (2013), 219.
291. Langdon, Arthur G. (1896), 246 and fig.
292. Blight (1856), 42 and fig.
293. Langdon, Arthur G. (1896), 313–14 and fig.
294. Langdon, Andrew G. (1997), 43.
295. https://www.heritagegateway.org.uk/ Gateway/Results_Single.aspx?uid= MCO5018&resourceID=1020.
296. Cooke (2002), 18.
297. Anon. (1844), 485–86.
298. Blight (n.d.), I, 37.
299. Blight (1856), 30 and fig.
300. Langdon, Arthur G. (1896), 115–16 and figs.
301. Langdon, Arthur G. (1901–09), drawing dated 1903.
302. Langdon, Arthur G. (1906), 438–39 and fig.
303. Ellis (1959–61), 34.
304. Doble (1945), 58.
305. Polsue (1870), 357.
306. Maclean (1876), 559 and fig.
307. Langdon, Arthur G. (1896), 186–87 and fig.
308. Blight (1856), 29 and fig.
309. Langdon, Arthur G. (1896), 150–51 and fig.
310. Langdon, Arthur G. (1896), 335–37.
311. Herring (1993), 77–79.
312. Penaluna (1838), 111.
313. Maclean (1873), 586.
314. Langdon, Arthur G. (1890–91), 38.
315. Okasha (1993), 320.
316. Preston-Jones and Okasha (2013), 169.
317. Thomas, A.C. (1993), 109–10; Turner (2006), 36, 38, 161.
318. Padel (1988), 109.
319. Maclean (1879), 9; see also Polsue (1870), 370.
320. Penaluna (1838), 125.
321. Blight (1856), 48 and fig.
322. Harvey (1875), 18.
323. Langdon, Arthur G. (1896), 283–84 and figs.
324. Preston-Jones and Okasha (2013), 247.
325. Polsue (1870), 394.
326. Iago (1870), 162–64.
327. Sedding (1909), 81.
328. Langdon, Arthur G. (1896), 342–43 and fig.
329. Polsue (1870), 408.
330. Langdon, Arthur G. (1896), 405–06.
331. Henderson, C.G. (1925a), 171.
332. Henderson, C.G. (1929), 47.
333. Langdon, Arthur G. (1896), 406.
334. Henderson, C.G. (1929), 47.
335. Olson (1989), 85–86, 89, 105.
336. Padel (2002), 324.
337. Thorn and Thorn (1979), 4,28.
338. Martyn (1748), fig.
339. Thomas, N. (1996), 5.
340. Swete (1780), no page numbering.
341. Thomas, N. (1996), 5.
342. Thomas, N. (1996), 4–10.
343. Corpus Christi College Cambridge, MS 183, f. 1v, available at: http:// parkerweb.stanford.edu/parker/actions/ page_turner.do?ms_no=183; and Cramp (2006), ills 529–34.
344. Cramp (2006), 41.
345. Preston-Jones and Okasha (2013), 175.
346. Langdon, Arthur G. (1891), 306–07.
347. Langdon, Arthur G. (1906), 438; see also Langdon, Andrew G. (1996b), 59, no. 89.
348. Langdon, Arthur G. (1896), 408.
349. Herring (1998), 36.
350. Langdon, Arthur G. (1896), 409–10.
351. Langdon, Arthur G. (1896), 397.
352. Langdon, Andrew G. (1996b), 60.
353. Preston-Jones and Okasha (2013), 180–81.
354. Olson (1989), 72.
355. Anon. (1851), 157.

356. Blight (1856), 20 and fig.
357. Anon. (1884–88c), 322.
358. Olson (1989), 20–28.
359. Trelease (2006), 2; Langdon, Andrew G. (2006a), 38.
360. Preston-Jones (2009), 18.
361. Preston-Jones (2009), 20.
362. Langdon, Arthur G. (1896), 202–03 and fig.
363. Langdon, Arthur G. (1896), 202n.
364. Preston-Jones (2011b), 1–28 and figs.
365. Langdon, Andrew G. (1997), 47 and 72.
366. Langdon, Andrew G. (2004), 13.
367. Langdon, Andrew G. (2006a), 12.
368. Paris (1824), 20 and fig.
369. Millett (1888–92), 350.
370. Courtney (1878), 18.
371. Langdon, Arthur G. (1896), 308.
372. Langdon, Andrew G. (1997), 48; Thomas, A.C. (1999), 12–13.
373. Preston-Jones and Okasha (2013), 187.
374. Preston-Jones and Okasha (2013), 157–58 and figs 103–09.
375. Anon. (1851), xxx, 142–43.
376. Langdon, Arthur G. (1896), 181.
377. Sawyer (1968), 227, no. 684; Hooke (1994), 28–33; Padel (2014), 81.
378. See for example Henderson, C.G. (1931), 39, 54; Hencken (1932), 267–68, 306.
379. Padel (2014), 81.
380. Preston-Jones (2018), 167–69.
381. Allan and Blaylock (2007), 31.
382. Padel (2014), 81.
383. Langdon, Arthur G. (1896), 390, quoting Rev. Mr Hockin.
384. Blight (1856), 22 and fig.
385. Preston-Jones (1984), 170, 176–77; Thomas, A.C. (1990), 9–10.
386. Hare (1881–83), 139.
387. Padel (1988), 146.
388. Lysons and Lysons (1814), ccxlv.
389. Anna Tyacke, Portable Antiquities Scheme, pers. comm.
390. Cole and Jones (2002–03), 107, 136–37.
391. Blight (1856), 21 and fig.
392. Langdon, Arthur G. (1896), 362–63.
393. Preston-Jones and Okasha (2013), 153–55.
394. Padel (1988), 153.
395. Lysons and Lysons (1814), ccxlv.
396. Langdon, Arthur G. (1896), 360–61.
397. Langdon, Arthur G. (1896), 362.
398. Preston-Jones and Okasha (2013), 251–52, Wendron 6.
399. Blight (1856), 47 and fig.
400. Langdon, Arthur G. (1896), 269.
401. Blight (n.d.), I, 4; also reproduced in Cooke (2000), 10.
402. Langdon, Arthur G. (1896), 108.
403. Langdon, Arthur G. (1896), 108.
404. Henderson, M. (1985), 931.
405. Blight (1858), 67.
406. Langdon, Arthur G. (1896), 166.
407. Langdon, Arthur G. (1896), 166.
408. Anon. (1945), 6.
409. Anon. (1950), 5.
410. Quiller-Couch and Quiller-Couch (1894), 183.
411. Henderson, C.G. (1957–60b), 447.
412. Langdon, Andrew G. (1999), 58, no. 89.
413. Preston-Jones and Okasha (2013), 251–52, Wendron 6.
414. Anon. (1883), 78.
415. Anon. (1883), 77.
416. Anon. (1883), 77.
417. Langdon, Andrew G. (1996d), 570–71.
418. Blight (1858), 33.
419. Maclean (1879), 180.
420. See Okasha (1993), 293–94.
421. For details see Preston-Jones and Okasha (2013), 201–02.
422. Langdon, Arthur G. (1896), 368.
423. Nash-Williams (1950), 33, 38; Redknap and Lewis (2007), 117–18.
424. Nash-Williams (1950), no. 383, p. 211 and figs; Edwards (2007), 444–6.
425. Nash-Williams (1950), no. 61, pp. 76–77 and figs; Redknap and Lewis (2007), 210–13.
426. Preston-Jones (2006a), 11.
427. Blight (1858), 17.
428. Polsue (1872), 236.
429. Langdon, Arthur G. (1896), 98–99 and fig.
430. Maclean (1879), 190; Ellis (1962–64), 275.
431. Henderson, M. (1985), 993–94.
432. Michell Whitley (1921), 288.
433. Canner (1982), 16.
434. Henderson, M. (1985), 1016.
435. Langdon, Andrew G. (1989), 406–09.

436. Langdon, Andrew G. (2019).
437. Henderson, C.G. (1957–60b), 460.
438. Douch (1977), 20.
439. Wills (1890), 90.
440. Sedding (1909), 44.
441. Padel (1985), 130; Padel (1988), 96.
442. Henderson, C.G. (1925a), 202–03; Padel (2002), 309.
443. Barnicoat (1839), illustration 61.
444. Langdon, Arthur G. (1896), 264–65 and figs.
445. Langdon, Arthur G. (1896), 264.
446. Polsue (1872), 312.
447. Langdon, Arthur G. (1896), 346.
448. Henderson, C.G. (1957–60b), 477.
449. Langdon, Andrew G. (1999), 64, no. 101.
450. Dexter and Dexter (1938), 3.
451. Thomas, A.C. (1968), 81–82; Langdon, Arthur G. (1896), 346.
452. Thomas, A.C. (1968), 81–82.
453. Henderson, C.G. (1957–60b), 476–77.
454. Padel (1985), 164; Padel (1988), 120, 164.
455. Andrew (1950–51), 177–79.
456. Anon. (1819), p. 3, col. 4.
457. Langdon, Arthur G. (1896), 94–95.
458. Andrew (1950–51), 178.

# Bibliography

## Abbreviations used in the Bibliography

**Arch. Camb.**: Archaeologia Cambrensis
**Arch. J.**: Archaeological Journal
**BAR**: British Archaeological Reports
**CA**: Cornish Archaeology
**CA Soc. Newsletter**: Cornish Archaeology Society Newsletter
**CMCS**: Cambridge/Cambrian Medieval Celtic Studies
**Cornish Stud.**: Cornish Studies
**Cumberland, Westmorland Antiq. Archaeol. Soc.**: Cumberland and Westmorland Antiquarian and Archaeological Society
**Devon & Cornwall N & Q**: Devon and Cornwall Notes and Queries
**Gents. Mag.**: The Gentleman's Magazine
**JBAA**: Journal of the British Archaeological Association
**Journ.**: Journal
**JRIC**: Journal of the Royal Institution of Cornwall
**n. ser.**: new series
**RIC MS**: Manuscript in the Courtney Library, Royal Institution of Cornwall
**Rpt. RIC**: Report of the Royal Institution of Cornwall
**Trans. Exeter Dioc. Archit. Soc.**: Transactions of the Exeter Diocesan Architectural Society
**Trans. Penz. NHA Soc.**: Transactions of the Penzance Natural History and Antiquarian Society

Allan, J. and Blaylock, S. (2007), 'Notes towards a Structural History of the Church', in Cole, D., *St Piran's Church, Perranzabuloe, Cornwall: Archaeological Excavation, Conservation and Management Works*, Historic Environment Service, Cornwall County Council report (Truro).
Anon. (1803), Letter initialled D.D.S., *Gents Mag.*, 78, 2: 717–18.
Anon. (1819), *The Royal Cornwall Gazette*, 20 November.
Anon. (1844), Letter I, initialled P., reprinted from the *Cornwall Gazette*, *Gents Mag.*, 22: 483–86.
Anon. (1851), *A Hand-book for Travellers in Devon & Cornwall* (London).
Anon. (1877), *The Cornish Telegraph*, 17 April, p. 3, col. 1.
Anon. (1878), 'Lelant', *The Cornish Telegraph*, 12 March, p. 2, col. 7.

Anon. (1883), 'Two Cornish Crosses', *Antiquarian Magazine & Bibliographer*, 4: 76–80.

Anon. (1884–88), 'Excursions', *Trans. Penz. NHA Soc.*, n. ser. 2: 311–24.

Anon. (1893–95), 'Annual Excursion (1894)', *JRIC*, 12, part 2: 141–45.

Anon. (1945), *Cornish & Devon Post, Launceston*, 10 February.

Anon. (1950), *Cornish & Devon Post, Launceston*, 10 June.

Anon. (1952), 'Long Lost Cross Found at Laneast—Discovered in Churchyard when Grave was Dug', *Cornish & Devon Post*, 28 June.

Andrew, C.K.C. (1937–42), 'Three Holes Cross, Egloshayle', *Old Cornwall*, 3: 221–23.

Andrew, C.K.C. (1950–51), '158. Parish Bounds of St Columb Major in 1613', *Devon & Cornwall N & Q*, 24: 177–79.

Aston, M. *et al.* (2013), 'An Unusual Stone at Gulval Church: A Note', *CA Soc. Newsletter*, 112 (June): unnumbered 4–5.

Bailey, R.N. (1980), *Viking Age Sculpture in Northern England* (London).

Bailey, R.N. and Cramp, R. (1988), *Corpus of Anglo-Saxon Stone Sculpture*, II: *Cumberland, Westmorland and Lancashire North-of-the-Sands* (Oxford and London).

Barnicoat, W. (1839), *Sketchbook*, RIC MS (Truro).

Bates, S. and Spurgin, K. (2006), *The Dust of Heroes: The Life of Cornish Artist, Archaeologist & Writer John Thomas Blight, 1835–1911* (Truro).

Beacham, P. and Pevsner, N. (2014), *The Buildings of England. Cornwall*, 2nd ed. (New Haven).

Blight, J.T. (1856), *Ancient Crosses, and other Antiquities, In the West of Cornwall* (London and Penzance).

Blight, J.T. (1858), *Ancient Crosses, and Other Antiquities in the East of Cornwall* (London, Dublin and Penzance).

Blight, J.T. (1861), *A Week at The Land's End* (London).

Blight, J.T. (1865), *Churches of West Cornwall; with Notes of Antiquities of the District* (Oxford and London).

Blight, J.T. (n.d), Sketchbooks, Morrab Library, Penzance.

Borlase, W. (1751–58), *Memorandum of Excursions 1751–1758*, RIC MS, Borlase 41 (Truro).

Borlase, W. (1754), *Observations on the Antiquities Historical and Monumental, of the County of Cornwall* (Oxford).

Britton, J. (1835), *The Architectural Antiquities of Great Britain*, I (London).

Britton, J. and Brayley, E.W. (1801), *The Beauties of England and Wales ...*, vol. 2 (London).

Butler, L.A.S. (1964), 'Minor Medieval Monumental Sculpture in the East Midlands', *Arch. J.*, 121: 111–53.

Camden, W. (1600), *Britannia ...* (London).

Canner, A.C. (1982), *The Parish of Tintagel: Some Historical Notes* (Camelford).

Cole, D. and Jones, A.M. (2002–03), 'Journeys to the Rock: Archaeological Investigations at Tregarrick Farm, Roche, Cornwall', *CA*, 41–42: 107–43.

Cooke, I.M. (1993), 'Charles Henderson (1900–1933)', in I.M. Cooke, *Mother and Sun: The Cornish Fogou* (Penzance), 31.

Cooke, I.M. (2000), *Crosses and Churchway Paths in the Land's End Peninsula, West Cornwall*, II: *Sennen & St Levan* (Penzance).

Cooke, I.M. (2002), *Crosses and Churchway Paths in the Land's End Peninsula, West Cornwall*, V: *Madron & Morvah* (Penzance).

Cooke, I.M. (2003), *Crosses and Churchway Paths in the Land's End Peninsula, West Cornwall,* VII: *Lelant, St Ives & Towednack* (Penzance).

Courtney, L. (1878), *Half a Century of Penzance (1825–1875)* (Penzance).

Cox, T. (1720), *Magna Britannia* (London).

Cramp, R. (2006), *Corpus of Anglo-Saxon Stone Sculpture,* VII: *South-West England* (Oxford).

Cumber, W.G. (1950), *The Story of St Stythians Parish Church, Cornwall* (Gloucester).

Dexter, T.F.G. and Dexter, H. (1938), *Cornish Crosses Christian and Pagan* (London).

Doble, G.H. (1945), *St Neot: Abbot & Confessor.* Cornish Saints Series, no. 21 (Exeter).

Douch, H.L. (1977), *The Book of Truro* (Chesham).

Edwards, N.M. (2007), *A Corpus of Early Medieval Inscribed Stones and Stone Sculpture in Wales,* 2: *South-West Wales* (Cardiff).

Ellis, G.E. (1937–42), 'Middle Moor Cross', *Old Cornwall,* 3: 237–39.

Ellis, G.E. (1950–51), '129. Cornish Crosses (*continued ...*)', *Devon & Cornwall N & Q,* 24: 137–42.

Ellis, G.E. (1952–53a), '27. Cornish Crosses (*continued ...*)', *Devon & Cornwall N & Q,* 25: 29–34.

Ellis, G.E. (1952–53b), '54. Cornish Crosses (*continued ...*)', *Devon & Cornwall N & Q,* 25: 57–61.

Ellis, G.E. (1952–53c), '137. Cornish Crosses (*continued ...*)', *Devon & Cornwall N & Q,* 25: 145–49.

Ellis, G.E. (1954–55a), '60. Cornish Crosses (*continued ...*)', *Devon & Cornwall N & Q,* 26: 65–70.

Ellis, G.E. (1954–55b), '94. Cornish Crosses (*continued ...*)', *Devon & Cornwall N & Q,* 26: 100–01.

Ellis, G.E. (1954–55c), '119. Cornish Crosses (*continued ...*)', *Devon & Cornwall N & Q,* 26: 161–63.

Ellis, G.E. (1954–55d), '139. Cornish Crosses (*continued ...*)', *Devon & Cornwall N & Q,* 26: 130–31.

Ellis, G.E. (1954–55e), '158. Cornish Crosses (*continued ...*)', *Devon & Cornwall N & Q,* 26: 193–98.

Ellis, G.E. (1956–58), '1. Cornish Crosses (*continued ...*)', *Devon & Cornwall N & Q,* 27: 1–5.

Ellis, G.E. (1959–61), '19. Cornish Crosses (*continued ...*)', *Devon & Cornwall N & Q,* 28: 33–37.

Ellis, G.E. (1962–64), '164. Cornish Crosses (*continued ...*)', *Devon & Cornwall N & Q,* 29: 273–76.

Forbes, J. (1794), 'A Tour into Cornwall to the Land's End, etc.' in a letter written 1794, *JRIC* n. ser. 9, 2, vol. ed. H.L. Douch and R.D. Penhallurick: 146–206.

Gilbert, D. (1838), *The Parochial History of Cornwall, Founded on the Manuscript Histories of Mr. Hals and Mr. Tonkin ...,* 4 vols (London).

Godwin, E.W. (1853), 'Examples of Church Architecture in Cornwall', *Arch. J.,* 10: 317–24.

Gossip, J., Preston-Jones, A., Smith, R. and Langdon, Andrew G. (2016), *St Buryan Churchyard Cross, Cornwall: Archaeological Recording and Watching Brief during Repairs,* Cornwall Archaeological Unit, Cornwall Council report (Truro).

Gough, J. and Padel, O.J. (2009), 'Richard Gough's tour of Cornwall in 1765', *JRIC,* no vol. no.: 67–94.

Gough, R. (ed.) (1789), *Britannia ... By William Camden* (London).

Hals, W., ed. Hals's nephew; name not given (1750), *Compleat History of Cornwal, General and Parochial* (Truro).

Hammond, J. (1897), *A Cornish Parish. Being an Account of St. Austell: Town, Church, District and People* (London).

Hare, N. (1881–83), 'The Quethiock Cross', *JRIC*, 7: 139–40.

Harvey, E.G. (1875), *Mullyon: Its History, Scenery and Antiquities* (Truro).

Haslam, W. (1845), 'On the Crosses of Cornwall', *Rpt RIC*, 27: 26–32.

Haslam, W. (1847), 'An account of some monumental and wayside crosses, still remaining in the west of Cornwall', *Arch. J.*, 4: 302–13.

Hencken, H.O'N. (1932), *The Archaeology of Cornwall and Scilly* (London).

Henderson, C.G. (1912–17), *Antiquities of the Deaneries of Penwith, Kirrier and Carnmarth*, RIC MS (Truro).

Henderson, C.G. (1925a), *The Cornish Church Guide* (Truro).

Henderson, C.G. (1925b), *Parochial History of East Cornwall*, RIC MS (Truro).

Henderson, C.G. (1928), 'Warleggan, a Cornish Parish', in T. Roberts and C.G. Henderson (eds), *Tre Pol and Pen: The Cornish Annual 1928*, London Cornish Association (London), 104–08.

Henderson, C.G. (1929), 'Records of St. Neot in Cornwall', in G.H. Doble (ed.), *S. Neot Patron of St. Neot, Cornwall and St. Neot's, Huntingdonshire* (Exeter), 39–58.

Henderson, C.G. (1930), 'Missing Cornish Crosses', *Old Cornwall*, 1, 12: 6–12.

Henderson, C.G. (1931), 'The Cult of S. Pieran or Perran and S. Keverne in Cornwall', in G.H. Doble (ed.), *Saint Perran, Saint Keverne, and Saint Kerrian* (Shipston-on-Stour), 36–68.

Henderson, C.G. (1935), in A.L. Rowse and M.I. Henderson (eds), *Essays in Cornish History* (Oxford).

Henderson, C.G. (1937), *A History of the Parish of Constantine in Cornwall*, ed. G.H. Doble (Long Compton).

Henderson, C.G. (1953–56), 'The Ecclesiastical History of the Four Western Hundreds of Cornwall, Part 2', *JRIC*, n. ser. 2, 4: 105–210.

Henderson, C.G. (1957–60a), 'The Ecclesiastical Antiquities of the 109 Parishes of West Cornwall', *JRIC*, n. ser. 3, 2: 211–382.

Henderson, C.G. (1957–60b), 'The Ecclesiastical History of the Four Western Hundreds, Part IV', *JRIC*, n. ser. 3, 4: 383–497.

Henderson, M. (1985), *A Survey of Ancient Crosses of Cornwall. 1952–1983*, 3 vols plus a fourth of illustrations by Laura Rowe and R.D. Penhallurick, RIC MS, catalogue no. 270.012 (Truro).

Herring, P.C. (1993), *An Archaeological Evaluation of St Michael's Mount*, National Trust and Cornwall Archaeological Unit, Cornwall County Council report (Truro).

Herring, P.C. (1998), *The Archaeology of Kit Hill*, Cornwall Archaeological Unit, Cornwall County Council report (Truro).

Herring, P.C. (2011), 'Later Medieval Cornwall: Rural Landscape', *CA*, 50: 287–93.

Hingston, F.C. (1850), *Specimens of Ancient Cornish Crosses, Fonts, etc.* (London, Oxford, Plymouth and Truro).

Hooke, D. (1994), *Pre-Conquest Charter-Bounds of Devon and Cornwall* (Woodbridge).

Iago, W. (1870), 'Mylor Church; its Crosses, Frescoes, etc.', *JRIC*, 3, 11: 162–72.

Iago, W. (1874–78), 'Cardinham Inscribed Stones, etc.', *JRIC*, 5, 19: 358–65.

Iago, W. (1876), 'Sketches of Various Antiquities in Bodmin and in Other Places in Cornwall', Society of Antiquaries Library, London.

Iago, W. (1878–81), 'The Lanhadron Inscribed Stone', *JRIC*, 6, 23: 397–401.

Johnson, N.D., Rose, P.G. *et al.* (1994), *Bodmin Moor An Archaeological Survey*, I, *The Human Landscape to c 1800* (Swindon).

Jones, A.M. and Quinnell, H. (eds) (2018), *An Intellectual Adventurer in Archaeology: Reflections on the Work of Charles Thomas* (Oxford).

Kirkham, G. (2018), 'Inscribed and Decorated Stones at Lanivet: Exploring the Context', *CA*, 55: 187–202.

Langdon, Andrew G. (1992a), *Stone Crosses in North Cornwall* (Padstow).

Langdon, Andrew G. (1992b), 'Cornish Crosses: Recent News', *CA*, 31: 154–65.

Langdon, Andrew G. (1996a), *Stone Crosses in East Cornwall* (Penryn).

Langdon, Andrew G. (1996b), *Stone Crosses in North Cornwall*, 2nd ed. (Penryn).

Langdon, Andrew G. (1996c), *An Addendum to Arthur G. Langdon's Old Cornish Crosses (Marking its Centenary) 1896–1996* (Truro).

Langdon, Andrew G. (1996d), 'Cornish Crosses—Update', *Old Cornwall*, 11: 567–72.

Langdon, Andrew G. (1997), *Stone Crosses in West Penwith* (Penryn).

Langdon, Andrew G. (1999), *Stone Crosses in West Cornwall (Including the Lizard)* (Penryn).

Langdon, Andrew G. (2000), 'Cornish Crosses: 2000 Update', *Old Cornwall*, 12: 10–21.

Langdon, Andrew G. (2002), *Stone Crosses in Mid Cornwall*, 2nd ed. (Penryn).

Langdon, Andrew G. (2004), 'The Discovery of Medieval Four-Holed Cross at Pelynt', *Cornwall Association of Local Historians' Journ.*, 48: 13–18.

Langdon, Andrew G. (2005), *Stone Crosses in East Cornwall*, 2nd ed. (Penryn).

Langdon, Andrew G. (2006a), 'The Preservation of Pelynt's Four-Holed Cross', *Cornwall Association of Local Historians' Journ.*, 52: 11–16.

Langdon, Andrew G. (2006b), 'Cornish Crosses 2004–06 Update', *Old Cornwall*, 13, 7: 33–9.

Langdon, Andrew G. (2006c), 'Old Tom: The Discovery of an Unfinished Cross on Catshole Tor, Bodmin Moor', *CA*, 45: 117–21.

Langdon, Andrew G. (2009), 'Cornish Cross 2006–08 Update', *Old Cornwall*, 13: 29–36.

Langdon, Andrew G. (2011), 'Cornish Crosses', *CA*, 50: 301–02.

Langdon, Andrew G. (2017), 'Whitecrosses', *Old Cornwall*, 15: 45–52.

Langdon, Andrew G. (2019), *High Cross, Truro: Recording and Monitoring Repairs* (Truro).

Langdon, Andrew G. (2020), 'A Museum of Crosses: The Medieval Stone Crosses of Lanteglos by Camelford', in *St Julitta's Church Lanteglos by Camelford: The Restoration of a Medieval Church. Discovering 800 Years of History: A Collection of Papers*, 105–24.

Langdon, Arthur G. (1890), personal letter dated 22 June in possession of Andrew G. Langdon.

Langdon, Arthur G. (1890–91), 'Ornament on the Early Crosses of Cornwall', *JRIC*, 10: 33–96.

Langdon, Arthur G. (1891), 'The Padstow Crosses', *JBAA*, 47: 301–07.

Langdon, Arthur G. (1896), *Old Cornish Crosses* (Truro).

Langdon, Arthur G. (1901), 'Restoration of the Cross at No-Man's-Land, Lanlivery, Cornwall', *Reliquary and Illustrated Archaeologist*, 7: 130–34.

Langdon, Arthur G. (1901–09), Additional Drawings, RIC MS (Truro).

Langdon, Arthur G. (1902), 'A Newly-Discovered Inscribed Stone in Cornwall', *Reliquary*, n. ser. 8: 50–53.

Langdon, Arthur G. (1906), 'Early Christian Monuments', in W. Page (ed.), *The Victoria History of the Counties of England, Cornwall*, I (London), 407–49.

Langdon, Arthur G., and Allen, J.R. (1888), 'The Early Christian Monuments of Cornwall', *JBAA*, 44: 301–25.

Langdon, Arthur G., and Allen, J.R. (1895), 'Catalogue of the Early Christian Inscribed Monuments in Cornwall', *Arch. Camb.*, 5, 12: 50–60.

Leland, John, ed. L.T. Smith (1907), *The Itinerary of John Leland in or about the years 1535–1543 Parts I to III* (London).

Lysons, D. and Lysons, S. (1814), *Magna Britannia …*, III, *Cornwall* (London).

Macalister, R.A.S. (1945), *Corpus Inscriptionum Insularum Celticarum*, I (Dublin).

Maclean, J. (1873), *The Parochial and Family History of the Deanery of Trigg Minor in the County of Cornwall*, I (London, Bodmin).

Maclean, J. (1876), *The Parochial and Family History of the Deanery of Trigg Minor in the County of Cornwall*, II (London, Bodmin).

Maclean, J. (1879), *The Parochial and Family History of the Deanery of Trigg Minor in the County of Cornwall*, III (London, Bodmin).

Martyn, T. (1748), *A New and Accurate Map of the County of Cornwall …* (?London).

Michell, J. (1977), *A Short Life at the Land's End: J.T. Blight F.S.A., Artist, Penzance* (Bath).

Michell Whitley, H. (1921), 'Cornish Folklore: to Avert an Ill Wish', *Devon and Cornwall Notes and Queries*, 11: 288.

Millett, G.B. (1844–48), 'The Cross of St. Ia', *Trans. Penz. NHA Soc.*, n. ser. 2: 145–46, 202.

Millett, G.B. (1888–92), 'Penzance Market Cross', *Trans. Penz. NHA Soc.*, n. ser. 3: 350–51.

Moyle, W., ed. T. Sergeant (1726), *The Works of Walter Moyle Esq; None of which were ever before Publish'd*, I (London).

Munn, P. and Long, L.E. (1988), *Bodmin, County Town of Cornwall in Old Picture Postcards* (Bodmin).

Nash-Williams, V.E. (1950), *The Early Christian Monuments of Wales* (Cardiff).

Norden, J. (1728), *Speculi Britanniae Pars. A Topographicall & Historical description of Cornwall* (London).

Ó Floinn, R. (1987), 'Irish Romanesque Crucifix Figures', in E. Rynne (ed.), *Figures from the Past: Studies on Figurative Art in Christian Ireland in Honour of Helen M. Roe* (Dublin), 168–88.

Okasha, E. (1971), *Hand-List of Anglo-Saxon Non-Runic Inscriptions* (Cambridge).

Okasha, E. (1993), *Corpus of Early Christian Inscribed Stones of South-West Britain* (London and New York).

Okasha, E. (1998–99), 'A Supplement to *Corpus of Early Christian Inscribed Stones of South-West Britain*', *CA*, 37–38: 137–52.

Olson, B.L. (1989), *Early Monasteries in Cornwall* (Woodbridge).

Olson, B.L. and Padel, O.J. (1986), 'A Tenth-Century List of Cornish Parochial Saints', *CMCS*, 12: 33–71.

Orme, N. (2007), *Cornwall and the Cross: Christianity 500–1560* (Chichester).

Orme, N. (2010), *The Victoria History of the Counties of England. A History of the County of Cornwall*, II: *Religious History to 1560* (Woodbridge).

P.C.P.W. (n.d.), *Lanherne: The Oldest Carmel in England* (London).

Padel, O.J. (1976–77), 'Cornish Names of Parish Churches', *Cornish Stud.*, 4/5: 15–27.

Padel, O.J. (1981), 'The Cornish Background of the Tristan Stories', *CMCS*, 1, Summer: 53–81.

Padel, O.J. (1985), *Cornish Place-Name Elements*, English Place-Name Society, 56–57 (Nottingham).

Padel, O.J. (1988), *A Popular Dictionary of Cornish Place-Names* (Penzance).

Padel, O.J. (2002), 'Local Saints and Place-Names in Cornwall', in Alan Thacker and Richard Sharpe (eds), *Local Saints and Local Churches in the Early Medieval West* (Oxford), 303–60.

Padel, O.J. (2014), 'The Boundary of Tywarnhayle (Perranzabuloe) in A.D. 960', *JRIC*, no vol. no.: 69–92.

Paris, J.A. (1824), *A Guide to the Mount's Bay and the Land's End …*, 2nd ed. (London).

Penaluna, W. (1838), *An Historical Survey of the County of Cornwall, Etc.* (Helston).

Peter, T.C. (1898), 'Cornish Crosses, Some Recently Discovered', in A.T. Quiller-Couch (ed.), *The Cornish Magazine*, 1, July to December: 74–77.

Peter, T.C. (1899–1900), 'Notes on the Church of S. Just-in-Penwith', *JRIC*, 14: 173–90.

Picken, W.M. (1955), '160. Trezance, Lahays and the Manor of Cardinham', *Devon & Cornwall N & Q*, 26: 203–08.

Polsue, J. (1867), *A Complete Parochial History of the County of Cornwall …*, I (Truro and London).

Polsue, J. (1868), *A Complete Parochial History of the County of Cornwall …*, II (Truro and London).

Polsue, J. (1870), *A Complete Parochial History of the County of Cornwall …*, III (Truro and London).

Polsue, J. (1872), *A Complete Parochial History of the County of Cornwall …*, IV (Truro and London).

Polwhele, R. (1803), *The History of Cornwall …* (Falmouth).

Preston-Jones, A. (1984), 'The Excavation of a Long-Cist Cemetery at Carnanton, St Mawgan, 1943', *CA*, 23: 157–78.

Preston-Jones, A. (2004), *Cross-Shaft and Base on the Western Approach to St Michael's Mount, Cornwall: Repairs to the Base*, Cornwall Archaeological Unit, Cornwall County Council report (Truro).

Preston-Jones, A. (2005), *Sancreed Churchyard: Repair and Restoration of Medieval Granite Wayside Crosses*, Historic Environment Service, Cornwall County Council report (Truro).

Preston-Jones, A. (2006a), *Wharncliffe Arms Hotel, Tintagel: Restoration of an 11th Century Cross*, Historic Environment Service, Cornwall County Council report (Truro).

Preston-Jones, A. (2006b), *High Hall Cross on Laneast Down, Cornwall: Restoration of a Medieval Wayside Cross*, Historic Environment Service, Cornwall County Council report (Truro).

Preston-Jones, A. (2007), *Cross Gates Cross, St Clether, Cornwall: Repair and Restoration*, Historic Environment Service, Cornwall County Council report (Truro).

Preston-Jones, A. (2009), *Paul, Cornwall, Churchyard Crosses: Conservation and Investigation*, Historic Environment Service, Cornwall Council (Truro).

Preston-Jones, A. (2011a), 'The Early Medieval Church', *CA*, 50: 269–76.

Preston-Jones, A. (2011b), *Kerris Cross, Paul, Cornwall: Conservation and Repair*, Historic Environment Service, Cornwall Council (Truro).

Preston-Jones, A. (2017), '"A large block of granite" or a Unique Piece of Sculpture?', in P. Holden (ed.), *Celebrating Pevsner. Papers from the 2015 Cornish Buildings Group*

Conference 'Only a Cornishman Would Have the Endurance to Carve Intractable Granite' (London), 31–40.

Preston-Jones, A. (2018), 'St Piran's Cross: A Cornish Icon Re-Considered', in A.M. Jones and H. Quinnell (eds), *An Intellectual Adventurer in Archaeology: Reflections on the Work of Charles Thomas* (Oxford), 159–74.

Preston-Jones, A. and Attwell, D. (1997), *The Rectory Cross-Head at Lanteglos by Camelford*, Cornwall Archaeological Unit, Cornwall County Council report (Truro).

Preston-Jones, A. and Langdon, Andrew G. (1997), 'St Buryan Crosses', *CA*, 36: 107–28.

Preston-Jones, A. and Langdon, Andrew G. (1998), *The Restoration of the St Erth Churchyard Cross*, Cornwall Archaeological Unit, Cornwall County Council report (Truro).

Preston-Jones, A. and Okasha, E. (2013), *Corpus of Anglo-Saxon Stone Sculpture*, XI: *Early Cornish Sculpture* (Oxford).

Preston-Jones, A. and Rose, P.G. (1986), 'Medieval Cornwall', *CA*, 25: 135–85.

Prout (1809), illustration, RIC MS (Truro).

Quiller-Couch, M. and Quiller-Couch, L. (1894), *Ancient and Holy Wells of Cornwall* (London).

Redding, C. (1842), *An Illustrated Itinerary of the County of Cornwall* (London).

Redknap, M. and Lewis, J.M. (2007), *A Corpus of Early Medieval Inscribed Stones and Stone Sculpture in Wales*, vol. 1, *Breconshire, Glamorgan, Monmouthshire, Radnorshire and Geographically Contiguous Areas of Herefordshire and Shropshire* (Cardiff).

Rhys, J. (1875), 'On some of our Inscribed Stones', *Arch. Camb.*, 4, 6: 359–71.

Rowe, J.H. (1926–28), 'Tristram, King Rivalen and King Mark', *JRIC*, 22, 3: 445–64.

Rowse, A.L. (1984), 'A Memorial to Charles Henderson (1900–1933)', *JRIC*, n. ser. 9: 218–25.

Ryder, P.F. (1991), *Medieval Cross Slab Grave Covers in West Yorkshire*, West Yorkshire Archaeological Service (Wakefield).

Ryder, P.F. (2005), *The Medieval Cross Slab Grave Covers in Cumbria. Cumberland, Westmorland Antiq. Archaeol. Soc.*, extra ser., 32 (Kendal).

Sawyer, P.H. (1968), *Anglo-Saxon Charters: An Annotated List and Bibliography* (London).

Sedding, E.H. (1909), *Norman Architecture in Cornwall …* (London and Truro).

Spence, C. (1849), '"Iter Cornubiense", a Relation of Certain Passages which Took Place during a Short Tour in Cornwall', *Trans Exeter Dioc. Archit. Soc.*, 3: 205–23.

Stephens, W. (1915), 'St. Kew Crosses', *JRIC*, 20: 87–90.

Stockdale, F.W.L. (1824), *Excursions in the County of Cornwall …* (London).

Swete, J. (1780), A Tour in Cornwall MDCCLXXX, RIC MS, catalogue no. DJS/2/1 (Truro).

Thomas, A.C. (1965), 'The Hill-Fort at St. Dennis', *CA*, 4: 31–35.

Thomas, A.C. (1967), *Christian Antiquities of Camborne* (St Austell).

Thomas, A.C. (1968), 'Merther Uny, Wendron', *CA*, 7: 81–82.

Thomas, A.C. (1978), 'Ninth Century Sculpture in Cornwall: A Note', in J. Lang (ed.), *Anglo-Saxon and Viking Age Sculpture*, BAR British Series, 49 (Oxford), 75–79.

Thomas, A.C. (1986), *Celtic Britain* (London).

Thomas, A.C. (1990), *Phillack Church. An Illustrated History of the Celtic, Norman, and Medieval Foundations*, 2nd ed. (Hayle).

Thomas, A.C. (1993), *Book of Tintagel: Arthur and Archaeology* (London).

Thomas, A.C. (1994), *And Shall These Mute Stones Speak? Post-Roman Inscriptions in Western Britain* (Cardiff).

Thomas, A.C. (1997), 'Christian Latin Inscriptions from Cornwall in Biblical Style', *JRIC*, n. ser. 4, 4: 42–66.

Thomas, A.C. (1999), *Penzance Market Cross: A Cornish Wonder Re-Wondered* (Penzance).

Thomas, A.C. (2018), 'A Second Inscribed Stone at Lanivet Church', *CA*, 55: 181–84.

Thomas, N. (1996), 'An Archaeological Investigation of Four Holes Cross Minzies Downs, St Neot', Cornwall Archaeological Unit, Cornwall County Council report (Truro).

Thorn, C. and Thorn, F. (eds) (1979), *Domesday Book*, vol. 10, *Cornwall* (Chichester).

Trelease, G.M. (2006), *The History of the Church in Paul Parish* (Newlyn).

Trevan, J.W. (1834), 'Summary Memoirs, of the Parish of Endellion, prior to the Year 1834', unpublished transcription by Port Isaac Local History Group.

Turner, S. (2006), *Making a Christian Landscape. The Countryside in Early Medieval Cornwall, Devon and Wessex* (Exeter).

Webster, L. (2012), *Anglo-Saxon Art, A New History* (London).

Willmot, H.J. (1933), 'Long Cross Restored to Long Cross', *Old Cornwall*, 2: 17–18.

Wills, S.J. (1890), 'Wendron Churchyard Cross', in E. Vincent (ed.), *The Eagle—A Miscellany of Art, Literature, Comment and Gossip*, 1, 8: 90–91.

# Index

References in **bold** indicate main catalogue pages.